# Gruppé on Color

# Gruppé on Color

## Using Expressive Color to Paint Nature
## By Emile A. Gruppé   Edited by Charles Movalli

Watson-Guptill Publications/New York

*I dedicate this book to my grandchildren.*

I would like to thank Don Holden, who originated the idea for this book, and Charles Movalli, who organized the project, photographed it, and brought it to a successful conclusion.

First published 1979 in the United States and Canada by Watson-Guptill Publications
a division of Billboard Publications, Inc.
1515 Broadway, New York, N.Y. 10036

**Library of Congress Cataloging in Publication Data**
Gruppé, Emile A        1896-
   Gruppé on color.
   Bibliography:   p.
   Includes index.
   1. Color in art.    2. Landscape painting—Technique.
3. Marine painting—Technique    I. Movalli, Charles.
II. Title.
ND1489.G75      1979        751.4'5        78-27121
ISBN 0-8230-2155-6

Manufactured in Japan

First Printing, 1979

# Contents

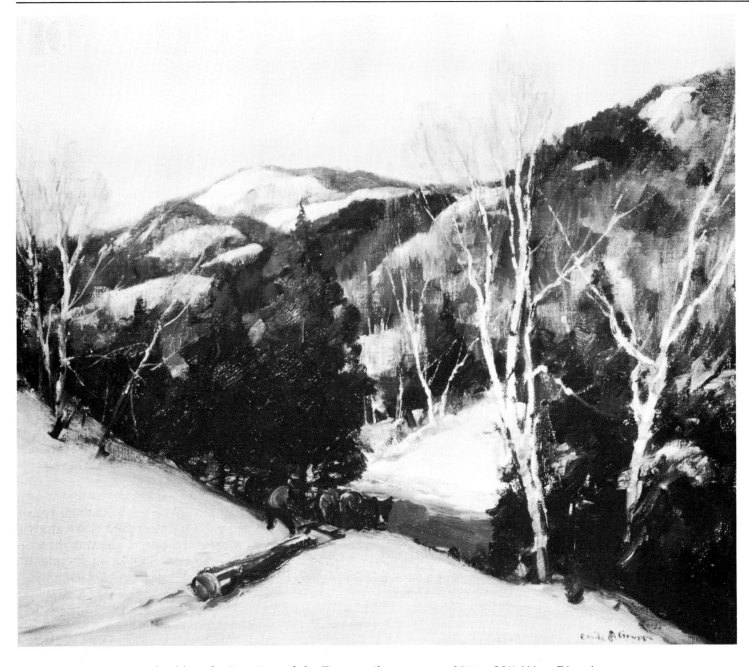

**Snaking the Log Out of the Forest,** oil on canvas, 25″ × 30″ (64 × 76 cm). This is an early morning picture, with the foreground mostly in shadow. Since it's a clear day, the background is dark. I use the very dark foreground pines to contrast with the distance and thus throw it back in space. These dark pines also help define the sunlit birches.

# Introduction

I've always been lucky, for since I was a kid, painting has been my whole life. It's all I've known—morning, noon, and night. When I was a student at Woodstock, New York, my shed bulged with pictures. And once I got my own studio, I always painted every day. I loved the fresh air. And when I couldn't paint, I felt as if I'd lost something. If I missed three days—well, then I was miserable!

I was also lucky to have grown up during a great period in American art. The years prior to World War I were filled with fine landscape painters. There'd been some outstanding men in the nineteenth century—Winslow Homer is a notable example—but most of them used landscape as a background for their figure work. When I was a student, this had all changed. My studio, for example, was down the hall from the great Childe Hassam. John Carlson and Charles Hawthorne were actively teaching the principles of outdoor painting. At the Art Students League, I could listen to Robert Henri—an hour of whose talk could change your life! And at Woodstock, I'd see Henri and his best student, George Bellows, exchange toasts. To us students, these were the "Big Men."

I can still remember the great National Academy shows. Three painters dominated the walls: Edward Redfield, Daniel Garber, and Elmer Schofield. They all worked boldly and with wonderful color—and you never critically compared them, for you loved each one when you stood in front of his canvas. Redfield was my favorite; I could never figure out how he got such wonderful effects—with such simple means. From a distance, his 40''×50'' (102 × 127 cm) looked like nature itself. They were perfect: a street with ruts, probably a figure standing in the snow near a house, and beautifully drawn trees and buildings receding into the distance. But when you stepped up to the picture, you just saw rough strokes and funny squiggles for the background trees. I can still see the big smacks of paint that ran across the front of Redfield's canvases. I'd *run* home from these shows, anxious to see if I could get some of that feeling in my own pictures. The Big Men did beautiful work. And, thinking about them, I often feel as if art has stood still since their time.

I was also lucky to have had great teachers—not only academic men who drilled me in the fundamentals, but also teachers who stressed the importance of feeling and imagination. In my illustration class, for example, we'd be told to paint an Indian—using an Italian as a model. It was our job to make him *look* like an Indian. We had to use our imagination. In a similar way, the instructor told us to feel our way into a draw-ing. Rather than make an outline, we approximated the shape with a lot of rhythmic lines. As we worked, we eventually discovered the line that intuitively looked right. It was like drawing without drawing; we found what we wanted within the lines.

John Carlson turned me into a painter. He showed me what art was all about. And I don't think anyone had a better ability to see the pictorial possibilities of a subject. I took him all over Jeffersonville, Vermont, one fall, showing him my favorite painting sites. He didn't react, so I kept driving. I can still remember his turning to me and saying "Will you please *light!* I've seen a dozen pictures this morning. Let's get out and work!" He didn't need a hand-picked subject; he could make a painting out of anything.

Finally, I've been lucky to have spent almost sixty years as a teacher. I studied under a number of fine painters; but when I left their classes, my knowledge was full of loose ends. In talking to my own students, I had to tie those ends; in teaching, I taught myself.

## The Organization of the Book

This book is very simply planned. Although color is my main interest, I can't divorce it from either drawing or values. So I'll take some time to discuss these important matters. I'll then explain my color theories and how they've led logically to the pigments I use.

After I discuss the palette, you'll have an understanding of the basic mixes that I use in my pictures. Then I'll talk about color relationships in nature, the characteristics of the seasons, and some aspects of marine painting. I should tell you now, however, that I won't list all my color mixes. I get a certain green one way—but there may be a hundred variations of that color, depending on the amount of each pigment used. Looking at an old picture, for example, I know approximately how I got a color—but I might have trouble mixing an exact match. The color was the result of the moment, of how I saw the thing, and of the colors I'd already mixed on the palette—in short, of the whole process of painting. You come to understand color through experience, not by my describing each mix.

At the end of the book a sample demonstration shows you how I go about painting a picture. But remember: you don't have to paint like me, or like any of your instructors—or like anyone else but yourself. I simply want you to *look* at nature, to see it as a series of big relationships and not as a bunch of meaningless details. If you learn to look at nature, you can put paint on with a stick—and still get some of the truth that makes a real work of art!

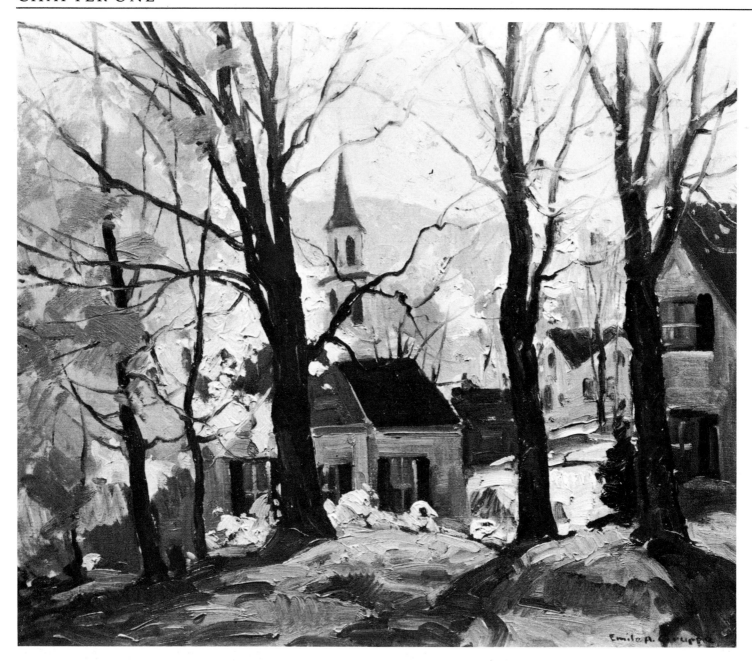

**Height of the Fall,** oil on canvas, 25'' × 30'' (64 × 76 cm), Collection of C. Richard Clark. When you look into the light, the sun brightens the sky, making it very light in value. The shadowed white houses look dark in comparison to the sky—and the foreground trees appear even darker. By blocking the left side of the canvas with foliage and the right side with a large house, I force you into the center of the picture and lead your eye toward the distant mountain.

# Drawing and Values

Although this book is concerned with color, I want to spend the first chapter talking about things which are as important—if not more important—than color: namely, drawing and values. You can know everything about color; but you have to be able to draw in order to put that color in the right spot. And if you don't understand values, your color will fail to hold its place on the canvas, thus destroying all sense of form and atmosphere.

I also want to use this and other chapters to tell you a little about my own background in art and to show you how and why I made the decisions that gradually led me to my present manner of painting. Showing you my own development may help you to understand what I think painting is all about.

## My Early Days

When I was young, I was surrounded by art. My father was a painter. One of my brothers planned to be a sculptor; the other, a cellist. My sister worked in watercolor. Artists visited our home for dinner, and we visited the studios of our friends. My father's pictures were all over the house. I can still remember using my brother's crossbow to shoot a hole through five of my father's stacked canvases—one of which had won a gold medal at the Salon. After that, my father put me in a closet, later saying he had to get me out of reach—or he'd have killed me!

I had a small work space at home and did a lot of still lifes under my father's instruction. He'd set up apples, plums, and grapes in an effort to teach me how to draw. He was a great believer in accuracy, and I can remember how he'd break open an apple and spread the pieces on the table, so I could try to draw the seeds, stem, and the broken core. His conscientiousness was a by-word in our house; and he once told me how he'd labored to capture just one aspect of a group of pears: the few rotten spots that many painters might have ignored. A patron later offered to buy the picture, if my father would only get rid of those spots. Of course, he refused. To him, those rotten areas *were* the picture. They were the characteristic details that set those pears apart from all others. He loved such touches. And I recall the pleasure he took in drawing the broken movement of tree roots and in capturing the individual texture or bark. He did it so perfectly that you could actually feel the tree, just from the way he handled its surface details.

## Learning to Draw

Naturally, a man with that kind of eye was determined his son would be able to draw. As a result, I was soon enrolled in the Art Students League, studying the figure with George Bridgman. Bridgman made us see everything. But we had to see in terms of an expressive contour. He wasn't interested in three-dimensional shading; he said anyone could learn to shade. Instead, he wanted us to catch the swing of the figure, to see the general movement. We might work all week, just getting a single contour right. We learned to ask ourselves questions. How were the feet placed? How was the weight of the body distributed on the feet? How did the hips of the model twist as he or she settled into the pose? In short: how was the figure constructed?

In Figure 1, a few sketches suggest the linear approach recommended by Bridgman. The sketches were made from twenty-minute poses at a local art association. Notice the different angles of the legs, waist, and shoulders. You might wonder what figure drawing has to do with landscape painting. Well, everything! The figure nails you down; it forces you to look. And if you know how to look, you can paint. John Sargent, for example, was a great portraitist—and a *tremendous* outdoor painter.

The accuracy recommended by Bridgman came naturally to me, for my father, as I've suggested, had the same attitude. In my first year at the National Academy school I won the Cézanne Medal for a meticulously rendered still life of a bottle, porcelain urn, and a broken orange (Figure 2). I worked for days on just part of the orange, trying to show the peel, the color of the flesh, and the delicacy of the white seams. There were three big skylights in the room—and I carefully showed where each reflected onto the urn. In that year, I only finished five still lifes. But working so carefully was great practice for me—and by mentioning the experience, I hope you'll realize how my present, more sketchy approach is based on this early discipline. There's no way to sidestep drawing.

When I won the Cézanne Medal, my father decided there was some hope for me and enrolled me in the Art Students League summer school at Woodstock. The school was run by John Carlson and was specifically designed to teach the fundamentals of outdoor painting. Studying with Carlson was the best thing that ever happened to me, not only because of his technical advice but also because he proved to me that great

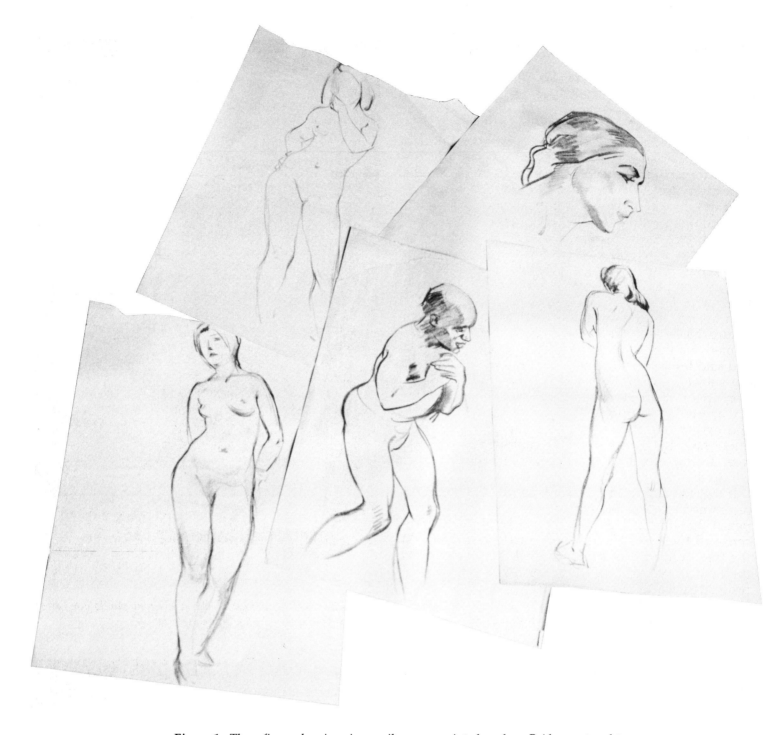

**Figure 1.** *These figure drawings in pencil on newsprint show how Bridgman taught us to look for the characteristic contour of the subject. Drawing the figure, you train your eye and, through that discipline, make yourself into a better landscape painter.*

painters are always generous and helpful. He rested on the porch after dinner; and as the other guests headed home, he'd stretch his legs and tell me to bring down the day's work. Then he'd spend half an hour talking about my little *pochauds* (studies).

Although Carlson's students worked every day, Tuesday and Thursday were the "official" painting sessions. Carlson and his assistants methodically talked to each student for about three minutes—the maximum time, since they had over a hundred youngsters to instruct. On Saturdays, Carlson critiqued the whole week's production (Figure 3). That's when you really learned, both by listening to Carlson—who was like fire when he talked—and by comparing your work to that of the other students. Just by comparing, you often saw where you were going wrong.

In his teaching, Carlson stressed that everything in nature has a definite, characteristic pattern. I was primed for that kind of instruction, since Bridgman had said the same thing in regard to the figure. Study the subject, Carlson told us, and look for its design. Don't paint "a tree"—but get the character of the particular tree in front of you. Don't make it so straight and perfect that it looks as if it came off a tree farm. Show how the forest affects it: how it relates to the trees around it and how branches react to one another within the tree itself.

If we were doing a birch, for example, Carlson often recommended that we first do three or four careful pencil drawings. That way, we could begin to get a sense of the tree's movement. Once we understood the tree, we could paint it. Figure 4 is an example of the kind of careful tree study we'd do for Carlson. I proceeded exactly as if I were drawing in Bridgman's class. What was the characteristic movement of the tree? Here I was struck by the way that (1) the large central branches shoot upward toward the sky while (2) the smaller branches start upward and then veer downward and to the sides in an effort to work their way toward the sun. Pay particular attention to the small branch at the top center of the study. It, too, starts up, is blocked by the heavy mass of overhead foliage, and then drops quickly downward. You must see and record such movements if you want to capture the truth of your subject.

## Values and Tonality

By constant practice, I eventually learned something about drawing. The other troublesome part of my student days centered around the judging of *values*. When I mention the "value" of a color, I'm talking about how light or dark it is. How would it look if you took a black and white picture of it? The value of a color changes according to (1) the nature of the day, (2) whether the color is in light or shadow, and (3) whether the color is near to you or far away.

When I was studying art—just before World War I—values were all the rage. The great paintings were the ones with the most subtle value relationships. The closer you could bring your values—and still distinguish between them—the stronger you were as a

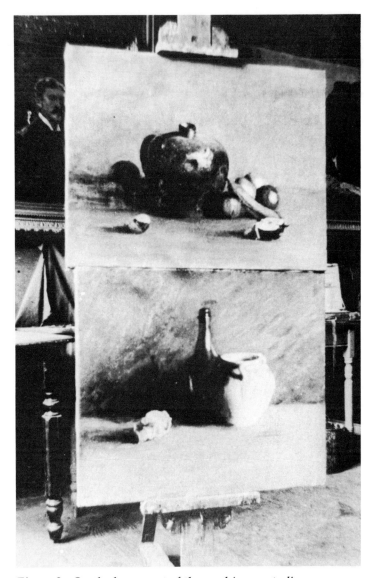

*Figure 2.* On the lower part of the easel in my studio you can see the picture that won me the Cézanne Medal.

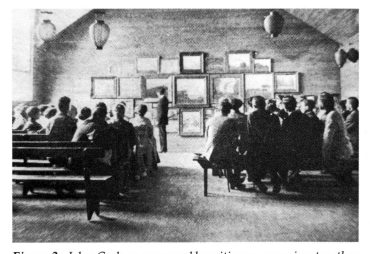

*Figure 3.* John Carlson gave weekly critiques, grouping together paintings with similar errors so that the students could more easily see their mistakes. These critiques were the heart of his teaching method.

11

***Figure 4.*** Tree Study, *oil on board, 12'' × 9'' (30 × 23 cm). When doing tree studies for Carlson, we tried to get the exact character of the particular tree. The procedure was similar to that used in Bridgman's life class.*

painter. Gallery men would give you a magnifying glass so you could better study the subtlety of the masters. As you'd expect, gray days were particularly loved by the "tonal" painters. There was no sun to create strong contrasts, and all the values came close to one another. The silvery, gray-day pictures of Corot are classic examples of the tonal approach. My father did a lot of gray day painting himself, mostly in Holland, where the sky is perpetually overcast.

It's not easy to explain the effect of a good tonal painting. You have to see one. Thinking of them, I'm reminded of the singing of Caruso. He might hit a strong note, but he carefully built up to it, so that it remained part of the overall form of the song. He stirred you because you felt that, no matter what note he hit, he still held something back—he still had more to give. The tonal painters were reserved in their color and sparing in their use of contrast. Carlson was trained as a tonal painter, for example, and if he were working on a clear winter's day, he'd never use a pure white for the sunlit snow. The snow would be light in value, but always slightly grayed—so that the lights and darks worked together as a unit. When you looked at the picture, you knew Carlson could go lighter in the lights and darker in the darks, but you also felt that—like Caruso—he had purposely decided not to

do so. You sensed the reserve behind the work, and that made it wonderful to look at.

I was determined to be a tonal painter, just like my father. But when I began, I mistook reserve for murkiness and ended painting darkly, with lots of blacks and browns. The picture that won the Cézanne Medal was done in these earth tones, and I'm sure that I got the prize because the older judges liked that style and wanted to send a message to the other, more "modern" pure-color students—students who were much better painters than I.

In fact, the students had themselves sent *me* a message while I was working on the picture. In those days, the places at the National Academy school were given out on a first-come, first-served basis. And I monopolized the best-lit spot in the hall for three whole weeks. Everybody wanted me out of it. I came in early one morning to find that someone had drawn a white mouse coming out of my urn, and painted a candle in my bottle, and had put yet another mouse in a lower corner, eating a piece of cheese! I couldn't get angry, because it was funny—and darn well drawn. So I moved to another part of the hall.

The added candle suggests how dark my painting looked to the more advanced students. Everything I did in those days was dark and low in key—in the "Rembrandt manner." I remember doing a figure study at the time in these same dark tones. The instructor, Maynard, came by and put a spot of pure white right next to the figure. "Life's too short to be painting as dark as that," he said—and I was sixteen and he eighty-five!

Years later, I had a similar experience, one you'll do well to remember whenever you begin to work in too dull and dark a key. I was painting a Portuguese fisherwoman, lit from the back. Her face was in shadow; her complexion, very dark. As I remember, I had planned to set the whole off by the brilliant touch of a red ribbon in her hair. Before I got that far, however, George Elmer Browne came by, looked at the study, and stuck a spot of white paint right in the middle of the shadowed face. "Too dark," he said—and walked on!

## Value Relationships

Carlson soon showed me that the real strength of tonal painting wasn't its low key—but rather its careful consideration of the value relationships *between* objects. Things in nature are always seen in relation to one another—never alone. Carlson was particularly interested in (1) the values of the big elements in the landscape and (2) the effect atmosphere has on the value of objects as they recede in space.

The first value relationship concerned the flat earth, the upright and slanted planes, and the sky. Again, the student had to learn to ask questions. How dark was the sky in relation to the earth? How dark was the earth in relation to the sky? How dark was the sloping side of a mountain—*compared* to the earth and the sky? Carlson knew that the truth of a picture depended on the painter's getting these relationships right. As an exercise, he'd tell us to take a small canvas and divide

**Figure 5.** Woodstock, *oil on canvas, 20'' × 24'' (51 × 61 cm). In this early painting, I suggest distance by carefully judging my values. Notice, for example, the contrast between the dark foreground shadows and the lighter shadows of the distant foliage.*

***Figure 6.*** *Carlson told his students to make a simple viewfinder. We'd hold it in front of us; the large opening isolated our subject, while the small slit helped us gauge the values of the big landscape units.*

it into quarters. In each quarter, we'd do a small value painting looking (1) into the light, (2) away from the light, (3) to the left, and (4) to the right. Each mass—sky, earth, trees, mountains—had to be noted with only a few strokes of the brush. We weren't composing; we were simply trying to get the values right. Looking at the sketches, the viewer should immediately tell where the sun was in the sky.

When commenting on our paintings, Carlson would himself do similar small sketches right on our palettes. Using five or six strokes, he'd show the relation of the sky and the earth—so beautifully that you could immediately see where you were making a mistake. He'd usually do three such sketches. If you wanted to keep them, you'd have to buy a new palette; for he'd rub them out on the fourth day and start all over again.

Figure 5 has been battered by the passage of time, but it's the only record I have of the kind of work I did during my first few years with Carlson. The picture illustrates one set of basic value relationships: the sky is the lightest element in the landscape, since it's the source of light. The earth is the next lightest, for the light of the surrounding sky falls onto it. Upright planes—like the masses of foliage—are the darkest; they receive less light than the horizontal surfaces.

Carlson was also a profound student of the way objects change in value as they move into the distance. He often said you were painting when you could show each foot of recession into the landscape. The values change, of course, because the dust in the atmosphere forms a veil between you and the distant objects; a dark object thus appears light in value as it moves away from us. This is part of what we call atmospheric

perspective. Such changes are especially evident over long distances. Look again at Figure 5, and you'll see how the shadows on the trees get lighter in value as they recede. But you can also see value changes of this sort over relatively short distances. I remember a flower painting by the great still-life painter Emil Carlsen. There was only about two feet of real depth in the picture. Yet the foreground flowers were clearly different in value and more brilliantly colored than those only a short distance behind them. By emphasizing the changes in value, Carlsen gave a great feeling of volume to the bouquet. You felt that it existed in a deep, three-dimensional space.

## Seeing Value Changes

Outdoors, students don't see these changes in value because they're distracted by the details of the scene. In order to improve our ability to see values, Carlson had us make a viewfinder. The viewfinder was smaller than this page and fit easily into our paintbox (Figure 6). We cut a square hole in the cardboard. That helped us to compose by condensing the subject, isolating it, and cutting away peripheral details. Of equal importance, however, was a quarter-inch-wide slit next to this square opening. Holding the viewfinder in front of us, we saw bands or value through the slit. We couldn't tell what the objects were, and so we weren't distracted by what we knew about them. We could make comparisons more easily, checking how dark the bit of sky was in relation to the trees or land beneath it.

Once we began to understand values, we no longer needed this preliminary aid. Instead, we squinted at our subject. If you keep your eyes wide open, everything looks brilliant. And the longer you stare at a thing—even a dark shadow—the lighter it gets. When you squint, you cut down the amount of light entering the eye. Try squinting so that you can barely see what's in front of you. The details of the scene will be reduced to a few big units, and you can more easily make comparisons between them.

Don't expect to master these comparisons right away. It takes a while to learn to gauge values. But as I said earlier, it's *essential* that you learn to do it—for the value of a color must be right if you want it to take its proper spacial position in the picture. That's why you see outdoor painters squinting all the time. And that's why they have marked crow's feet around their eyes. That's how I got mine!

## Black and White Portfolio

In order to make the subject of values more easily understood, let's look at the following portfolio of paintings. By looking at values first, we won't be distracted by color. Later, we can talk about my palette and the nature of outdoor color. Don't worry about color, however, until you feel that the concept of values is clear in your mind.

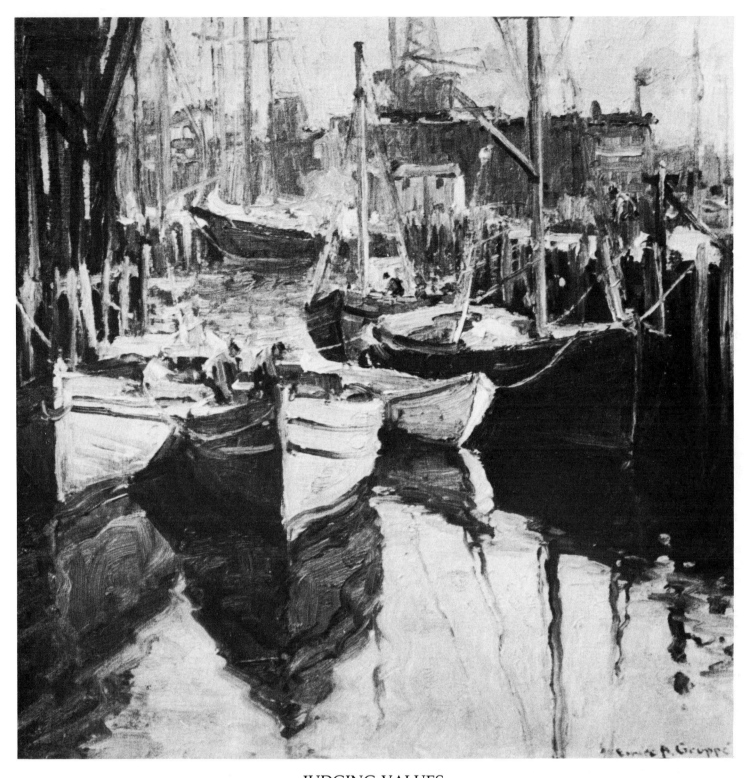

## JUDGING VALUES

**Gloucester Harbor,** oil on canvas, 20″ × 20″ (51 × 51 cm). One way to control the values in your work is to select your darkest dark, determine its exact value, and then compare the values in the rest of the painting to it. Because of the effects of atmospheric perspective on the more distant objects, the darkest value is usually in the foreground, as is the case here: the dark boats, wharf, shadows, and, especially, the dark building to the far left. Notice that this structure is much darker than the background buildings to its right. This contrast in value is what makes the distance recede. Similarly, to the right, a few dark accents on the boat mast contrast sharply with the lighter buildings in the distance. The accents help create a feeling of space. I painted this picture on a clear day, and if I'd stared at the background buildings alone, they'd have looked much darker than I painted them. But I looked at them— and *then* at the foreground. Remember: never consider an object in isolation. Always see it in relation to its surroundings.

## TONALITY: GRAY DAY

**Sycamores Along the Hoosatonic,** oil on canvas, 24″ × 20″ (61 × 51 cm). This gray-day picture is handled in a "tonal" manner. There are no strong lights or darks—and no pure whites. The values are close, and you have to be very careful when judging them. Notice, for example, how the trees across the river are only slightly lighter in value than the mass of foliage to the far right. The upper parts of the sycamores are light—but they're still dark in value compared to the overcast sky. The student often sees such light trees on a gray day, and in order to express that fact, he darkens the sky. That completely destroys the beauty and truth of the day. Here, you know how light the upper parts of the trees are by comparing them to the darker trunks. In the foreground, you can see individual leaves on the trees; but in the distance, the leaves become a single large value mass. Although I no longer paint as softly as I did in this old picture, I've never regretted my training in the tonal approach. It made me appreciate the importance of values.

## SHARP CONTRAST: CLEAR DAY

**Boats at Dock,** oil on canvas, 24″ × 20″ (61 × 51 cm). This painting is a complete contrast to the preceding one. It was painted on a bright day, and the value contrasts are clear and sharp. I go from black to white. The day is so clear that even the background buildings are fairly dark in value. Their dark shapes help emphasize the interesting design of the light sails. Because the sun is so bright, the shadows are almost opaque; you have trouble seeing into them. The dynamic, angular design of the picture works with the strong contrasts to create a painting with lots of punch. The close values in the preceding painting, on the other hand, give that picture a quiet, restful feeling. In this picture, I pull out all the stops. In the other, I'm much more reserved.

## ATMOSPHERIC PERSPECTIVE: HAZY DAY

**Fall in Vermont,** oil on canvas, 30″ × 36″ (76 × 91 cm). In this panorama, I tried to suggest the rolling hills of Vermont by emphasizing their convex, bulging shape. The dark pine in the lower right-hand corner is one of the key areas in the painting. It's the nearest tree to us and so is the darkest spot in the picture. I put it down early and used it as a standard to measure the other values against. You can see that the pines across the center of the painting are lighter; the distant pines, lighter still. At the horizon, trees and land all blur into a single light area of value. I should note that the foreground pine is also valuable in terms of scale. You compare it to the little dots in the distance and immediately feel how far back the other trees must be. Both value and size help step you back in space.

## ATMOSPHERIC PERSPECTIVE: FOGGY DAY

**Gloucester Fog,** oil on canvas, 25″ × 30″ (64 × 76 cm). A foggy day has the same characteristics as a regular day—only greatly exaggerated. All days have a certain amount of "fog" to them. Here you can see how sharp my foreground darks are—and how the heavy atmosphere rapidly affects all distant objects, making them very light in value. On the far left, the houses and wharves become one simple mass, broken only by the lighter shapes of the roofs. Notice how the darks on the boat in the middle distance are lighter in value than any of the foreground darks—yet darker than the distant buildings. These distant buildings pin down the corner. They catch your eye as it moves across the harbor from right to left and, by their tapering shape, direct you back into the distant fog. Careful value gradation is the key to the painting. If the values were wrong, the best color in the world could never make the picture look true.

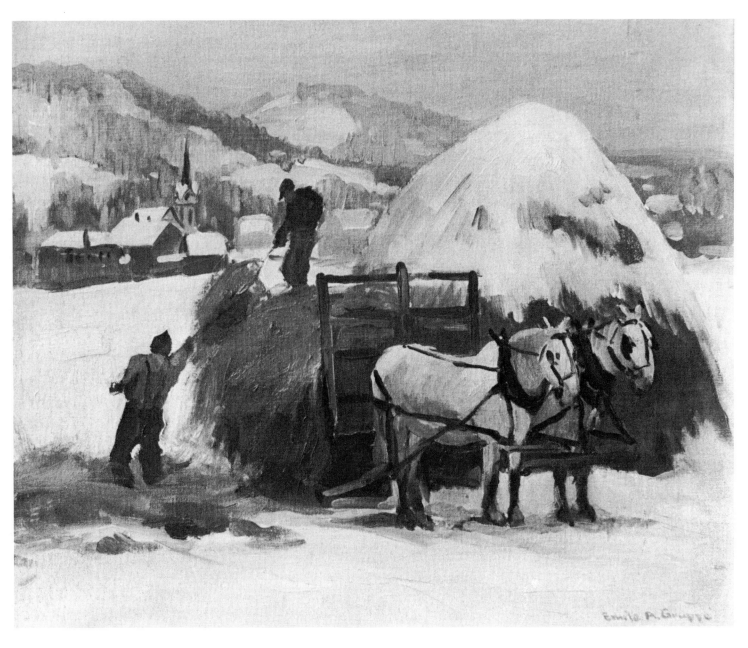

## LIGHT AGAINST DARK

**The Last of the Haystack,** oil on canvas, 20'' × 24'' (51 × 61 cm). Here I've used values (1) to create space and (2) to give definition to my subject. The man on top of the wagon wears a dark coat, and the value of that coat is played against the value of the distant trees. You immediately see how much lighter the trees are; and the contrast throws them back into the distance. Without the man, the buildings could be almost anywhere in space; cover his dark coat with your finger and see how the picture immediately loses some of its depth. In the foreground, I had the problem of painting white horses in white snow—on a gray day! In order to make them register, I placed the horses against the large dark piece formed by the hay, the wagon, and the lower part of the haystack. If it weren't for this dark band of value, the horses would disappear!

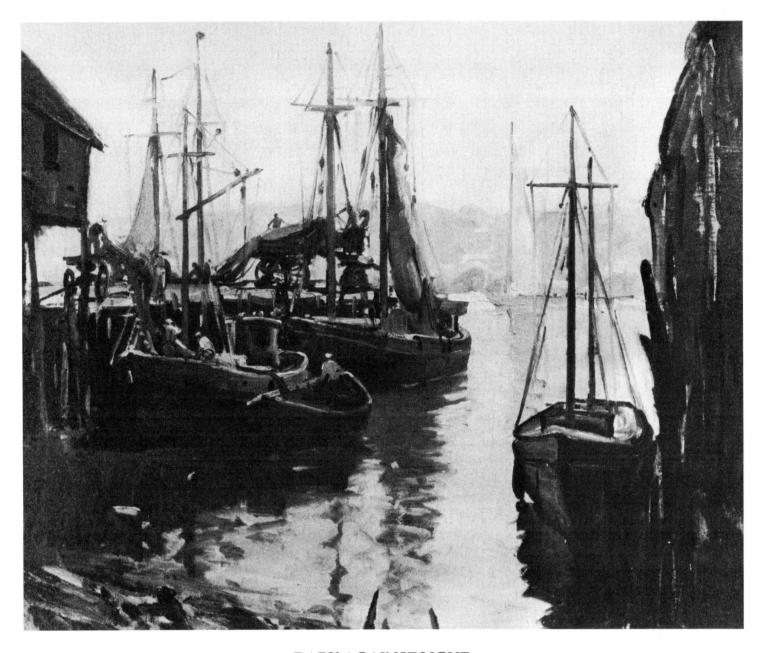

## DARK AGAINST LIGHT

**Unloading the Nets,** oil on canvas, 25″ × 30″ (64 × 76 cm). To emphasize the white horses in the previous painting, I placed them against a dark background. Here I do just the reverse, playing my dark boats against a light background. The sky and water are near each other in value, while the haze in the air lightens the distant hills. Together, they make up my light value mass. The nearby men, boats, docks, wagons, and buildings are similarly close in value and form a varied and interesting silhouette. Because the values are so close, I can show a lot of action on the docks while still holding the details together in a mass. You sense the mass first, then you notice the men and their activities.

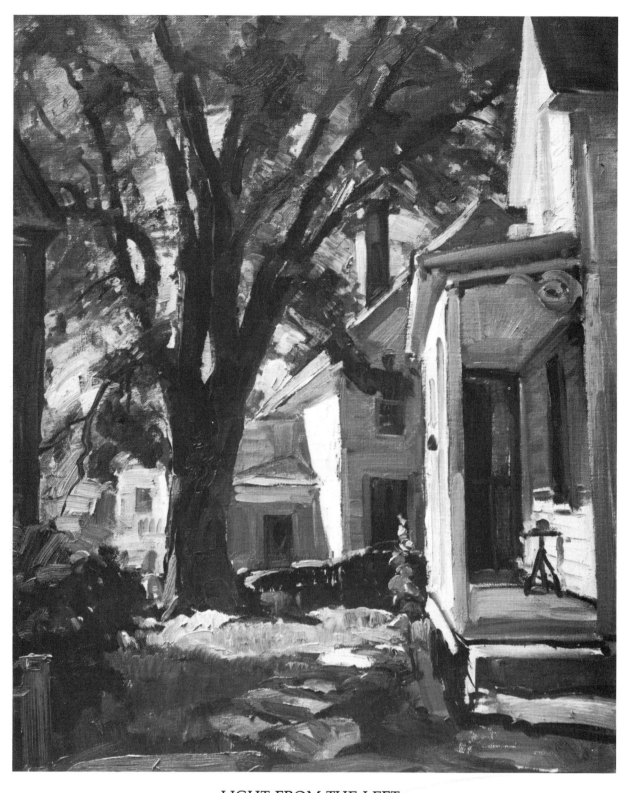

## LIGHT FROM THE LEFT

**Building Composition,** oil on canvas, 25″ × 30″ (64 × 76 cm). As you've already seen, the position of the sun in the sky has a marked effect on the values in your picture. Here, the sun is to your left. Objects facing in that direction receive a strong blast of light. Notice, however, that I had to make a choice: to emphasize the light or the shadow. I couldn't have equal amounts of both, for that would lead to confusion—I'd be trying to say two things at the same time. I decided to have most of the picture in shadow—the lights would then jump by way of contrast. Notice that the shadow sides of the houses are dark in value. The heavily foliaged tree blocks the sun and light has little chance to creep into the shadows. There's no formula for deciding how dark to make such shadows. You have to go by the conditions at the site. A bit of sky peeks through the tree. Against the tree, these skyholes appear light, but they're gray when compared to the sides of the sunlit houses.

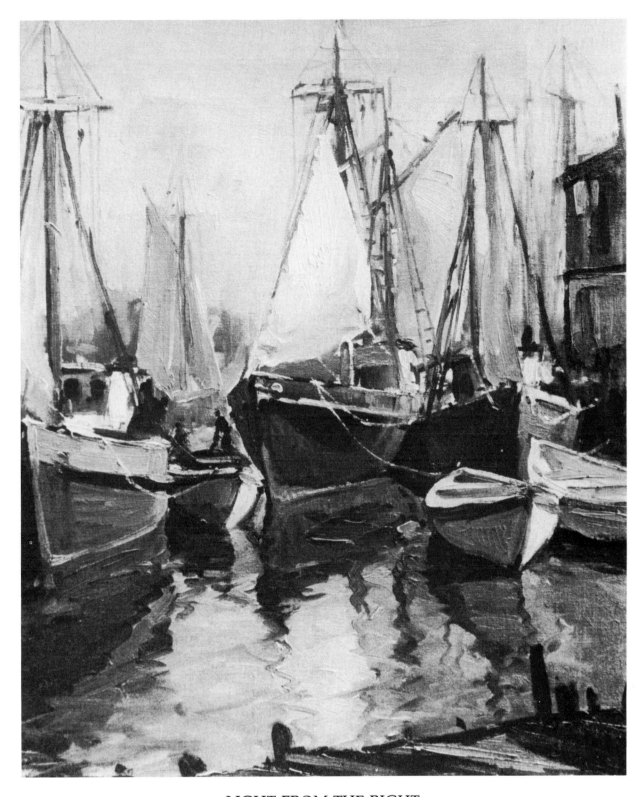

## LIGHT FROM THE RIGHT

**Drying the Sails,** oil on canvas, 30″ × 25″ (76 × 64 cm). Here, light comes from the right. The sky is relatively light in value—but not as light as the white boats or the central hanging sail. The sail is new; but it absorbs some light. The white seine boats are lighter in value because paint reflects light more effectively than cloth. I've purposely forced the shadows of my white boats, making them a bit darker than they'd be in reality. That gives the light areas more punch. One of the most important notes in the picture is the distant, shadowed schooner. By placing that sail near the sunlit one, I create a contrast; you immediately sense how light the foreground sail is.

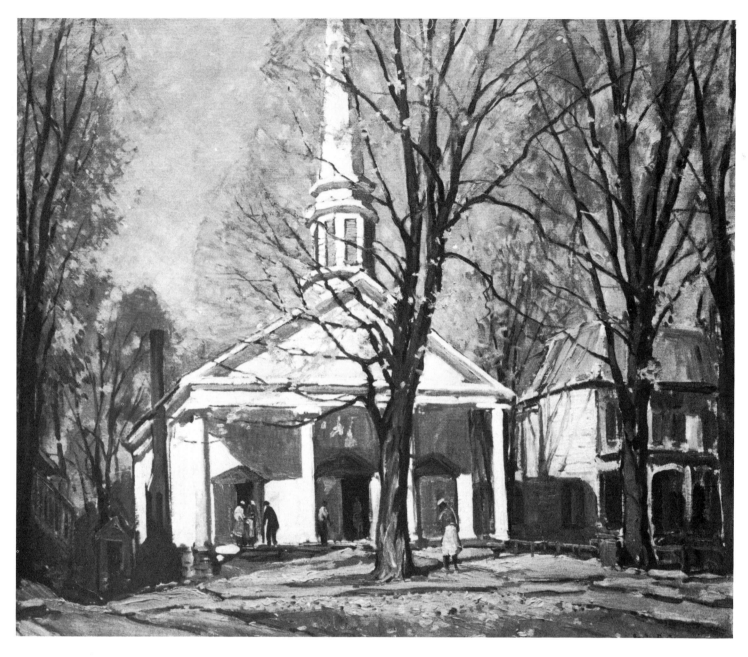

## FRONT LIGHTING

**Church in Woodstock,** oil on canvas, 30″ × 36″ (76 × 92 cm). When you paint with the light behind you, objects receive their illumination head on. The sky, being far from the source of light, is dark in value. This dark sky gives the sunlit objects their punch. Notice, however, that the sky is dark only in comparison to the highlights on the church. It's not black. The shadows on the church are much darker in value than the sky itself. Probably the subtlest value change occurs on the column to the immediate right of the foreground tree. That column catches the sun and is actually a hair lighter in value than the adjacent white church wall. It's a slight distinction, but one that gives an added touch of truth to the picture.

## BACK LIGHTING

**The Road to the Stoney House,** oil on canvas, 25'' × 30'' (64 × 76 cm).
Looking into the light, you see a lot of silhouettes. Here the hills and trees
become dark masses against the sky. The sky is near the source of light and
becomes very light in value—the reverse of what happened in the preceding
painting. Since the sun hits the dirt road, it, too, becomes light in value—
though not as light as the sky. Notice how the sun affects the foliage of the
main trees. At the edge of the mass, the sun shines through the individual
leaves, lighting them up. Toward the middle of the trees, however, the
foliage piles up and the light has a harder time penetrating. The mass is
naturally darker in value. Nowhere on the tree do I show individual leaves.
They're so far back that you see only the mass—without a lot of distracting
details.

## SHADOWS

**Vermont Hills,** oil on canvas, 30″ × 36″ (76 × 91 cm). The most interesting part of this panorama is the group of shadows cast by the big trees in the center. Notice how these shadows get bigger as they come nearer. They also get lighter in value, for as they move away from the trees, the surrounding light has more of a chance to shine into them. This additional light also breaks across the edges, so that while the shadows are dark and crisp near the trees, they're much softer—more "diffracted," Carlson would say—as they near the frame. You should also note that the sun is directly in front of us. As a result, the shadows fan out to the sides.

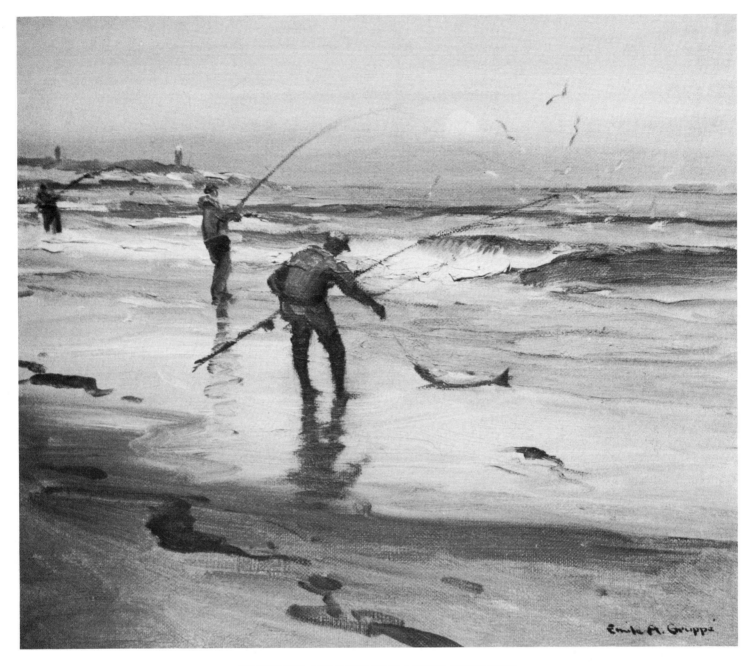

## SOURCE OF LIGHT IN THE PICTURE

**Fishermen,** oil on canvas, 20'' × 24'' (51 × 61 cm). This picture was painted late in the day, and the low evening sun has thrown most of the foreground into shadow. Only the upright planes of the waves are strongly illuminated. This painting illustrates one of the few times when you can successfully show a source of light—here, the moon—in a picture. The sun is still so strong that the moon is nothing more than an interesting shape. If I were doing a traditional moonlight scene, I'd leave the moon out. Oil paint could never equal its brilliance. To make the moon bright enough, I'd have to make the rest of the canvas practically black!

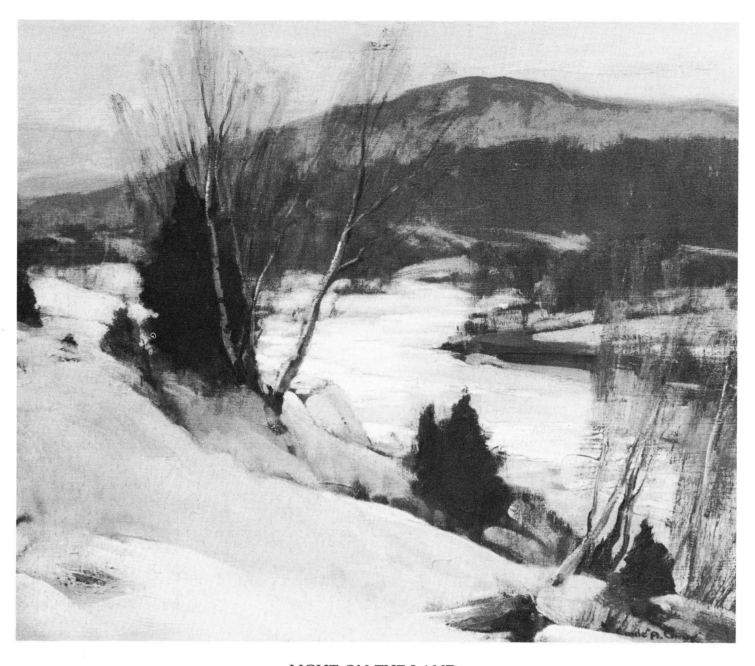

## LIGHT ON THE LAND

**Late Afternoon Along the River,** oil on canvas, 20'' × 24'' (51 × 61 cm), Collection of Mr. and Mrs. Miller Primm. Here the sun throws light on snow-covered ice, creating a strong glare. The glare is the lightest value in the picture; it's brighter than both the sky and the snow. When painting the picture, I established this brightest spot first and judged all the other values in the picture by it. The effect would have been lost if I'd made either the sky or the foreground too light. Notice also that the distant trees form large and very simple bands of value. The dark foreground evergreens are painted against this distant mass, and the contrast in their value helps push the mountain back in space.

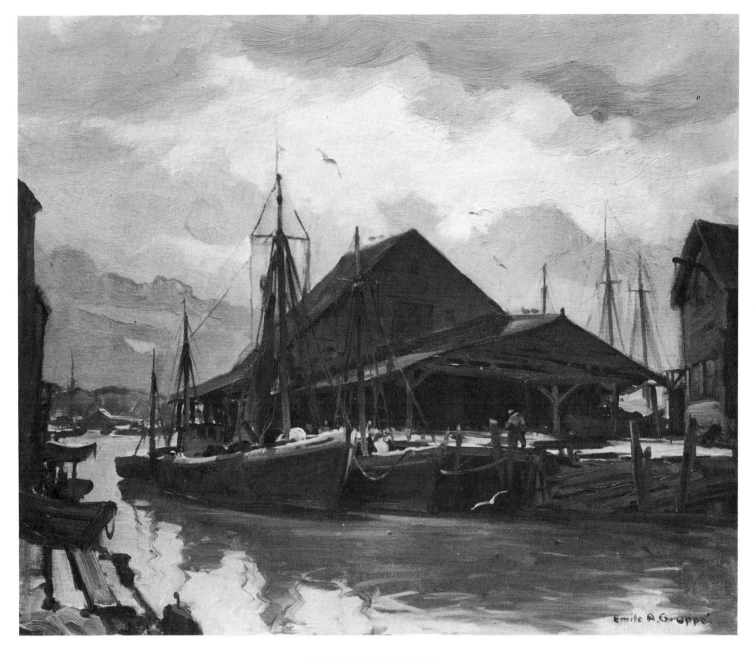

## LIGHT IN THE SKY

**Late in the Day,** oil on canvas, 30'' × 36'' (76 × 91 cm). Here the brightest light is in the sky instead of on the land. The sky is so bright that the buildings and the boats form a silhouette against it. The colors of the buildings and boats may differ, but they're all similar in value. The bright light also obliterates the reflections, hitting the dust in the water and making them into a single dark mass. The most important spot in the painting is the bit of light that shows through the broken porch on the far right. That spot explains the building—you see that people can walk under the roofed-in work space—and makes the building into a self-contained shape. Cover the spot of light with your thumb and see how heavy the whole composition becomes. When you can see around both sides of the main structure, you feel as if there's more breathing space in the picture.

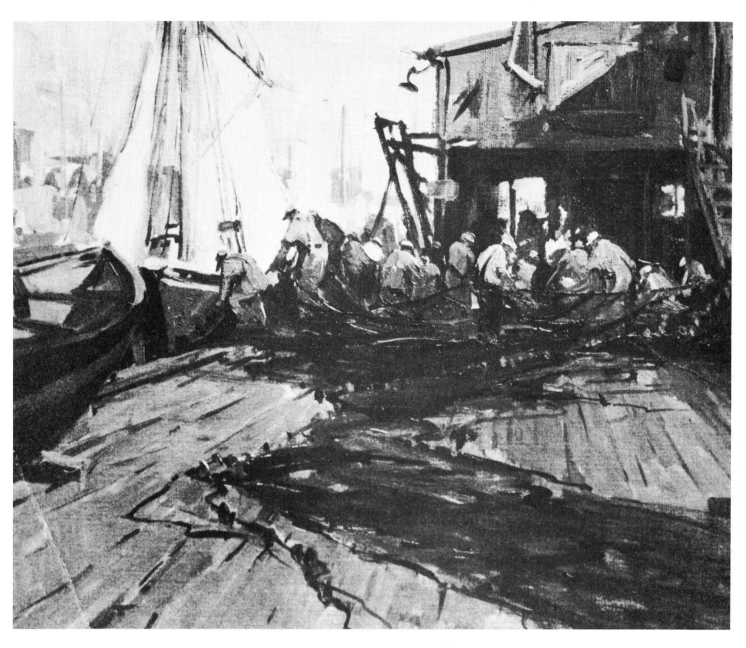

## LEADING THE EYE: DARKS

**Mending the Nets,** oil on canvas, 20'' × 24'' (51 × 61 cm). This picture is done for the sake of the figures. The foreground net acts as a dark path, zigzagging you toward them. I've kept the workers together by my use of values; if you squint, you can see how the legs and arms blend into the net, with only a few light shirts and hats indicating the men's poses. Notice how the background attracts you into the picture by acting as a light foil to the shadowed foreground. If you stared into the sunlit background outdoors, you'd see lights and darks within it. But what counts here is the relation of the dark foreground to the light distance—and not the less important relation of darks and lights within the sunlit background. You must sacrifice one set of relationships in order to emphasize another more essential one.

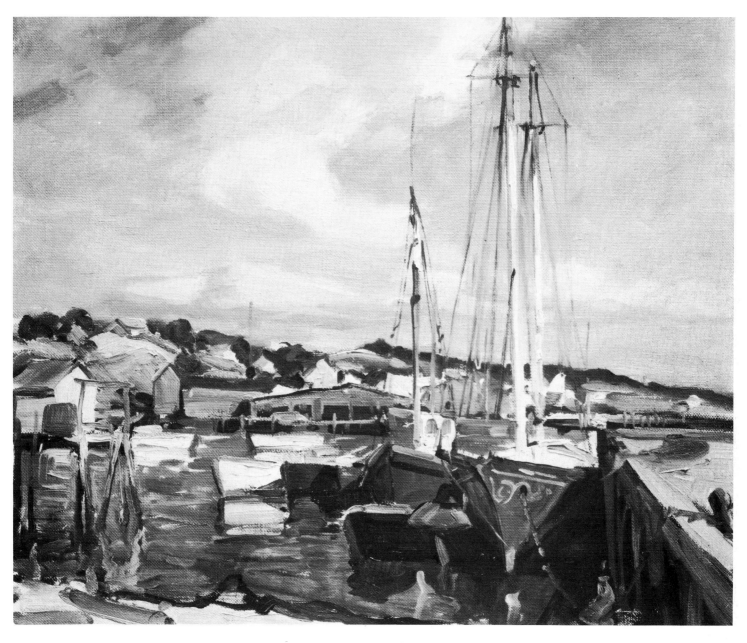

## LEADING THE EYE: LIGHTS

**The Sadie Noonan,** oil on canvas, 25″ × 30″ (64 × 76 cm). In this panoramic study of the harbor, you can see that the various white objects in the landscape are the most brilliantly lit. (The clouds in the sky are also white, but they're not as light in value as the sunlit boats and houses.) The white spots help lead you through the picure. Starting with the brightly lit wharf, you move across the harbor, using the white boats as stepping stones. The eye is always attracted to such brilliant spots. Stopping at the white house on the far left, the eye jumps back into the picture, moving to the right and investigating the light shapes on the distant hillside. It then sees the white masts, goes to the deck of the *Sadie Noonan,* and begins the circular journey all over again.

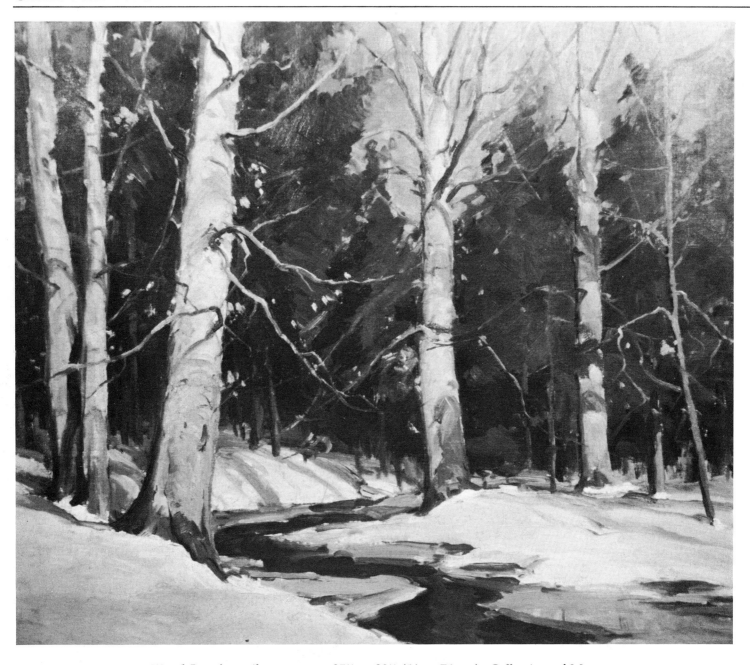

**Wood Interior,** oil on canvas, 25″ × 30″ (64 × 76 cm), Collection of Mrs. Cathryn Nugent Gibbs. Carlson taught me to appreciate the dignity of the forest. As you can see by the long shadows, the picture was painted late in the day. Because the sun is low in the sky, it penetrates the shadowed areas under the pines, keeping them from going too dark. Notice how the sunlit background attracts and leads the eye into the picture.

So far, I've talked about my father and Carlson, and their generation's interest in values. It was, I think, a justified concern. Values make a picture "true." And truths make a picture *livable*. If you can get even a small piece of the truth, you'll have a masterpiece.

Color differs from person to person, and we all see some colors better than others. Carlson saw a lot of green in the landscape, and his pictures have a greenish tonality. I see more red and purple. So my color may not be your color. But if the value is correct, almost any color will look natural and right.

## Discovering Color

During my first year at Woodstock, I was deeply impressed by the work of one of my fellow students, John Follansbee. He'd been to France, and was full of Impressionist ideas about color. He'd lost the use of his legs in a childhood accident, and I'd carry him to painting spots, my hands cupped behind me and the bones of his legs sticking into my back. I can still feel his knees!

Follansbee's paintings usually had the place of honor at Carlson's Saturday critiques—right in the center of the wall. I loved Follansbee and thought he was the greatest painter that ever lived! His work was never matter of fact—it was all feeling. He did wonderful moonlights, for example, in which the edges of the trees and figures were so delicate and elusive that you could feel the light shimmering around the forms.

Probably the most important thing I learned from him was the importance of using color all over the canvas. Every part of his canvas had a definite color. I'd been doing almost black-and-white pictures till then. Follansbee used short strokes of color—*à la* Monet—and carefully wove them together like threads in a carpet. I adopted the technique for a while, working indirectly and building my effects by running one layer of color over another (Figure 7).

Carlson had mixed feelings about my new enthusiasm. He'd criticize me sometimes for copying another's style, saying, rightly, that there's more to painting than technique. Yet when I was struggling with Follansbee's method one day, Carlson ran up and cried "Bully! Bully! Stop right there. If you can paint that well five years from now, you'll be an artist!" He always said that every student paints one masterpiece. But not realizing what he has, he continues working—and ruins it.

I appreciated Carlson's concern for "quality" and tone; but, at the same time, working in color gave my pictures more pep. So I asked myself, "Why can't I have color and tone, too?" I was bothered, however, by the small strokes that covered my pictures. They were all the same size and had little relation to what they were describing. Carlson warned me that if I didn't watch out, my pictures would look as if they were made of confetti. I wanted a more expressive stroke—and more expressive color, too. By working color over color, I got delicate effects. But the results were muted. If I kept working in that way, I felt I might eventually go stale.

## Hawthorne

Luckily, a friend then showed me a painting he'd done in Charles Hawthorne's class at Provincetown (Figure 8). Hawthorne at this time was one of the country's greatest teachers. He was an amazing demonstrator, too, doing huge canvases for his students—usually of posed figures standing against the sun. He'd demonstrate on the Provincetown sand dunes, and I can remember how half the town would come to see him work.

I knew that Hawthorne was just what I needed. He worked in a manner exactly opposed to that of Carlson. Carlson, as I've stressed, was primarily interested in the relationship of one value to another. He knew a lot about light and color—but they weren't his over-riding concerns. Hawthorne was primarily interested in color and believed you should start with full intensity color on your palette. Be strong in color first—you can always go back and tone it down. With Hawthorne, my study of color really began.

## The Eye: Seeing Color

One of the first things I discovered was that the amount of color you see is a result not so much of what you look at—but of *how* you look at it. To help you understand the idea, we should first examine how the eye operates.

The eye sees through color cones. It has three sets of cones: one for red, one for blue, and one for yellow. From these colors, it creates everything you see in the world. For the eye to be excited and stimulated—and for pictures to have snap—the viewer should see a bias toward the red, blue, or yellow in all your color. The eye should be able to dissect the colors. That's one reason black and the earth colors have little effect on the eye. Black, for example, is opaque; it's just black and the eye can't decipher it, can't break it into recognizable color parts.

**Figure 7.** Woodstock, 1916, oil on panel, 12'' × 16'' (30 × 41 cm). Here you can see how I used short, choppy strokes to weave together my oranges, greens, and purples. For the colors to work together, they had to be of exactly the same value. The sky, for example, was painted with purple and green—but in black and white, they read as a single value. If one were darker than the other, it would jump out, disrupting the sky and giving the area a spotty look.

## Eye Fatigue

You might think that the best way to analyze an area of color is to stare at it intently. But that's just the wrong way to do it. The longer you stare at an area, the grayer it gets. Your eye becomes used to the color; it fatigues; your sense of color dies. The only way to judge the color of an object is to compare it with the color of objects near it.

Let's say, for example, that you want to determine the color of the sky at the horizon. It can be anything from purple to green. But to see it, you should first look over your head for a few seconds at the color of the zenith. Then quickly lower your eyes. For a few seconds, you'll see vivid color near the horizon. Then the color will rapidly fade. If you want to get the character of that day, you should paint the horizon as you see it for those few seconds. That's why I constantly move my eyes over a scene, comparing values and colors. If I'm stumped by an area, I work on another spot; then, when I turn back to the troublesome place, I'm usually able to see the color.

## A Natural Way to See

When I tell you to look all over a scene in order to see color, I'm not giving you a professional "trick." Think for a minute: how do you normally look at the world? You see color because you move your eyes, constantly giving them new objects and colors to look at. The cones are always stimulated. Staring at a spot—something you habitually do when you draw or paint—is an unnatural way of looking. So when you stare and paint, you lose the sparkle that comes with a casual glance. Train yourself to keep your eyes moving, to compare area with area—and you'll find that there are no nondescript colors in nature.

## Basic Principles of Color in Nature

When you work outdoors, you only need to worry about a few basic concepts: (1) the nature of the eye, (2) the local color of the object, (3) the color of outdoor light, (4) the color of the atmosphere itself, and (5) the effect of neighboring colors on one another.

## The Eye

Remember what I said about the eye. If it sees in broadly defined terms of red, yellow, and blue, then you must learn to analyze colors in terms of red, yellow, and blue. In short, you should see in terms of the positive colors of the spectrum—and not, as many students do, in the negative and colorless terms of brown or black. The Impressionists showed us that there isn't any black in nature.

## Local Color

You might immediately object that some things *are* black: "What, for example, if I were doing a boat that had been painted with black paint?" I'll admit that the paint was black as it came out of the bucket. But "black" is only the local color of the object—the object's "natural" color. And that's rarely the color's most interesting aspect, although it's the color many students think they see. For example, painting a

*Figure 8. Charles Hawthorne was probably one of the greatest teachers America ever produced. Working in "color spots," he taught us to see how each color in a scene was related to all the others.*

nearby red barn and another one a mile away, they'll make both the same color, thinking that "red is red." They'll paint a green tree a flat green. They have no concern for light and shadow or for the tree's position in space, or for the many different types of green within that tree.

## The Color of Light and Shadow

Local color is merely a starting point. The local colors of our black boat, red barn, and green tree are all profoundly influenced and transformed by the color of outdoor light.

On the average sunny day, objects are affected by two sources of light: (1) the sun, which is warm and yellow and (2) the sky, which is cool and blue. Whatever isn't colored by the rays of the sun is colored by the rest of the sky. Generally speaking, a red barn in sunlight has a touch of yellow in it—and looks orangy. The shadow side catches cool light from the sky and so tends toward purple (blue plus red). A green tree will look yellow-green in the light. A sunlit black boat will have a tremendous amount of red in it.

To see the effect of light on objects, stand in a field on a sunny day and look into the sun. You'll see that the sun lights up the grass, making it look a vivid yellow-green. If you suddenly turn and look in the opposite direction, away from the sun, you'll see that the grass appears darker—and very blue. It picks up a lot of cool color from the sky. The local color of the grass will be seen, if at all, only on overcast days when the sun and sky are hidden and have little chance to affect objects.

The importance of these color changes was made clear to me when I studied with Hawthorne. If Carlson were painting on a clear day, he'd notice shifts of color—but he wouldn't emphasize them. He'd be more interested in values, recording how light the sunlit areas were in comparison to the areas in shadow. Hawthorne, on the other hand, would jump on the color changes and play them up. These color changes were what excited him about the scene.

In order to make his students see these changes, Hawthorne forced them to paint with palette knives. You should try the same experiment yourself. We worked very broadly and looked only for the big color masses. It was like painting a poster in big areas of flat color. We always worked from models posed on the beach. Where the model's hat cut off the light, the shadowed area might be reddish. So we'd put down a spot of red. Since the sunlit side would be much lighter and warmer—down went a spot of orange. The water might be greenish-blue; so we painted it green-blue. We hit the mass first, stating the color as strongly as we could. If we wanted to record more subtle changes of color, we could always work into it later. We painted very directly, trying to get a quick impression. And since we all worked broadly, the sketches looked terrific from a distance. When I first saw Hawthorne's students at work, I thought they were all masters!

I was soon doing two or three such pictures a day, using the palette knife and working in what Haw-

thorne called "big color spots." I took what Hawthorne taught me about color and combined it with what I knew from Carlson about composition and values. I exaggerated everything. If a boat was green, I made it very green. If it had a red waterline, I made it very red. And if the water was blue, I painted it very strongly and very blue.

## Warm and Cool Contrasts

The fact that objects outdoors are either warm or cool was a great discovery for me. For it's the contrast between warm and cool color that makes you feel the light in a picture. If both your highlights and shadows are warm, as they are when you use earth colors everywhere, then there's nothing to tell you how warm the sunlight is. The cool color gives you a gauge. It's the same principle discussed in Chapter 1, where we saw how a strong foreground dark contrasts with lighter, distant darks and thus creates a feeling of pictorial space.

My father naturally preferred the tonal painter's predominantly warm colors. Such pictures were—and still are—very soothing, for they make little demand on the viewer. My father was amused by color painting and, especially, by its reliance on purple as a cool shadow color. We were coming into New York harbor once from an overseas trip, and I can still remember his looking at the buildings and saying, "Well, we're back in the land of the purple painters!"

Of course, it's possible to handle your color in a clumsy manner. I often misjudged my values as a student, and my purples and blues jumped right off the canvas. But in the hands of a master, the technique worked like magic.

I used to have a studio next to Childe Hassam, and he used the method of warm-cool contrasts to perfection. Nobody painted foliage the way Hassam did—nobody then, and nobody today. In one of his paintings of the Church at Old Lyme, Connecticut, he hid the steeple behind the leaves of a foreground tree. He cleverly painted it so you could just about make out the time on the church steeple—a quarter to three, as I recall! Purples and blues were worked into the shadow areas of the leaves. And Hassam distributed his short, sharp strokes so that not only was every inch of the canvas beautifully designed, but the contrast of the small green, purple, and blue strokes gave the picture a terrific feeling of three dimensions. You could actually feel the leaves vibrate; they came right off the canvas! I tried to get the same effect myself, but gave up. You had to be Hassam to do it.

## Position in Space

Like its value, the color of an object is directly related to its nearness to the viewer. Carlson always said, "Yellow is on the tip of your nose." By this, he meant that if bright yellow was to appear anywhere in a picture, it would be in the foreground. Because of the graying and cooling effect of atmospheric perspective, the yellow rapidly drops out of colors as they recede. A white house, for example, would appear very yellow, with the sun shining on it. But if the same sunlit house

were a mile away, the yellow would start to drop out. It would still be a warm color—only now it would be more on the orange side—red modifies the yellow. Moved farther back still, the white house would become pink—the yellow would drop out still more. Thus, our sunlit barn now looks red as it moves into the distance. Even farther in the background, it begins to look purplish as the red color mixes with the blue haze of the atmosphere itself.

The color of the individual object (its local color) is also affected by its position in relation to the sun. For example, if a sunlit red barn is facing you, with the source of light slightly to your right, the part of the barn wall on the right will have a slightly warmer glow than the part on the left. The wall may be only ten feet long—but you can actually see the change of color as the barn nears the sun. If you record it, you'll give interest and an added truth to your color masses.

The same effect occurs in the sky. The nearer the part of the sky is to the sun, the warmer it becomes. The sun colors it. On a clear day, for example, the sky near the sun looks yellow. But if you were to turn 90° from the sun, the natural blue of the sky would have more of a chance to register, and the sky would look green. If you now turned another 90° and faced away from the sun, the yellow would drop out of the sky completely. Without yellow, there's only the primary colors red and blue—and so the sky looks purple. Go outdoors and see for yourself. Stare into the sun and then suddenly turn 180°; you'll be surprised by how much red there is in what people call a "blue" sky!

## Neutralizing Color

As objects move back into space, atmospheric perspective cools and neutralizes them. Many students are in the habit of neutralizing color—graying it—by adding touches of black to it. But, as we've already noted, there are no blacks in nature. So how do we make color less intense?

It now becomes important to understand the behavior of complementary colors. The complements—or the secondary colors (green, orange, and purple)—are, of course, closely related to the primaries. To get the complement of one primary, you mix the other two. Thus, the complement of red is green (or blue and yellow); of blue, orange (or red and yellow); of yellow, purple (or blue and red). And *vice versa*.

Complements, when mixed, neutralize one another. In effect, you're mixing all three primaries. And whenever all three primaries are present, the resulting color is grayed. So if you want to mute a distant green tree, for example, you work a little red into it. I tend to do this on principle, since *all* objects in a painting are a slight distance from us. They're all slightly grayed, and that means that they all have a touch of the three primaries. Even if a red barn is nearby and hit by sunlight, for example, I touch some green into it, just to keep the color behind the picture frame, so the red of the barn wouldn't pop out. One or two of the primaries may predominate in a mix, but all three are present to some extent.

As a further example of how complements work,

let's look at an overcast day. If you had black on your palette, you'd be tempted to mix it with white and paint the sky a flat gray. But if you look more closely, you'll see that the sky has color. On a slightly hazy day, lots of yellow can come through the atmosphere. If the sky is overcast, less yellow penetrates, and there's more of an orangy cast. If it's even more heavily overcast, still less yellow comes through, and the sky looks red.

To paint the sky on an overcast day, I put one of these warmish colors (yellow, orange, or red) down first. Then, to neutralize the sky and make it look "gray," I run complementary blue-purples over the yellow and orange underpainting and complementary greens over the red underpainting. I start warm simply because it's easier to cool a warm color than it is to warm a cool one. Each color retains some of its identity, so that the eye can see that the gray is made of red, yellow, and blue. Thus, the final luminous gray is created *in the eye* of the viewer.

## Accentuating Colors

When complements are placed side by side, they accentuate each other. If I want a blue to look very blue, I put an orange next to it. In fact, it's usually essential to get the complement working somewhere near the principal color, if only because a color needs its complement in order to exist. A red isn't a red without a contrasting green to explain it.

A friend of mine always worked on a canvas that was lightly toned with rose madder. The stain was so slight that when you looked at the canvas, it looked white. If, however, you looked for a few seconds at something green and then looked back at the canvas, you immediately saw how red it was.

When I was in Woodstock and still trying to paint warm, tonal pictures like my father's, I did a fall scene with lots of reddish browns in it. Birge Harrison, the founder of the school, came down the road, looked at my picture, and pointed toward a spot of foreground grass, still green because it was near a natural spring. "Put that little bit of green in," he told me. "It'll make your picture." Harrison saw that my picture lacked contrast. With all my warm fall oranges and reds, I needed a touch of complementary green. That contrast of color gave the reds and oranges a chance to register.

Such warm and cool complementary contrasts are what give a picture a feeling of outdoors. In fact, the eye so hungers for relief from a dominant color that it often manufactures its complement. The classic example is the purple cow. A dark cow in a field of yellow-green grass will look like a purple spot. Purple is relative to all that yellow.

When I was at Woodstock, I painted a view looking through some green trees toward a distant stream. Because of all that green, the rocks near the stream looked pink! To see how pink the stones were, I didn't stare at them. I moved my eye back and forth between the green trees and the rocks—just as my eye would normally move outdoors. In order to judge the big color relationships, you have to learn to look at the landscape *as a whole*.

Some of these relationships can be very subtle. Earlier, we noted that the local color of a white house might be visible only on a gray day. But even a gray day has color. If, for example, the sky were a gray-red, a white house seen against it might look slightly green. If the sky were gray-green, the same white house might look slightly reddish.

## Reflected Light

Finally there's the question of reflected light. On a sunny day, a white house may appear to be a cool blue in the shadows. But if it's crowded by masses of green trees, some of the green from these trees will reflect into the shadow side of the building, making it a blue-green color. If two white houses are side by side, sunlight from one will often reflect into the shadow of its neighbor, giving the dark mass a warm, orangy glow.

## The Palette

One of my main problems as a student was to find pigments that had a logical relation to outdoor color. I wanted to be a landscape painter and needed a palette that was adapted to my specialty.

My present choice of colors is a very simple one. Here's a list of them as they're arranged in a row across the top of my palette: ultramarine blue, rose madder, cadmium red deep, cadmium orange, cadmium yellow deep, cadmium lemon, and phthalo blue. I could easily mix an orange, but I use a lot of it and find it looks cleaner and purer when it comes from the tube. On the other hand, since the greens in nature vary widely and no tube colors match them, I think it's easier to mix my own. I put zinc white in the lower middle of the palette.

We've already talked about the lack of black in nature. I don't use black—or the earth colors. The darks in nature always have color to them, but when you have a black or brown on the palette, you aren't challenged to see the color. The virtues of black are thus negative in character. It's a crutch, something to use when you can't figure out what color a thing really is. It also helps you to get a value quickly—again, without thinking. And that's another reason people use it. Color is no longer of importance and the painter can concentrate on other pictorial matters—on composition, for example. Many fine painters have used black and the earth colors—but color was not one of their primary concerns.

Students at first shy away from my palette, thinking it far too limited. But they're used to using too many colors. The fewer colors you use, the more likely you are to have a natural harmony within the picture. I'm told that the great Swedish painter, Anders Zorn, used only white, ivory black, vermilion, and yellow ochre. Yet he got brilliant color effects and beautifully subtle color harmonies.

My palette is logically constructed on certain basic color principles: (1) the importance of the primaries, (2) warm and cool color, (3) vibrancy of color, and (4) purity of color.

## The Primaries

In short, after analyzing how the eye sees—in terms of red, yellow, and blue—I've chosen a palette composed of these primary colors. By having only the primaries to work with, I'm forced to take a real look at the scene and to analyze the colors in front of me.

## Warm and Cool

We know from our discussion of the color of outdoor light that everything in nature tends to have either a warm or cool bias. So, starting with the primaries—the basic building blocks of color—I choose a warm and cool version of each. Phthalo blue is my "warm" blue—it has a touch of yellow in it. Ultramarine is my "cool" blue—it has red in it and red is "cooler" than yellow. By the same reasoning, lemon yellow is my "cool" yellow—it has blue in it. On the other hand, cadmium yellow deep has red in it. Since red is "warmer" than blue, cadmium yellow deep is my warm yellow. Rose madder has blue in it and is my cool red. Cadmium red deep has yellow in it; it's my warm red.

Lemon yellow is my lightest, most brilliant color. It's very intense as it comes from the tube, and a touch of white makes it still brighter. Ultramarine blue is my purest, darkest blue. The reds fall between these two extremes. I know most people consider red a warm color, but it's really neither warm nor cool in itself. It's a modifier. If I add red to lemon yellow, for example, it becomes orange, a much quieter color than the original lemon yellow. Similarly, if I add red to ultramarine blue, it becomes purple. A lot of the trouble with many of today's painters is that they paint at either one end of the palette or the other. Their pictures are either very cool—with lots of blues and greens—or very warm—with lots of ochres and umbers. They ignore the great modifier: red.

## Vibrancy of Color

All the colors on my palette have life to them. There's not a nondescript pigment among them. And as a result, even when I make a dark, the dark has color in it. It's never as heavy or negative as black—and it never kills the painting's sense of atmosphere by making a colorless hole in the canvas.

Because my colors are so vibrant, I always use them on a white, untoned canvas. My father used to take the junk left on his palette—the scrapings—and work that over his next canvas. This helped give his pictures a unifying tone. The method worked with him. But if I toned my canvas, I'd defeat my aim: to get the most brilliant effect possible. I want the viewer to feel the white canvas beneath my pigments. I don't mean that you actually see it, of course, but the light passes through the paint, bounces off the clean white canvas, and comes back to the eye. The result is an extra sparkle that adds life and character to the painting.

Zinc white is just right for color painting, because it's the most transparent of all the whites. Titanium white, on the other hand, is much heavier and more opaque. You can never get below the surface of titanium white. And it eats up pigment. You have to

force color into it with your brush, and in so doing, you usually end up overmixing. The relatively transparent zinc white, on the other hand, takes on color very quickly. And it lets you see the color more easily, for zinc white is the purest and most colorless of white pigments. Titanium, for example, has a distinctly bluish cast, which it adds to all the paint mixed into it. The only drawback to zinc white is its tendency to get brittle with age. I think the change adds a certain mellowness to the painting, but it would pose a problem if you ever had reason to roll up one of your pictures.

## Purity of Color

I also paint with "pure" colors. That means that each of the colors on my palette has only two of the three primaries in it. (All three primaries together in the same color would gray it.) Cadmium red deep, for example, has red and yellow, while rose madder has red and blue. Lemon yellow has a touch of blue—that's why it looks greenish. Cadmium yellow deep has red in it and tends a bit toward orange. Ultramarine blue has blue and red in it; phthalo blue has blue and yellow. The basic interrelationship of the primaries in the colors on my palette can be summarized in the simple table below:

| Palette Colors | Red | Yellow | Blue |
|---|---|---|---|
| Ultramarine Blue | X | | X |
| Phthalo Blue | | X | X |
| Cadmium Red Deep | X | X | |
| Rose Madder | X | | X |
| Cadmium Lemon Yellow | | X | X |
| Cadmium Yellow Deep | X | X | |
| Orange | X | X | |

We've already noted that the presence of all three primaries in a mix will gray the color. In order to fully understand how clean and pure my colors are, we've only to compare them to pigments in which all three primaries are thoroughly mixed; namely the ochres, siennas, umbers, and black. Such colors are always heavy and lifeless.

## Basic Mixes

Since color relationships outdoors are constantly changing, there's no way I can tell you how to paint a particular tree or rock. But I do have a few simple principles of color mixing that follow from my ideas about pure colors. The procedure is quite logical—as logical as my palette.

## Greens

Given my colors and what we know about complements, here are my thoughts on mixing the purest possible green—the color, let's say, of spring foliage hit by the sun. Examining my palette for possible combinations, I see that ultramarine blue and cadmium yellow deep make green. But when I mix that blue and yellow, I'm also adding the *red* that's in both pigments. The trace of the complement, red, dulls the green mix.

As a result, I don't get a brilliant green; instead, I end up with a terra verte (green earth) color. If I mix ultramarine blue and lemon yellow, the resulting green would be more brilliant, since only one of the components—ultramarine blue—has red in it. But if I want a clean and brilliant green, I mix phthalo blue and lemon yellow—for *neither* pigment has red in it.

As a general rule, I use phthalo blue for all my green mixes and change the yellow if I want a duller color. Phthalo blue and cadmium orange, for example, will give me an extremely rich color, typical of the green of hemlocks or pines hit by the sun. I should warn you, however, that phthalo blue is a very strong dye color and you should only use a speck of it in your mixes. If you're careless, it can get all over the palette and spoil your other colors. Most students have bad experiences with phthalo blue when they first use it and so shy away from it, using the safer and more easily controlled ultramarine blue in their green mixes. But that defeats a sunlight effect. If you're willing to experiment with phthalo blue, you'll learn how to use it. And once you do, its brilliant clarity will give your pictures an added wallop.

## Purples

You can use the same kind of thinking when you try to mix purple. Purple is an important color, for I use it to block in most of my darks. In fact, my friends joke about my love of the color. One claimed he saw two kids watching my class paint and that one asked the other, "what's the color they're all using?" "That's poiple," the friend said. "Poiple? It must be a cheap color—they're all using so much of it!" It bothered my father, too; and it finally led to my getting my own gallery. His warm, earth-colored pictures looked good by themselves, as did my cool, purplish ones. But on the same wall, they clashed, destroying one another.

Unfortunately, purple often looks too red or too blue. You need a color that's somewhere between red and blue, a fifty-fifty mix that's fairly neutral when you look at it. The viewer sees it; and the eye finds it more exciting than brown or black—but, at the same time, the eye isn't sure exactly what it's looking at. The purest purple would, of course, be one mixed without any of the complementary yellow present. Ultramarine blue and rose madder make this pure, strong purple. I find, however, that this purple can be overpowering. Rather than use it to block in a picture, I often work with ultramarine blue and cadmium red deep. The complementary yellow in the cadmium red helps neutralize the purple, giving it a rich, mellow tone. It took me a while to discover this fact. I carried burnt sienna with me for years, just to tone down the purple when I felt myself getting into trouble. Later, I found that extra cadmium red solved the problem.

In general, I don't use phthalo blue to mix my purples—just as I don't use ultramarine blue to mix my greens. The phthalo blue is so powerful that it takes a barrel of red to make it look purple. I occasionally mix phthalo blue and rose madder to make a near black. But I do that very seldom, and then use it only in small areas of the canvas.

## Earth Tones

So I have red, yellow, and blue on my palette. You've seen how I mix purples and greens. And orange is available out of the tube. That gives me the primaries and secondaries in a great variety of possible hues. If I want to get ochres, umbers, or siennas, I can add reds and oranges to my basic purple. That creates the feeling of an earth color, but since I'm mixing pure colors, my "earths" never have the dullness of the real thing.

## Pigment Harmony

My pigments all work together—without any "static." When you see paintings that look gaudy or that seem to break into spots of color as you look at them, the problem usually lies in the palette. The painter is probably using blacks, cadmiums, and umbers—all of which vibrate differently. When you look at the picture, your eye senses the difference, and that gets in the way of your enjoying the subject.

My palette helps you avoid that difficulty. At the same time, however, it poses other problems—for to be truthful, it's not an easy palette to use. It takes a while to get the hang of it. I sometimes say that, after sixty years, I'm just beginning to understand it! I remember Carlson could never figure out how I painted with it. Yet if you study the palette, use your head, and don't get frustrated, you'll see how beautifully it works. You can do almost anything with it. That's why

I don't take much pride in people telling me that I have a good color sense. I give the credit to a logically constructed palette.

## Color Portfolio

The following color portfolio contains a series of events that happened when I was painting outdoors and that I thought interesting enough to record. The portfolio has a variety both of natural effects and painting techniques. But it doesn't have a lot of color formulas. In some instances, I name specific pigments and tell why I use them. But since I've already explained how I get my greens, purples, and earth colors, I don't list every mix in every picture. Otherwise, we'd end up with just a bunch of recipes. And that would give you a false idea of the way color behaves outdoors. Outdoors, you don't work by formula: every day is different.

I want you to be alert to the color relationships between things. Having different eyes, we won't see these relationships the same way. But if you learn to look and compare, you'll slowly discover how much color there is in the landscape. Then you can experiment to get the color relationships you see. I want to open you up to nature. I want to make you look, ask questions, compare, and analyze. Remember: there aren't any pat answers when you work outdoors. That's what makes each day unique—and painting so much fun.

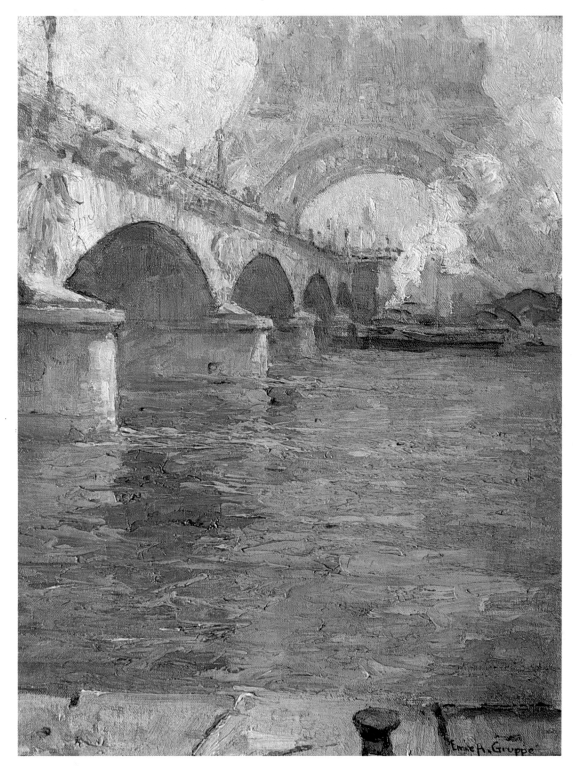

## BROKEN COLOR

**Paris, 1925,** oil on panel, 16″ × 12″ (76 × 64 cm), Collection of Mrs. Dorothy Gruppé. The most interesting part of this painting is the way I handled the overcast sky. I got the feeling of a gray day without using black. Instead, the sky was first painted a very light red. A complementary green *of the same value* was then worked over it. Each color was allowed to keep some of its own color identity. The red and green combine in the eye to form a luminous gray. Since the final color is created in the eye, it's more exciting than a color thoroughly mixed on the palette. The eye dissects the color into its component parts—and is thus more effectively stimulated. I've also shown the cooling effect of the heavy atmosphere (atmospheric perspective) on the distant Eiffel Tower. It's painted very cool and purple. Compare this distant purplish tone with the warm, orangy colors of the nearby bridge and foreground embankment. The warm foreground color contrasts with the cool distance, also throwing it back in space.

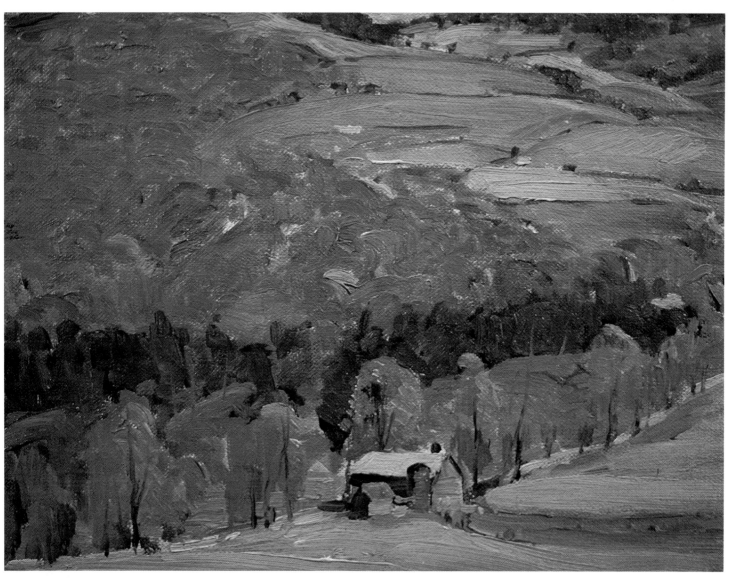

## THE PRIMARIES

**Vermont Hills, 1938,** oil on canvas, 20″ × 24″ (51 × 61 cm). When you paint green pines and very red fall foliage, there's always the danger of the color contrasts becoming too violent. I assure color harmony by getting a hint of all three primaries in my various mixes. They're present, but not thoroughly mixed. In the detail, you can see how I painted the distant red trees over a green underpainting. In principle, this is the same approach I used in the preceding painting. The green mixes with the red and neutralizes it slightly. The nearby evergreens are handled in a similar manner; there, however, I put the red down first and then worked green into it. A lot of cool sky color gets into the shadows of the deciduous trees, mixing with the prevailing red and making the darks appear purple. Remember: they look purple in relation to the surrounding reds and oranges. Outdoors, always look for the relationships *between* colors.

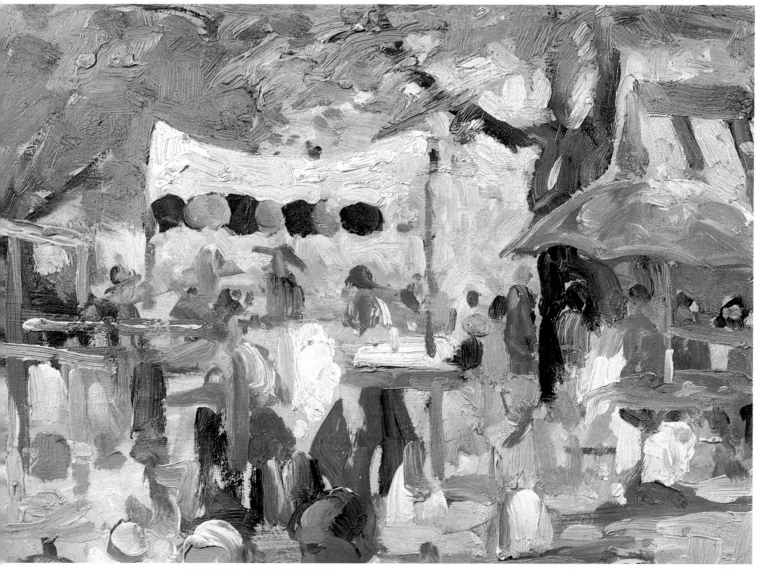

## COLOR CONTRAST

**The Village Fair,** oil on panel, 16'' × 20'' (41 × 51 cm), Collection of Mrs. Dorothy Gruppé. Here the sun is high in the sky and throws reflected light into all the shadows. I can't use strong value contrasts to get a feeling of sunlight. Instead, I work with *color* contrasts. In the detail, you can see how I've pushed the distant green trees back in space by running reddish-purple color over them. I also pull some contrasting yellow foliage in front of the trees; the yellow leaves come forward, throwing the cooler foliage even farther into the background. Such contrasts are at work all through the picture. I wanted the orange parasol to look sunlit. I therefore put a lot of yellow in it—and then surrounded it with cool purples and blues. The cool environment makes the parasol look twice as warm. I use the same effect on the ground. In order to emphasize its warmth, I run cool purplish shadows over it. Outdoors, they actually are purple—*in relation to* the warm ground.

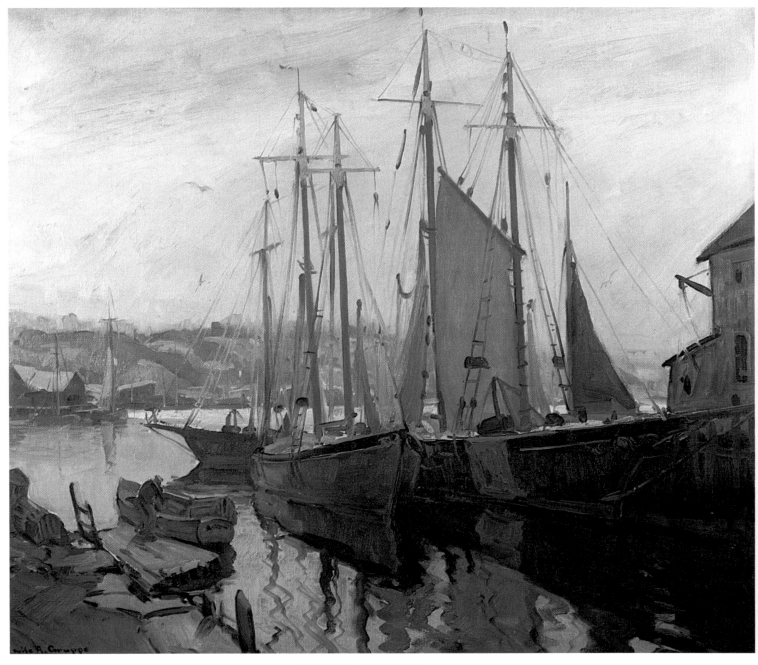

## TONAL PAINTING

**Early Morning, 1930,** oil on canvas, 30″ × 36″ (76 × 91 cm). During my career, I often moved back and forth between tonal and pure color work. This is an example of the former; color is not a major concern. Such a tonal picture almost looks as if it were painted in black and white. The interest is in the simple way I handled my masses. Notice that there's little variation within them. The building on the right, for example, is very flatly painted. And the hull of the boat beneath it is very close in color and value to the shadow under the dock. Of course, there's some color in the picture. I used cadmium orange and ultramarine blue to get a warm gray for the distance, adding hints of yellow to suggest fields of dying grass. A few bright spots of red attract your attention to the central boat. But my real concern is with the subtle value relationships: How does the house on the left compare in value to the distant trees, and how do they compare to the nearby sails and buildings? These are the crucial tonal questions. The picture proves that you can get an attractive design, without using every color under the sun.

## PURE COLOR

**Crowded Harbor, 1974,** oil on canvas, 25'' × 30'' (64 × 76 cm). This picture is the exact opposite of the preceding one. Here I'm very much interested in *color* relationships. Notice, for example, how I play up the distinction in color between the boat on the far right and the dark shadow under the dock. Although the shadow sides of the boats are close in value, each has its own special color. There's also lots of color in the sky and water. The tonal picture has a prevailing warm cast—the same color runs through everything. In this picture, however, I play with contrasts. The sky is full of reds—*and* greens. The wharves are orangy; the buildings, cool and full of purples and blues. The boats are yellow-green in the sun, with vivid red waterlines and deck gear. The picture is designed as a strong decoration for a wall. The preceding painting needs close examination—so you can see the value relationships. This picture can be understood a mile away.

## CONTRAST: RED AND GREEN

**Ogden, Utah,** oil on panel, 18'' × 20'' (46 × 51cm). Here the brilliant afternoon sun plays on the warm sandstone of Ben Loman. It's fall, and reddish trees spot the landscape. I run complementary greens and purples over the trees on the distant slope in order to mute their color. As with the trees on page 43, the blue sky affects the shadows on the mountain, giving them a purplish cast. These shadows look dark compared to the brilliantly lit rock. Because of atmospheric perspective, however, they're not dark when compared to the shadows near the foreground buildings. In reaction to the tremendous amount of red in the landscape, the sky takes on a complementary green look. Remember: outdoors, the sky won't look green if you stare at it by itself. You have to consider the sky in relation to the mountain. The contrast makes the picture. Cover the sky with your hand and see how tame the picture looks. I could pile on reds, yellows, and oranges—but without that complementary green sky, the mountain would never look hit by a strong blast of light.

## CONTRAST: GREEN AND RED

**Covered Bridge, Waterville,** oil on canvas, 18″ × 20″ (46 × 51 cm). In the previous illustration, the brilliant light made the color contrasts especially vivid and obvious. But similar interesting changes in color occur all the time in nature, and in much less spectacular ways. This gray-day scene, for example, first attracted me because of the interesting way the sides of the covered bridge were broken, letting me look through to the landscape beyond. Of interest to us, here, however, is the tin roof. The local color of this tin roof is a relatively neutral gray. Because it's a neutral, it has a tendency to pick up colors from its environment. In this case, the roof is surrounded by reds and oranges and therefore acts like the sky in the preceding plate; it becomes slightly green in color. If the picture had been painted in the summer—with green trees everywhere—the roof would have looked reddish in tone. Notice that the trunks of the trees, dark with the rain, also tend to look green against the red foliage. Not a green out of the tube, of course; they just have a bias in the green direction.

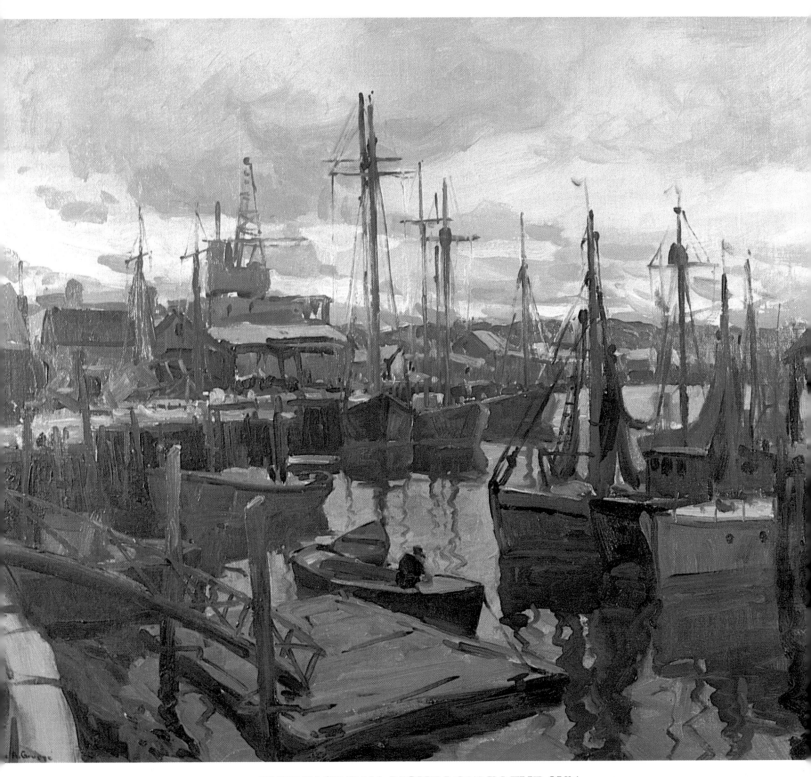

## OVERCAST DAY: LIGHT LOW IN THE SKY

**Crowded Harbor,** oil on canvas, 30'' × 36'' (76 × 91 cm). I painted this picture in the days when over 500 boats sailed out of Gloucester harbor. All my biggest shapes are in the foreground, and everything tightens up as we go back into the picture. Since the sky is breaking up in the distance, the background hills are fairly sharp and dark in value. I used orange and yellow to suggest the color of the sun near the horizon. The gray clouds were painted into this warm mass, using cadmium red and ultramarine blue. The red predominates because the sun is strongly affecting the thinning clouds. A huge overhead cloud shadows the foreground and reflects darkly into the foreground water. Since there's no strong sun, there are few strong color contrasts in the picture. The subtle variations of gray are what hold the picture together. The dark buildings, boats, wharves, hanging nets, and reflections read as big units against the lighter sky, water, and docks.

## NOON: LIGHT HIGH IN THE SKY

**The Yankee at Dock,** oil on canvas, 24″ × 20″ (61 × 51 cm), Collection of Mrs. Cathryn Nugent Gibbs. In contrast to the previous picture, the lightest part of the sky is now directly overhead. That's where the sun is, and that's where I have my warm color. As the sky nears the horizon, it gets slightly darker; yet the sun is so near that it colors what blue sky there is, turning it green. The bright zenith reflects directly down into the foreground water, making that area very warm and light in value. Notice, however, that this water is still darker in value than the sky; the bright light naturally loses some of its intensity when reflected. You can better see the value relationships if you turn the picture upside down and forget about the subject matter. The white and green boats both reflect a little darker, and the white boat in shadow is slightly darker than both the water and the sky. I keep stressing these subtle value relationships in order to make you realize how essential they are to the truth of the picture.

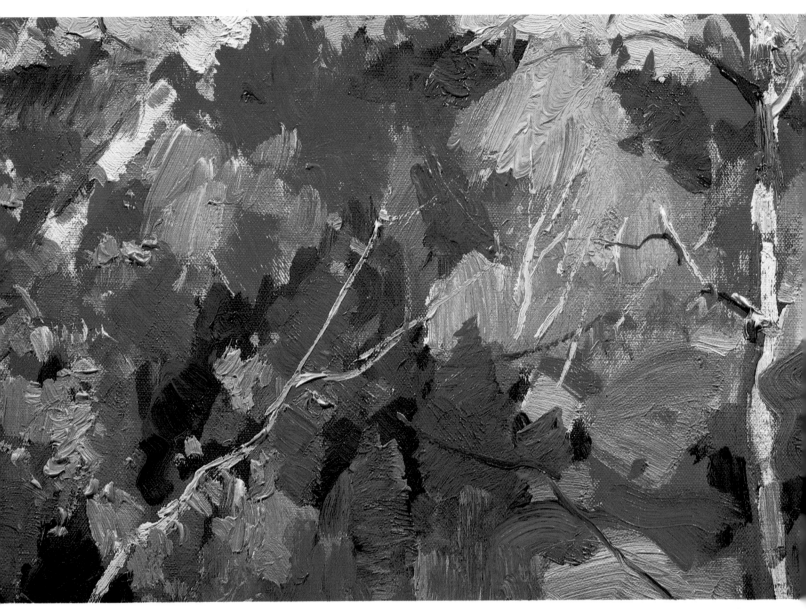

## MASS: FRONT LIGHTING

**Tree Screen,** oil on canvas, 25″ × 30″ (64 × 76 cm). When I arrived at this spot, it was a very clear day and the tree was hit head-on by a blast of light. Because of the strong light, there wasn't much atmospheric perspective between the background and foreground. The light on the different-colored leaves was so strong that it obliterated subtle nuances; you saw broad masses of brilliant color. I therefore decided to play up the color contrasts and developed the canvas as a flat, posterlike decoration. In the detail, you can see how flat areas of red, orange, green, and purple create an interesting abstract pattern. Although the color masses are broadly recorded, I haven't completely disregarded atmospheric perspective. Compare the close, heavily painted yellow leaves on the far left to the distant, massed foliage in the upper right. The latter is worked over a pinkish underpainting and is neither as strong nor as yellow as the nearer foliage.

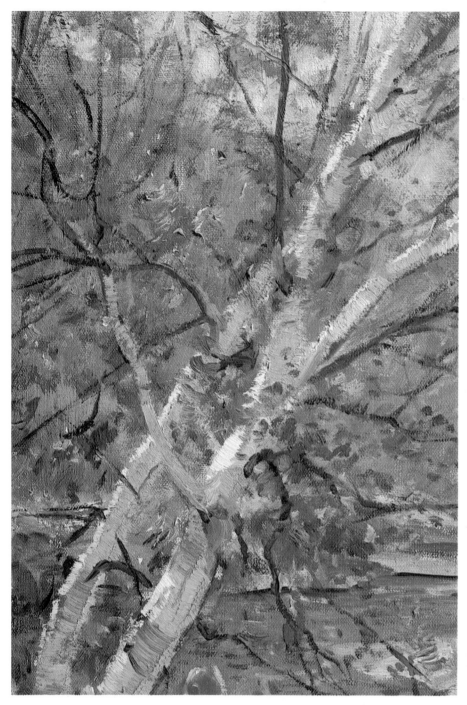

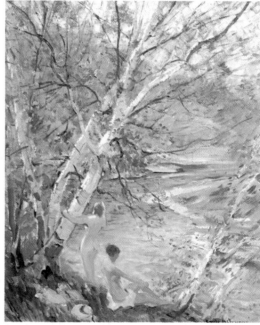

## BROKEN COLOR: BACK LIGHTING

**Summer Idyll,** oil on canvas, 24'' × 20'' (61 × 51cm), Collection of Mrs. Dorothy Gruppé. Here, the back lighting breaks the delicate spring foliage into countless bits of color. I was reminded of my favorite painter, Renoir. Handling such a scene in broad color masses would completely contradict its elusive character. I want to get the effect, without the details. In the detail, you can see how the birch almost disappears into the background because the values are the same; only the difference in color separates the objects. I first painted the distant purple background, and worked the dark green leaves over it. I then added highlights to the foliage, using pure lemon yellow—my most brilliant color—just as it came out of the tube. That gives the area sparkle. Because light is bouncing all over the place, the shadow sides of the birches are full of color. There are also few real darks in the picture. Renoir's paintings show that when you paint in color, you don't need strong contrasts. In fact, you get power in a painting not by how dark you go, but by how light you keep elements in the landscape. Colorful, high-key pictures have a tremendous carrying power.

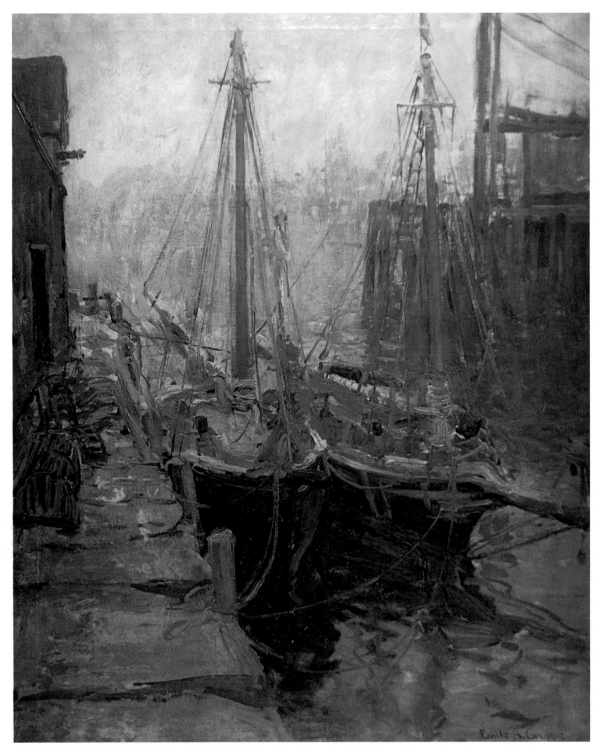

## BREAKING THE PICTURE SURFACE

**Rockport, 1925,** oil on canvas, 36″ × 30″ (91 × 76 cm), Collection of Paulo Gruppé. In the previous picture, I used a broken surface to create a sense of sunlight sparkling through delicate spring foliage. In this picture, however, you can see what happens when you break the surface too much. It was painted when I first came to Gloucester and had little first-hand knowledge of nautical subjects. I've often been told it has an oddly "foreign" look—as if painted in Europe. All I know is that I was struggling with the subject in those days, and I think some of this tentativeness comes out in the broken surface of the painting. Highlights, for example, are distributed all over the place, with the result that the picture is very confusing to look at. It doesn't have a strong, unified impact.

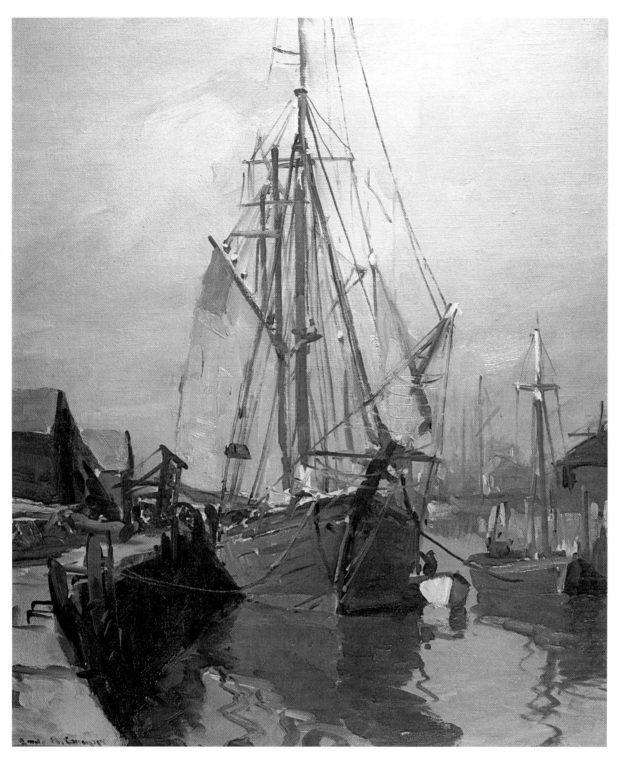

## VALUE MASSES

**The Old-Timer, 1939,** oil on canvas, 30″ × 25″ (76 × 64 cm). By 1939, I'd not only learned to understand the harbor, but I was painting in a much simpler manner. I saw things as dark, light, or a halftone—and let the nuances go. Notice how simple the shadow side of the stone wharf is, as is the distant wharf and building on the right. By keeping the masses unified, I can make maximum use of my bright lights. The white boat to the side of the Old-Timer, for example, is very important. It satisfies the eye by completing the value gamut from light to dark. And it also emphasizes the mass of the nearby boat. Block out the white boat, and you'll see that the hull of the Old-Timer suddenly loses much of its interest; your eye jumps to the warm sails. The contrast with the white boat makes the hull's light and shadow sides read *as a unit*; they hold your attention. White notes are repeated at the base of the main masts, on the bowsprit, on the boat at the far right, and in the highlights on the sunlit pulleys. The eye naturally goes to these bright spots and is drawn up and into the picture.

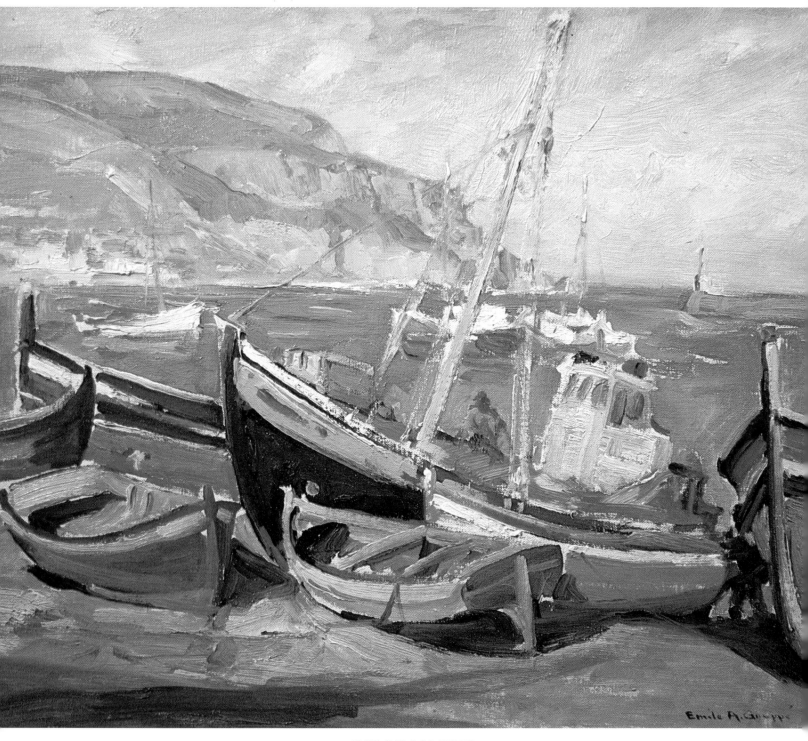

## COLOR MASSES

**Portugal,** oil on panel, 16″ × 20″ (41 × 51 cm). In the preceding picture, I showed how painting in simple masses can add impact to your picture. Here I'm drawing in color areas, bringing mass against mass rather than outlining objects and coloring in between the lines. I let color tell the story. In order to let things happen all over the canvas, I play up the exciting contrasts between colors: the green-blue sky against the red clouds; the cool water against the warm sunlit cliffs; the green foreground boats against the red dories. Look at the subtle play of gray-greens, tans, and reds in the distant headland. Such areas are elusive and interesting to look at because I don't nail anything down. The drawing is there—but it doesn't call attention to itself.

## COLOR CONTRAST

**Portuguese Hill,** oil on canvas, 20'' × 24'' (51 × 61 cm), Collection of Paul Clark. The principal color contrasts in the previous painting were between red and green and between blue and orange. They occur everywhere and help hold the design together. There's little purple in the picture, because the sun hits everything straight on, creating few areas of shadow. In the present painting, however, the back lighting creates large dark areas, and the sky has a chance to throw blue and purple color into the shadows. I now work with the full set of complements: purple, orange, and green. In the background, for example, the sunlit areas are painted as a simple, light-orange mass. Green acts as a harmonizing element. You can see the same purples, oranges, and greens at work in the foreground—only the purples are darker in value, while the greens and oranges are more intense in color. The coolness of my shadows helps accentuate the warmth of the sunlit road, buildings, and—especially—the glare in the water.

## WHITE IN SHADOW

**Busy Street, Portugal,** oil on panel, 20″×16″ (51×41cm). Seeing this street, I was struck by the red of the rooftops and the distant clay cliffs. Atmospheric perspective makes the distant bluffs paler than the foreground roofs. The buildings on the right in the detail screen light from the street—so their shadow sides are fairly dark. These shadows, however, are directly affected by the colors reflected from the buildings opposite them. In the foreground, the mass of buildings on the left catch the sun and reflect warm, orangy light into the shadows. Farther down the road, there's a break in the right-hand mass of buildings; and the blue sky color streams into the shadows. I blocked in all the darks with a purple first, then ran my warm and cool colors over it. Notice how simply the figures are drawn! I saw the lady with the shopping basket, and quickly put her in. She's the kind of detail you always see outdoors—and, if you're smart, put down right away.

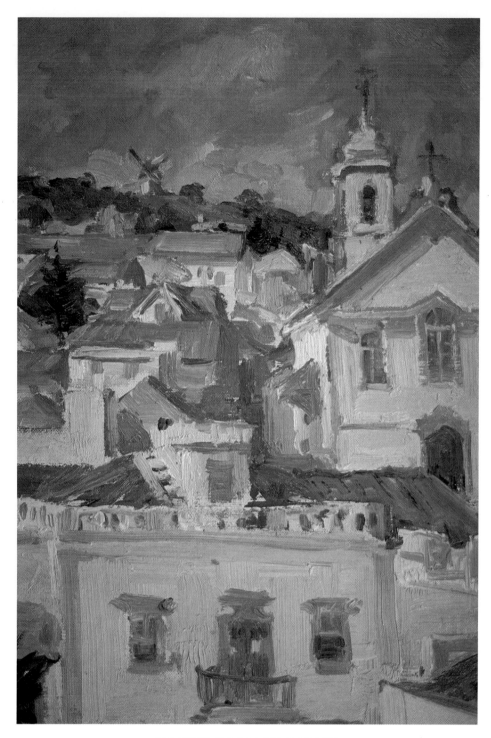

## WHITE IN HALF-LIGHT

**Portuguese Town,** oil on panel, 20″ × 16″ (51 × 41 cm). I especially liked the tile roofs in this town. Some were covered with moss; some were old, some new. In the detail, you can see the interesting relationship between the sides of the buildings that receive a full light and those that get a glancing light from the sun. Both sides have warm yellow in them, but in the side facing us, I've killed the yellow and lowered its brilliance by adding the slightest speck of ultramarine blue. Remember, however, that this area is still catching light; the roof casts light, warm shadows on the church façade. I use ultramarine blue in the shadow areas of the town; the blue already contains some of the red color reflected into these shadows by the nearby tiled roofs. As in the previous illustration, the light buildings make the sky appear dark by comparison. As I've said before, the sky would look light if you stared at it in isolation, but you have to consider the landscape *as a whole.*

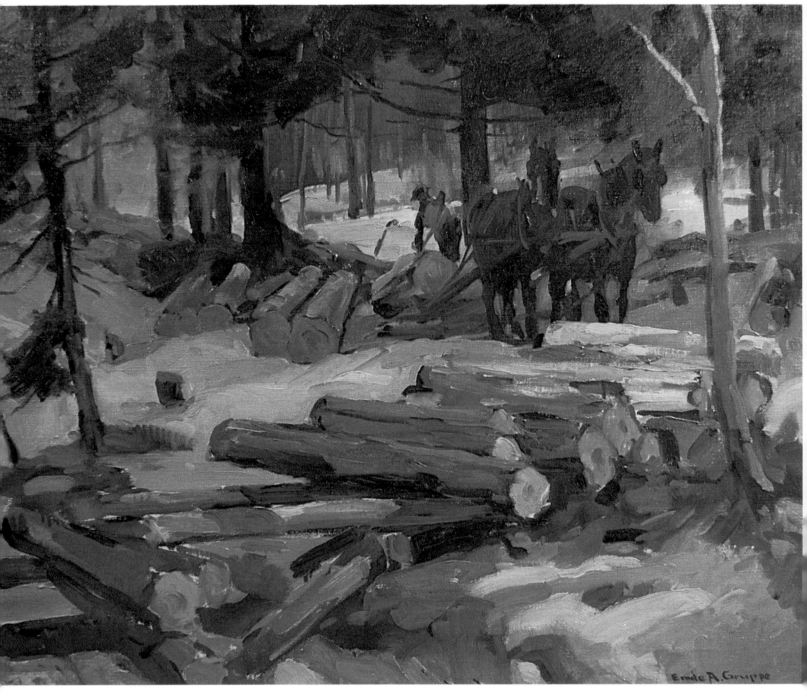

## SNOW IN SHADOW

**Logging,** oil on canvas, 25'' × 30'' (64 × 76 cm), Collection of Mr. and Mrs. Ernest S. Kramer. Here I rapidly painted the horses while they were waiting to be loaded with lumber. Notice how I've held the horses low in tone, with little variation in value. Because they're dark, they form a unit with the trees and other shadowed areas. In contrast to the surrounding green trees, the snow has a reddish cast. The warm light from the sun affects the snow only slightly because of the overshadowing pines. If you look into the distant clearing, however, you'll see that the shadows are a greenish-blue; here, reflected light from the sun has had a chance to warm them up. The foreground logs are very red, as newly cut pines usually are. Here and there, light sneaks through the trees and hits a log. I use this rich warm color to push back the cooler distance by comparison. Notice, however, that only one log is brilliantly lit; the others are slightly darker. If I had made them *all* bright, the foreground would look as if it were covered with orange-red polkadots.

## SNOW: OVERCAST DAY

**The Covered Bridge,** oil on canvas, 25″ × 30″ (64 × 76 cm). In this picture, the bridge and stream are the real interest, with the birches and maples forming a decorative foreground screen. The trees are kept together, so your only entrance to the painting is at the covered bridge. The bridge interests me, and I naturally want to direct your eye toward it. Because of the red sky, the snow appears slightly greenish in color. Here's a chance to test your sense of values: if you look carefully, you'll see that the foreground snow is a bit darker than the snow in the distance. (We saw a similar effect at work in the previous illustration.) This is because the branches of the nearby trees block light from the snow. Of course, it's only a small blockage, but I suggest it by darkening the snow with a touch of ultramarine blue. In the distant field, on the other hand, the trees don't interfere with what little light there is in the sky—and the snow there is thus a fraction lighter. These slight distinctions create the truth of the picture.

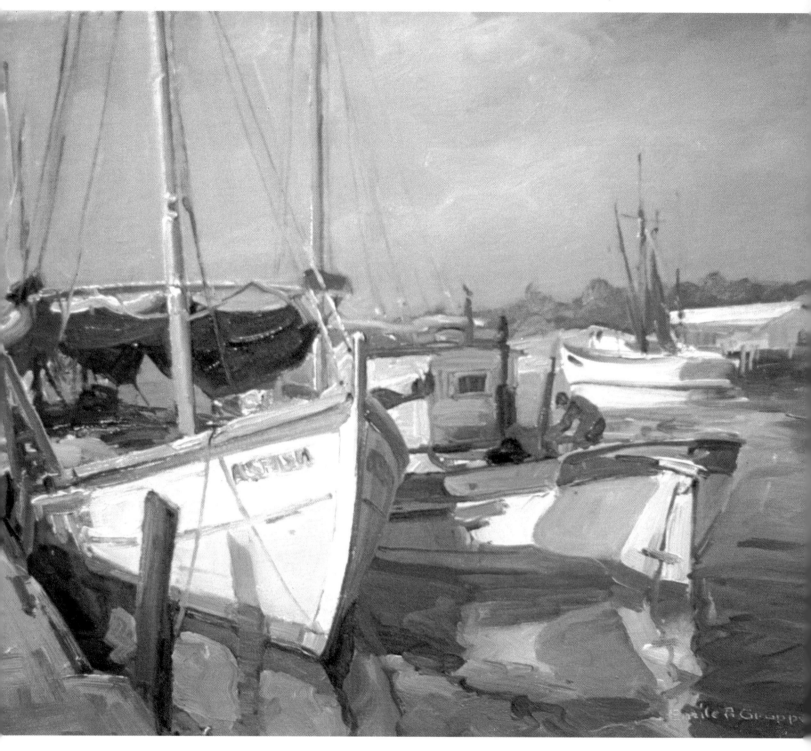

## REFLECTED LIGHT

**Sponge Boats at Tarpan Springs,** oil on canvas, 25″ × 30″ (64 × 76 cm). This painting clearly shows how the color of an object changes in relation to its surroundings. The darkest shadow and the one with the least noticeable color is under the tarpaulin of the nearby boat. Little sky or sun can get under the tarpaulin, so it becomes a dark mass. As the tarp folds under, however, it catches warm reflected light from the deck of the boat. The right side of the nearest boat is very blue; it's affected by the color of the sky and water. The stern of the boat next to it, however, is very warm; it catches a lot of reflected sunlight from the rudder. On the other hand, the other side of the stern (at our far right) receives cool color from the sky and water, and so almost disappears into the ocean. The larger boat blocks the light, throwing one side of the far boat into shadow. It looks dark when you squint at it—yet it remains *transparent*. You see the trim and the waterline and sense that the shadow isn't a black hole in the canvas.

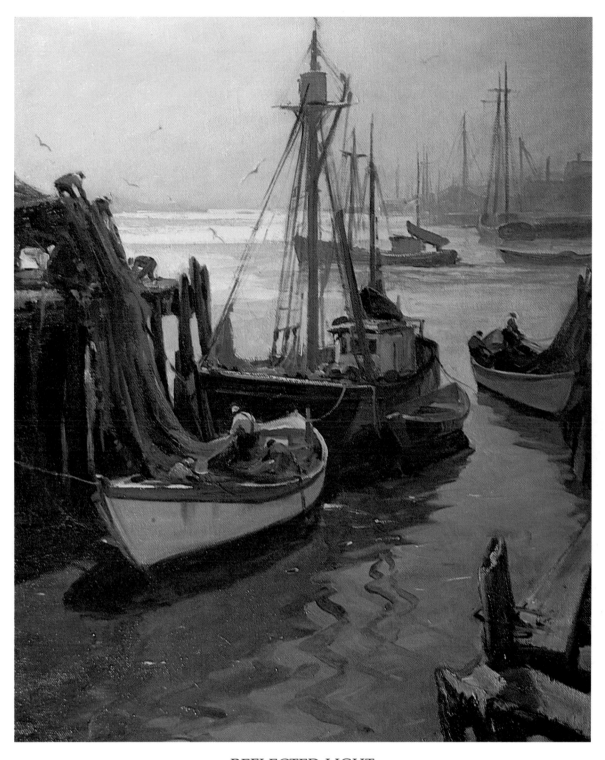

## REFLECTED LIGHT

**Early Morning,** oil on canvas, 36'' × 30'' (91 × 76 cm), Collection of Mr. and Mrs. Ernest S. Kramer. The bright morning sun turns the foreground of this picture into a simple, dark silhouette. The white seine boat is in shadow. It's dark in value, but appears light in contrast to the very dark surroundings. It catches both (1) cool color from the water and sky and (2) warm color from the sunlit dock on the right. The colors mix, giving the seine boat a slightly greenish cast. I got the color by blocking the boat in with purple first, and then working light blue-greens over it. It's a trial and error process. There's no formula; you just have to go out and do it. Although the foreground boat looks light against the dark dock, notice how dark the seine boat to the far right looks against the light harbor. A few touches of white (with a hint of orange) suggest glints of sunlight in the foreground water and help give you a sense of its surface.

## REFLECTED LIGHT: COOL COLOR

**The Yellow House,** oil on canvas, 25'' × 30'' (64 × 76 cm). The darkest part of each shadow cast on the house is at its center; the shadow gets lighter at the edges, where the sun can break through individual leaves. Although there's a hint of yellow's complement, purple, in the shadows, warm reflected color is also present; the shadows are thus related to the rest of the wall. Areas in the sun work on a similar principle. The brightest part of each sunlit area is at its center, since the sun has an unobstructed path to the house. The edges of the light areas, however, are darker; leaves interrupt and "diffract" the passage of light. Notice, too, that each one of the windows differs from the others. Where the curtains are parted, a dark spot pulls you into the building. I made that spot somewhat warm in color, since little cool sky color can get into the house. The blue of the sky reflects into the windows on the upper left, just as it colors the shadowed white trim of the porch. But sky color can't get under this porch, so the shade there is very warm.

## REFLECTED LIGHT: WARM COLOR

**My Family,** oil on canvas, 16″·× 20″ (41 × 51 cm), Collection of Mrs. Dorothy Gruppé. Cool sky color affects these shadowed figures, as it does the window of the previous illustration. But warm light from the sand also reflects into the figures, killing most of the cool sky color. Since they're dark spots against a violently warm, red background, the shadowed figures have a slightly greenish cast. Notice the warm light reflecting onto the woman's right leg from her sunlit left one, and the warm sand color reflected up under both her chin and that of the child. The warm spot under the chin gives shape to the face. The eye takes the hint, and it isn't necessary for me to draw eyes, mouth, and nose. Color again tells the story. The cool sky also affects the shadows in the sand. I used purple to paint them, working right into the wet sand color. Notice that there's also a hint of green to these purplish shadows.

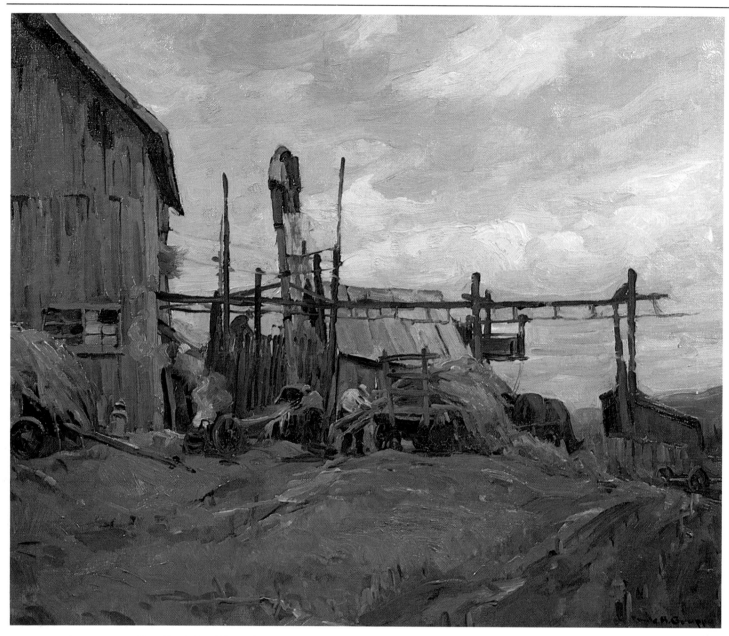

**Loading the Silo,** oil on canvas, 25″ × 30″ (64 × 76 cm), Collection of Mr. and Mrs. Ernest S. Kramer. I've always liked this picture. It's a good example of the kind of painting you can get only by working outdoors. The farmers are making a silo out of snow-fencing material. You can see the supporting two-by-fours sticking into the air. They show you how tall the silo will be, once the farmers fill the first level and add a few more snow-fenced stories. I liked the engine that powered the haylift, the grazing horses, the manure-spreader, the men, and the stubbly field—all characteristic bits that can only be found on the spot. Notice how these diverse elements are unified through my use of value: the buildings, men, machinery, and field form a big, dark mass against the light, overcast sky.

# Landscapes

I've talked a lot about the technical reasons for my palette. Now I'd like to take some time to talk about the painter's attitude toward his subject. In the process, I may have some suggestions that will help you to think—and therefore paint—better outdoors.

When you first start to paint, you're happy if you can copy what's in front of you. You fill your pictures with trees and maple-sugar houses, horses and men, barns and wagons. *Everything*'s there. But once you begin to understand what painting's all about, you find these details don't mean much. Even if you can make a photographic copy of the subject, what good is it? You have a map of the scene—but you haven't constructed a picture. You have all the facts—but you haven't made a statement. You haven't told people how you *feel* about the subject.

So when you arrive at a site, look around and try to decide what you like best. Does the sky impress you? Or do you have more of a feeling for the foreground? If you like the sky, let it predominate. If the foreground interests you, then let it be the dominant element. Remember, you can't look up at a sky and down at the foreground—not at the same time.

Once you know what you like, painting becomes much easier. Yet it's often hard to make the necessary decisions. When I started out, I put all kinds of junk in my pictures. My father would look, shake his head, and say, "Too much for the money!" I'd go over and over a sketch in the studio. But instead of improving it, I usually made it into an entirely different picture. It was all over the place—with too many ideas and not enough fluency or consistency. The original impulse was gone: the feeling that made me want to paint in the first place. A good painting hits you—bang!—the minute you see it. It gives you a jolt. The painter saw the effect in a glance, and you, looking at his picture, can see it in a glance, too (Figure 9).

When you don't know what you want to paint, your picture will never be a success. I tell people that a dud is always a dud, and no amount of work can save it. I'd lay awake nights worrying about a picture in my gallery. Sometimes I'd have to get up, go down to the studio, and wipe the painting out—just so I could get some sleep!

## The Value of Outdoor Work
Despite these frustrations, I always return to nature. And I remain convinced that the quickest way to learn about composition, values, and color is to work outdoors. Of course, you can work in the studio, too. You

can sometimes do wonders painting from a sketch done on the spot. But if you're going to work in the studio, use sketches, not photographs. If you've been honest, even a bad outdoor sketch has something in it. But photos are always wrong. The blues are too vivid; the shadows, too dark. Everything's off. Slides are okay if you're desperate, if you can't get out and want to experiment with color or composition. They give you a place to start. But save the pictures you do from photos—and then see what you paint outdoors. Once you compare the two, I'll bet you never use photos again.

Even working from sketches has its drawbacks. You're still making a picture from a picture. Carlson said that masterpieces are made in the studio; you have leisure to study and perfect your design. And he may be right. But you can't get color indoors. You always lose some of the sparkle of your original impression. That's why I can tell when a picture's been done on the spot. Indoor pieces seem manufactured. It's hard to explain; but looking at them, you smell the studio. They're neither true nor real. And they prove that you just can't get the outside, inside.

## The Changing Scene
Part of the joy of the outdoors is that it's always different. I can return again and again to the same spot, at the same time, and in the same season—yet it always looks brand new (Figure 10). It's as if I'm seeing it for the first time. And I think part of the reason I feel this way is that I'm not trying to force the subject into some preconceived format. I let the subject tell me what to do; I don't dictate to it. Probably my having so many teachers, each with his own philosophy, has also helped. That taught me that there's no one "right" way to tackle a subject. Everything depends on the personality of the painter.

## Pages from a Sketchbook
If we look at a few pages from one of my sketchbooks, we can probably see more clearly how the same site can be interpreted in a variety of different ways. In the first sketch (Figure 11), for example, I'm impressed by the foreground as a whole. The docks and boats form a large, lively unit against the sky and water. In Figure 12, I focus my attention on one aspect of the scene: the boats and the sails, with the emphasis on the large shadowed sail and its dark reflection in the water. In Figure 13, on the other hand, I concentrate on the dock and make it the biggest, most important element in the

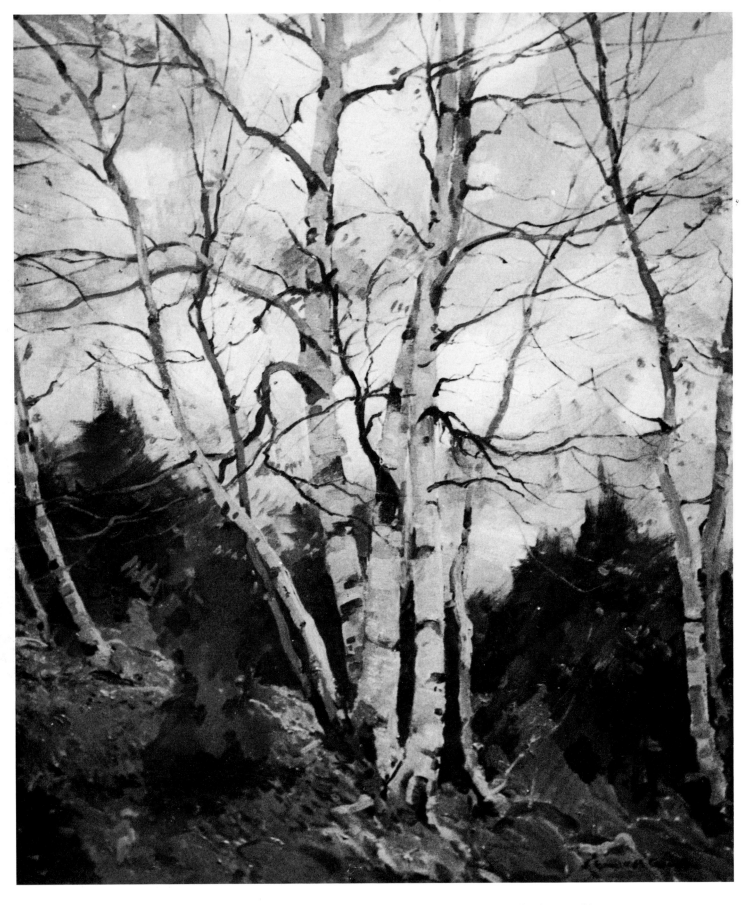

***Figure 9.*** Birches: Gray Day, *oil on canvas, 30" × 25" (76 × 64 cm). Looking at this picture, you see that I'm interested in one thing: birch trees. Notice that although the birches are white, they appear dark in value against the luminous gray sky.*

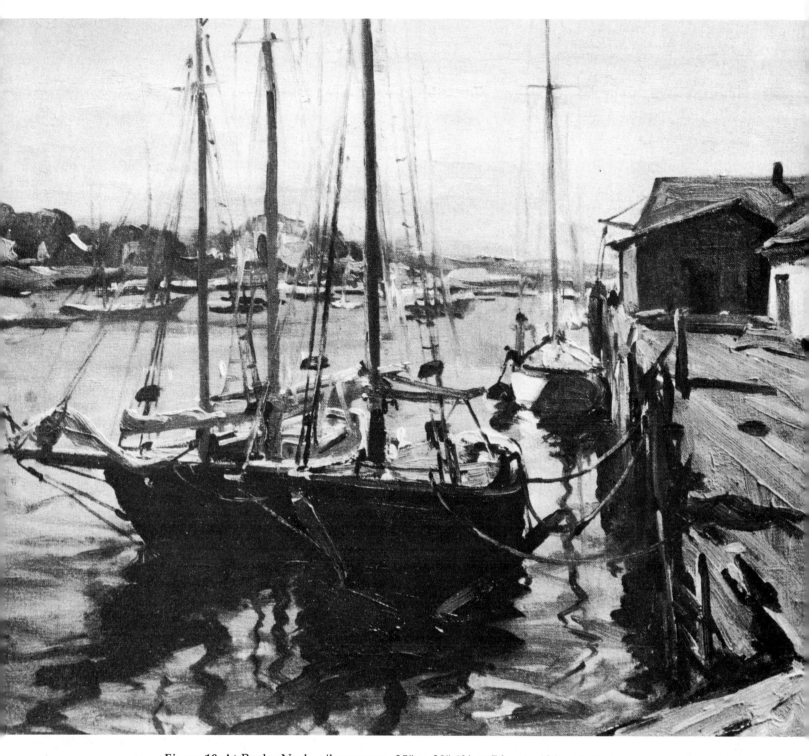

***Figure 10.*** At Rocky Neck, *oil on canvas, 25" × 30" (64 × 76 cm). Although I've painted in Gloucester for over fifty years, it looks new every time I go out. In this picture, back lighting makes the buildings, distance, and foreground boats into interesting, dark silhouettes.*

**Figure 11.** *In this sketch, I focus on the docks and boats; they dominate the design and make a lively, unified shape.*

**Figure 12.** *Here, I concentrate on one part of the scene: the sail of the central boat and its dark reflection in the water.*

*Figure 13.* In this sketch, I emphasize the floats at the dock, making them the largest and most important thing in the picture.

*Figure 14.* I now step back and look at the whole scene, using a panoramic view to give the viewer a feeling of the harbor as a whole.

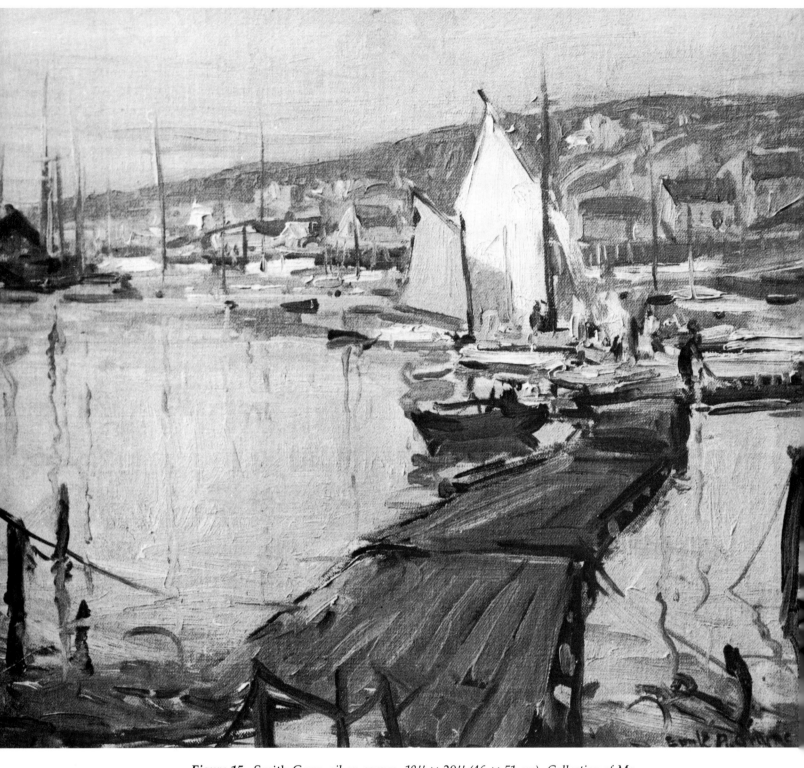

**Figure 15.** Smith Cove, *oil on canvas, 18'' × 20'' (46 × 51 cm), Collection of Mr. and Mrs. Paul Strisik. In the oil painting of the same site, I emphasize yet another characteristic: the contrast of the light-struck sails to the shadowed foreground.*

design. In Figure 14, I emphasize the harbor by working in terms of a panorama. Notice how the mood has changed. The activity of Figure 11 is replaced by the calm of Figure 14. A change in position has completely altered my feeling about the place.

I'll end this series by showing you one of my paintings of the scene (Figure 15). I finally decided to emphasize yet another quality of the subject: the dramatic way the late afternoon sun lights the distant sails and throws the foreground into shadow. So from the one site, I received five quite different impressions.

## Expressive Composition
In all of these cases, I felt free to move objects around, making them bigger or smaller as best suited my purposes. I said that Carlson made us do meticulous tree studies in order to increase our understanding of nature. But once we understood a subject, he encouraged us to alter it to fit our mood. We could interpret the scene in a lyrical or tragic way—as long as we got the feeling of the place. To do this, Carlson himself often contradicted the "facts" of nature. He grouped his trees close together, for example. And when you looked at his pictures, you felt as if you were in a cathedral. The massive trunks instantly made you sense the profound dignity of the forest. Yet if those huge trees had ever tried to grow that way, they'd have strangled and killed one another!

In Figures 16 and 17, you can see a simple example of how material can be adjusted to make a statement. In the photograph of the spot, there's a confusing amount of white. So to make the painting, I waited till late in the day, when shadows defined the architecture more clearly. Similarly, the church is in the "wrong" place. The road leads into the picture—but it doesn't go anywhere. So I moved the church toward the center of the design and made it the climax of the composition. I also pulled some of the other buildings together, making the scene more compact. By emphasizing the tall, slender trees, I echoed and reinforced the height of the steeple itself. And I used the tree mass on the far right to lead the viewer down and back into the picture. Cover these trees, and you'll see that the painting becomes a little flatter.

## Looking at the Landscape
In order to train you to stop worrying about the details of the scene, I'm going to ask you to look for a minute at some of nature's big relationships. As we've already seen when talking about color, the study of relationships forces you to look at the landscape *as a whole.* You stop seeing it as a collection of isolated objects.

As an example, let's say that you're painting in the woods. If you look at each tree individually, each will appear straight. You have to train yourself to look at the relationship between the trees. Then you'll notice that the supposedly "straight" tree actually leans a bit to the right or the left in order to avoid other trees near it. These other trees lean, too, and the slight variations in their growth are what make the subject interesting. The movements contrast with and accentuate one another, adding vitality to the picture. Sometimes I

exaggerate such movements. But more often, the shifts in direction are present at the site. You just have to look for them.

In Figure 18, I've emphasized the movement of the individual trees. The sunlit beech, for example, slants to the left. The big background tree slants in the opposite direction. The small sapling again slants leftward, in order to escape the bigger trees and get its share of sunlight. Since the tree to the far left stands alone, it's fairly straight. Notice that the branches of the shadowed beech slant upward, while the most important branch of the sunlit tree slants downward and across the picture. These contrasting movements make the picture worth looking at. In fact, they're what actually attracts the painter's eye, even though he may think he's just painting "trees." Of course, the subject is important. But the real excitement lies in the way the elements of the scene come together.

## Counterpoint
This interesting interplay of angles—"counterpoint" would be the best term for it—is not restricted to natural objects. It occurs in man-made things, too. Figure 19, for example, is entirely based on the opposition of angles. The boat in the foreground slants upward; the bridge wall moves downward; and the roof of the building slants into the picture. The wooden staircase slants one way. The pole that holds up the workshop roof slants in the opposite direction—and it, in turn, is contrasted to the angle of the man at work. You can probably find many more examples of counterpoint all through the painting.

If you look up at a skyscraper, you'll notice that the sides taper inward. The parallel edges appear to converge, just as the sides of a railroad track do in the familiar perspective illustration. Well, this convergence can be seen even in a little shed. Figure 20, for example, shows a small farm in Italy. Notice how the upright wall on the right slants slightly inward, as does the bit of wall to the left. The sides of the dark center window are straight; they're hardly influenced by perspective. By forcing my angles a bit, I increase the feeling of the building's height. Imagine how the painting would look if these lines were perfectly straight. The house would be as static as an architect's rendering. Again, it's the slight variations that add vitality to the picture.

In Figure 21, I've taken a simple barn and exaggerated the angles of the walls, the sway of the roof, and the jaggedness of the background mountains. I emphasize qualities inherent in the scene, playing with the facts to make a more interesting design. Friends often criticize me for taking such liberties, but I've never worried about literal accuracy. If an exaggeration works, I use it. In fact, I can remember painting one day with a new student and being amazed at the way she drew an old, familiar building. She worked in a cubist manner, angling the sides of the roof and making the whole thing extremely interesting to look at. It wasn't particularly "realistic"—but I liked it so much that I asked her if she'd mind my putting the same effect in my own picture!

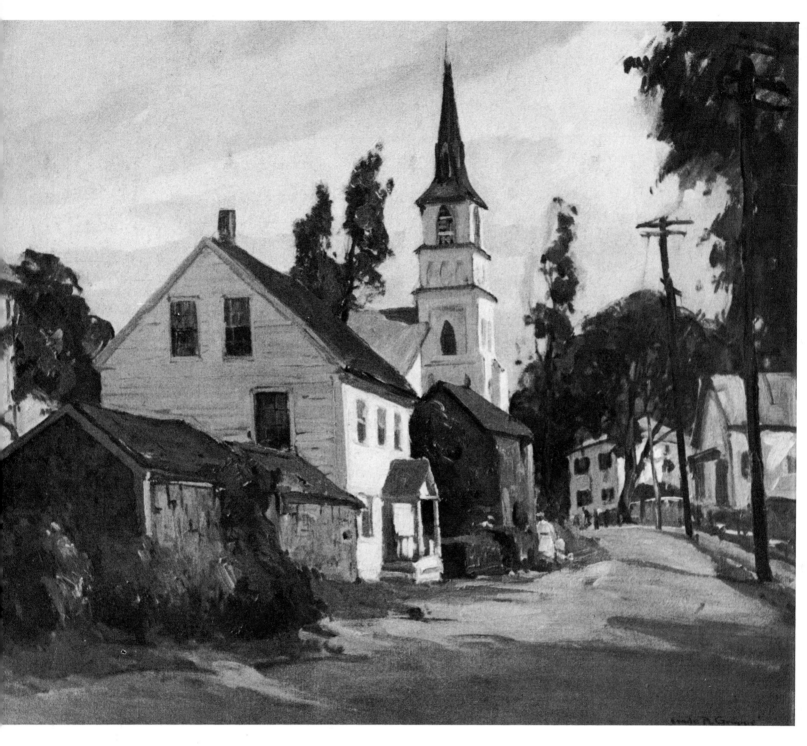

**Figure 16 (above).** Church in Rockport, *oil on canvas, 30″ ×
36″ (76 × 91 cm). I rearrange the facts of the site so that the road
logically leads to the climax of the design, the white church.*

**Figure 17 (left).** *Rockport, Massachusetts. A photograph simply
records the facts of the scene.*

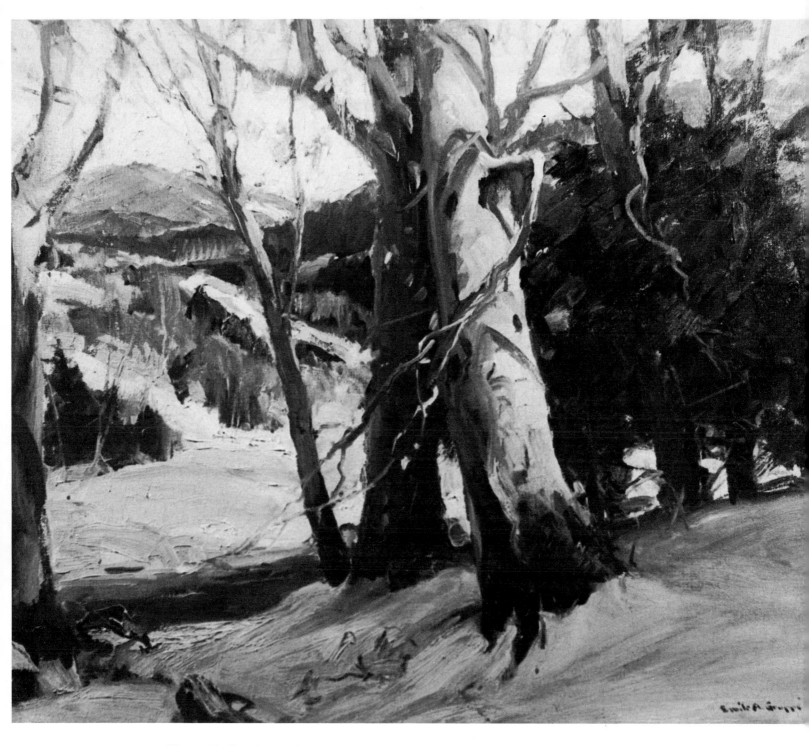

**Figure 18.** Beeches in Snow, *oil on canvas, 30'' × 36'' (76 × 91 cm). In order to see the way one tree reacts to another, it's necessary to train yourself to look at the scene as a whole.*

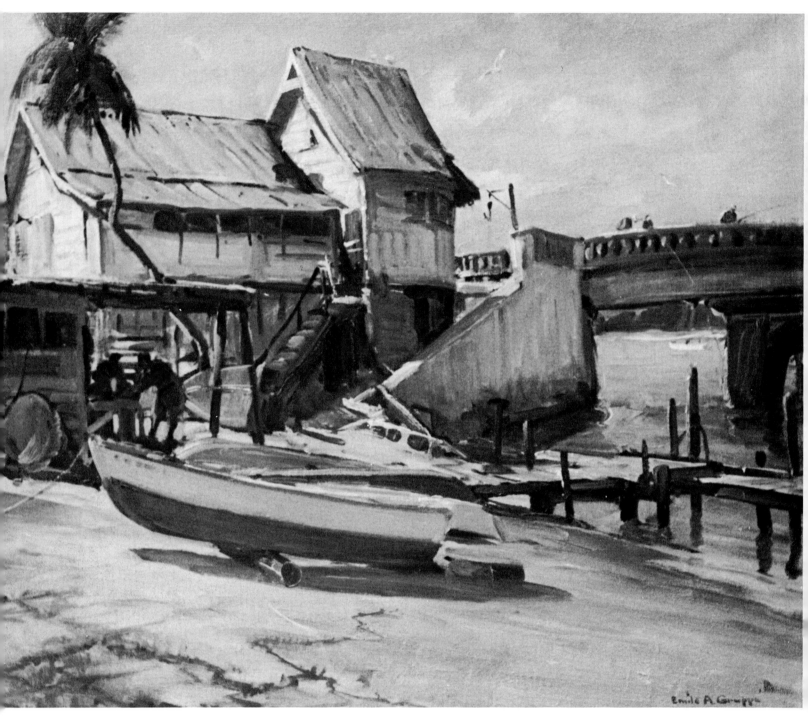

**Figure 19.** The Bridge to Long Boat Key, *oil on canvas, 30″ × 36″ (76 × 91 cm). The real subject of this picture is the counterpoint of the boat, wharf, bridge, and building.*

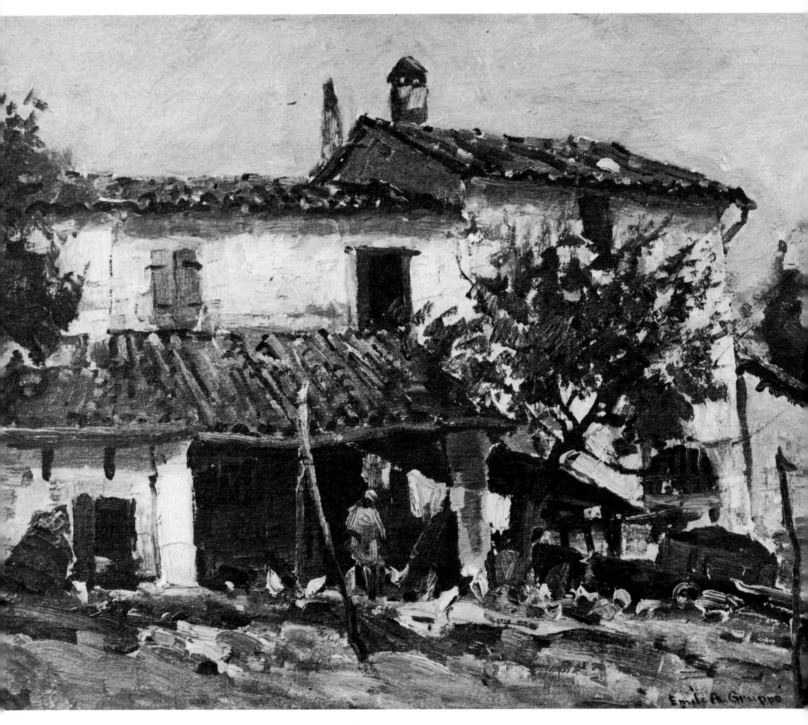

**Figure 20.** The Italian Farm, *oil on panel, 16″ × 20″ (41 × 51 cm). By angling the sides of the building, I exaggerate the perspective and give you a better feeling of the building's height.*

**Figure 21.** The Barn, *oil on canvas, 25" × 30" (64 × 76 cm). You can make a simple barn interesting by exaggerating its characteristic features. The lively counterpoint of angles is matched by the lively handling of the paint.*

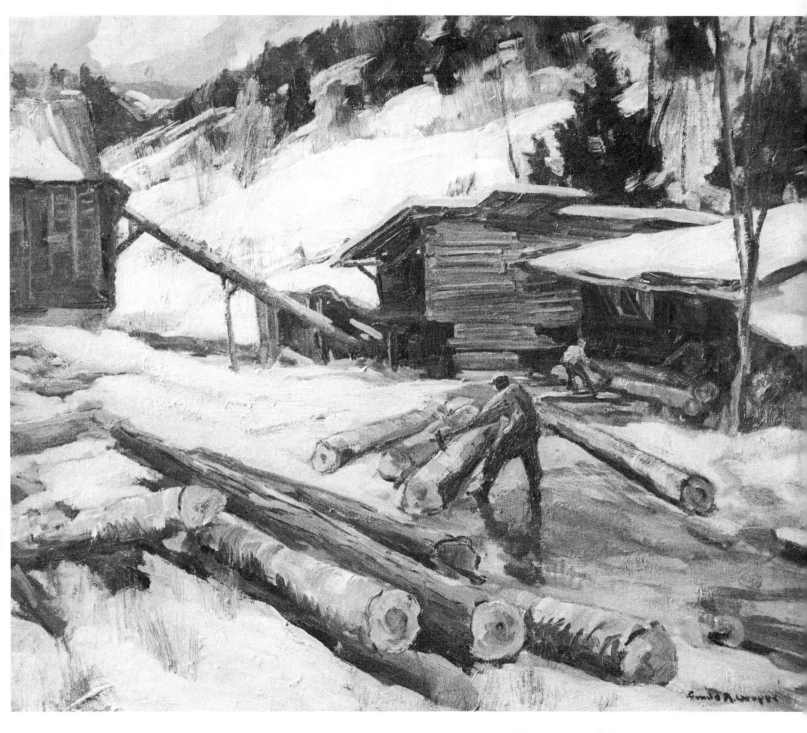

***Figure* 22.** Logging, *oil on canvas, 25" × 30" (64 × 76 cm). Working on a flat surface, artists must take advantage of shifts in size and shape in order to create the illusion of three dimensions. Here, the logs, men, and trees all get smaller as they recede into the painting.*

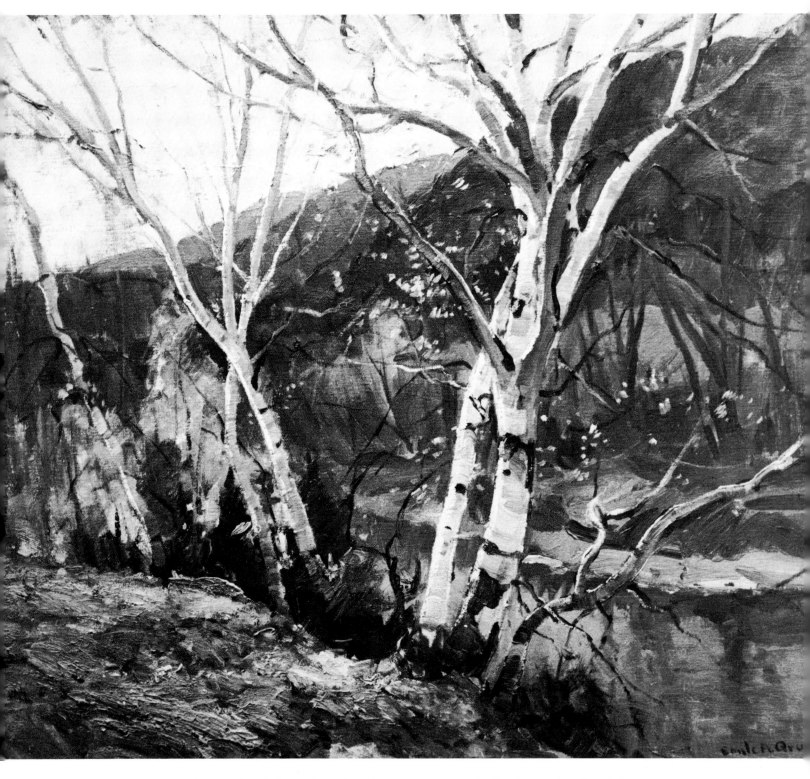

**Figure 23.** Birches Along the River, *oil on canvas, 30″ × 36″ (76 × 91 cm). The largest birches are near us; the smaller ones, off in the distance. The trees twist to escape nearby foliage and to get their share of sunlight.*

## Size and Shape

I've talked about the relationship between movements in a picture. Of equal importance are the relationships of size and shape. In order to create three-dimensional depth in a picture, you have to be aware of the differences in size among objects. When we're painting outdoors, we all make our foreground buildings large and the background ones small. And we think that, if anything, we're exaggerating the differences. As an experiment, however, take a photo of a spot someday—after you've finished painting it. The photograph flattens and compresses the scene and thus lets you compare the shapes more easily. I'll bet the background buildings in the photo are half the size you painted them. We *think* we force perspective, but we don't. Instead, we become interested in drawing each object and forget to make comparisons. And as our interest in each part grows, we naturally draw it a bit bigger than it should be.

In Figure 22, you can clearly see the importance of size. Huge foreground logs project toward us. The ones near the workman are much smaller; and those under the shed are smaller still. Similarly, the distant worker is only a third the size of the man in the foreground. I place the two figures close together so that the difference in size is clearly visible. Cover the distant figure and see how you suddenly lose a sense of scale.

In Figure 23, you can see similar changes in size as the trees recede. Of even more importance, however, are the sizes and shapes of the spaces between the trees. Not only are they all different and interesting, but the biggest space is to the right, nearest us. As we go into the distance, the spaces between the trees become smaller. Again, the change in size pulls the viewer into the picture.

## Drawing

In order to adjust angles and shapes, you have to be able to draw. As I said at the beginning of this book, drawing is the very essence of painting.

I think out my design by drawing on the canvas with a stick of soft charcoal. The charcoal can be wiped off with a rag and so corrections are easy to make. Since the charcoal is just ash, it never affects the paint. If you use too much charcoal, you can flick off the excess with a snap of the paint rag.

Once you've determined what you want to do, try to concentrate less on the facts in front of you and more on the *needs of the canvas.* I don't care how you draw, but make sure your drawing fits the canvas. It should form a decorative pattern within that square or oblong shape. Think of the areas in the painting, and make those shapes bigger or smaller—in order to design every part of the canvas. I sometimes get so involved in painting the patterns that I forget I'm doing a boat or a tree! And I've found that the best painters often start out as textile designers. They succeed because they're trained to fill a particular area—a sheet, or a scarf, or a curtain—with a beautiful and interesting pattern. They can make objects fit a particular shape.

## Shapes and Spaces

To clarify this point, look at Figures 24 and 26. Figure 26 is the completed painting; Figure 24 is the sketch I made on the canvas prior to starting work. The sketch isn't particularly detailed. At the beginning, I'm not interested in the little branches or the texture of the bark. There's no point in drawing such things at this stage, since the paint would quickly obliterate them. Besides, if the drawing were too good, I'd be tempted to paint between the lines—and the final picture would look as brittle as a page from a coloring book. I want to establish the basic areas, getting as much variety in the shapes as I can. Notice, for example, that the spaces between the trees are all different, as are the relative sizes of the foreground bank, the stream, and the bank in the distance.

Once I begin to work, I won't feel compelled to stick rigidly to these lines. Paint always has an effect on my drawing; it changes it, often leading me to discover new and better ideas. If I'd started drawing with paint, however, my first line would probably be my last. But using charcoal, I have a couple of chances at the composition. At the same time, however, my drawing is not done carelessly. I've considered each area. And one of the best criticisms I can give a student is to tell him to spend more time on his initial charcoal sketch. A well-composed picture paints itself.

Start by drawing your main subject first. I began Figure 24 with the upright lines of the principal beech tree. Students, unfortunately, like to start at the corners of the canvas. Looking at a student's sketch, I'd often have to ask him what he planned to paint. He might point to a boat or a nearby tree—but on the canvas, you'd see everything *but* that boat or tree. All the unimportant details were there, but not the subject. Don't feel that you have to get everything in! Don't even look to the sides as you draw. Look straight ahead. Go right for the thing you want to paint. And concentrate on that! Then make the surroundings fit your subject. As Carlson said: "In a good composition, it's everything for one thing."

## Masses and Values

In Figure 25, you can see how the picture looks after I've begun to block it in. I block in masses of color and value first, trying to establish the big areas before worrying about the details within them. Once I get the big masses, I could shoot paint on the canvas with a gun and it would look right. If a blob of white hit the sky, you'd think it was a bird. If it hit the earth, you might mistake it for a cow. And if it hit the water—well, maybe it's a duck!

I paint area into area and color into color, without worrying too much about edges. Later on, I can accent an edge here and there—mainly where I want to attract the viewer's eye. That's how the eye works. Put this book down for a second and look around the room. Focus on an area—a mantelpiece, or the arm of a chair. Where the eye focuses, you see an edge—that's your center of interest. But at the same time, everything else in the room is slightly blurred. In contrast to

79

*Figure 24. My preliminary drawing isn't detailed. I carefully consider the shapes of the objects, however, so that they make an interesting pattern on the canvas.*

*Figure 25. I block in the picture simply, concentrating on the big masses and not breaking up those masses until I have them firmly established.*

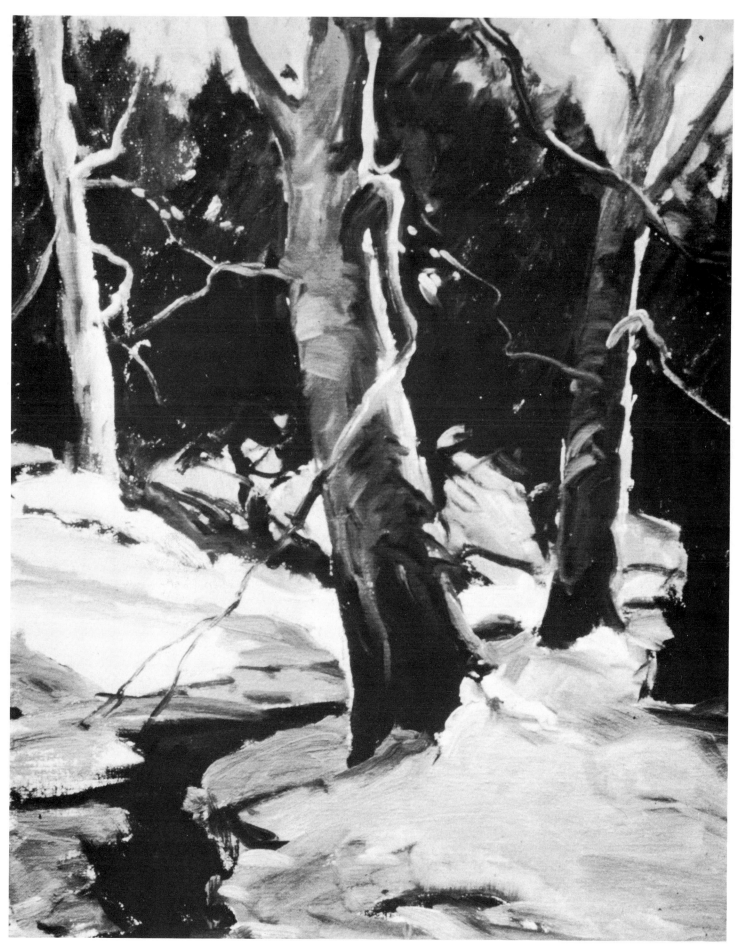

*Figure 26.* Beech in Winter, *oil on panel, 16'' × 20'' (41 × 51 cm). The picture needs only a few details—branches and a suggestion of the texture of the bark—to make it look complete. The background remains simply painted.*

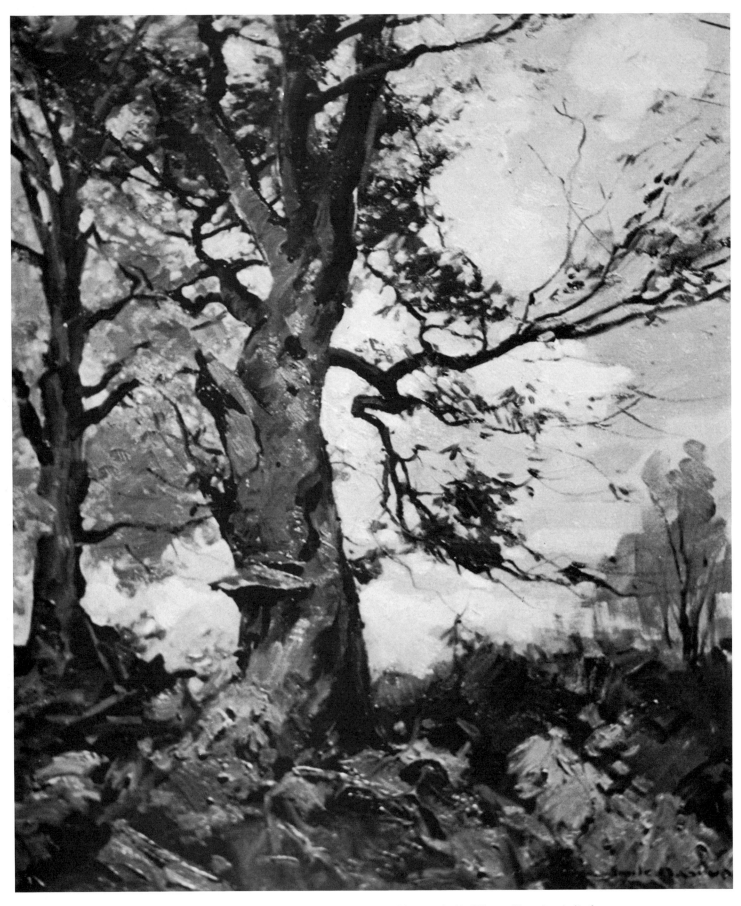

***Figure 27.*** The Old Beech, *oil on canvas, 30'' × 25'' (76 × 64 cm). A limb originally sheltered the small branch on the right. The branch grew downward to avoid the overhead foliage; then shot up when the larger limb fell off the tree.*

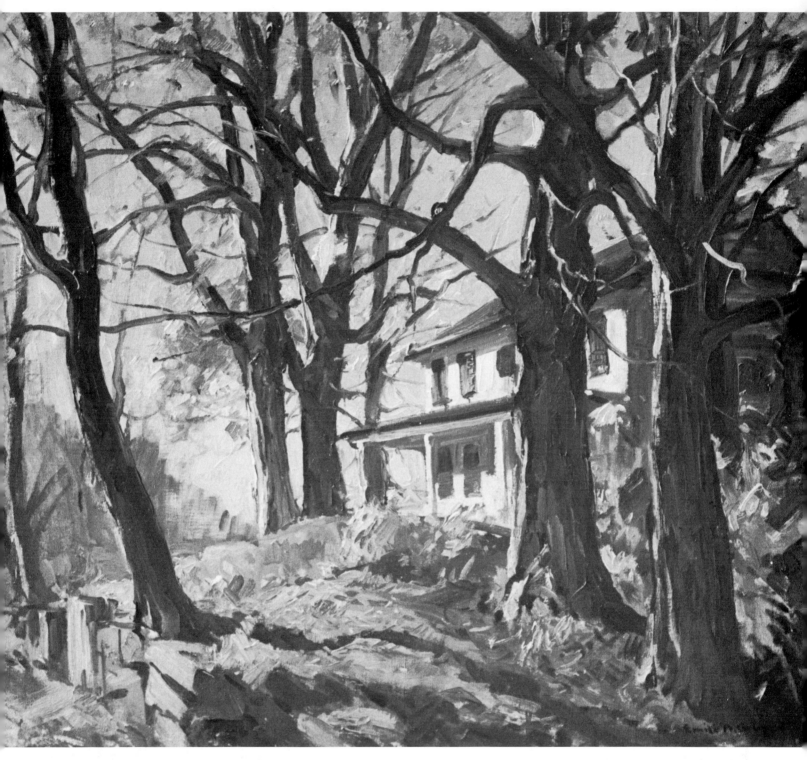

***Figure 28.*** The Haunted House, *oil on canvas, 30'' × 36'' (76 × 91 cm). In the fall, I like to study the interesting structure of the bare trees against the sky.*

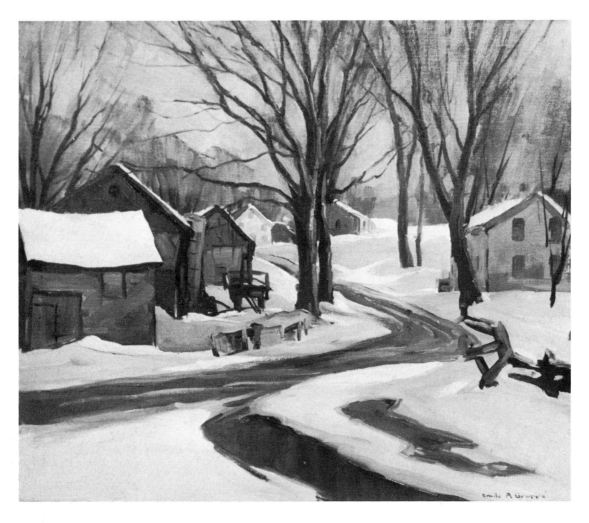

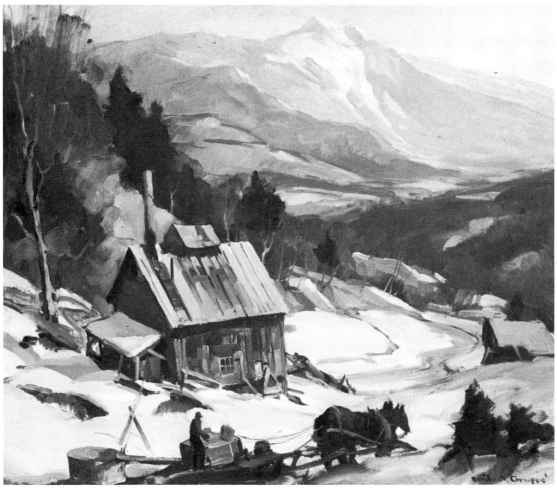

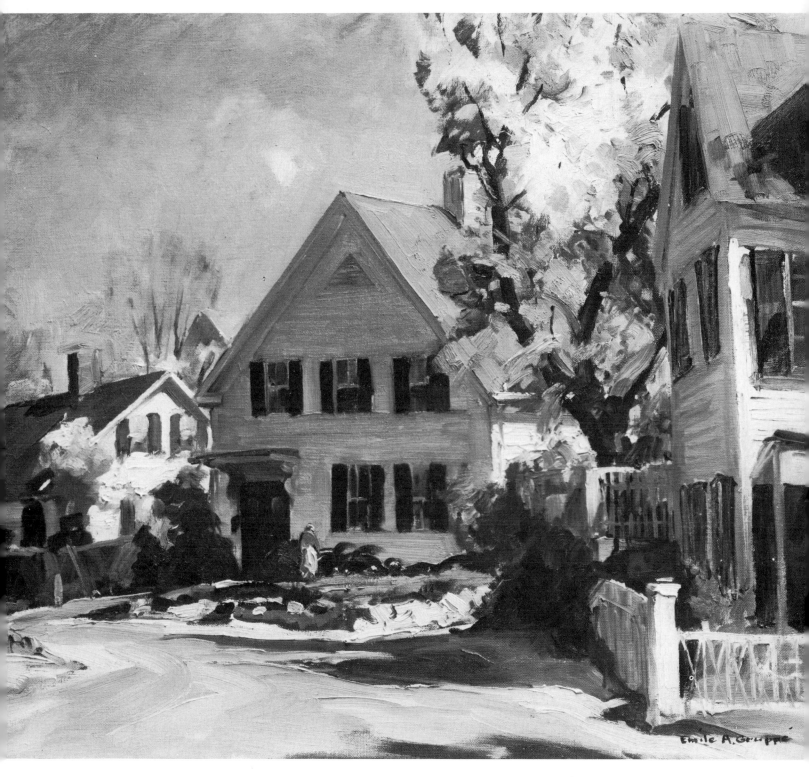

**Figure 29 (above left).** Farm in the Snow, *oil on canvas, 25″ × 30″ (64 × 76 cm). Against the white snow, you can see the strong reverse curve of the dark road. The road and the mass of distant trees lead you toward an arch formed by the foreground maples; the eye escapes through this arch into the distant vista.*

**Figure 30 (left).** The Sugar House at Mt. Mansfield, *oil on canvas, 25″ × 30″ (64 × 76 cm), Collection of Mr. and Mrs. Miller Primm. I add drama to the composition by putting the immediate foreground in shadow; the dark silhouettes accent the lightness of the snow. As the snow goes into the distance, it becomes grayer and darker in value.*

**Figure 31 (above).** The House at Annisquam, *oil on canvas, 30″ × 36″ (76 × 91 cm). This is a tricky piece of drawing, since the houses all are at slightly different angles. The brilliant area of apple blossoms contrasts with the shadow side of the house. When painting apple blossoms, treat them as a mass; don't get involved in the individual flowers.*

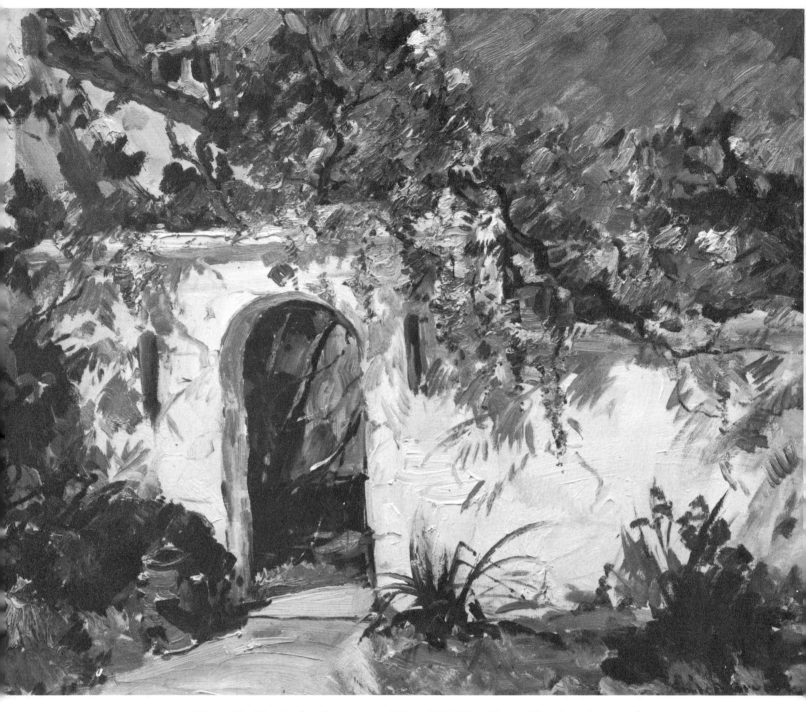

**Figure 32.** The Arch, *oil on canvas, 25″ × 30″ (64 × 76 cm). Here I was interested in the wisteria and the shadows it cast on the sunlit stucco. The stark white mass emphasizes the dark and mysterious distance seen through the arch; you feel that you want to find out what's beyond the wall.*

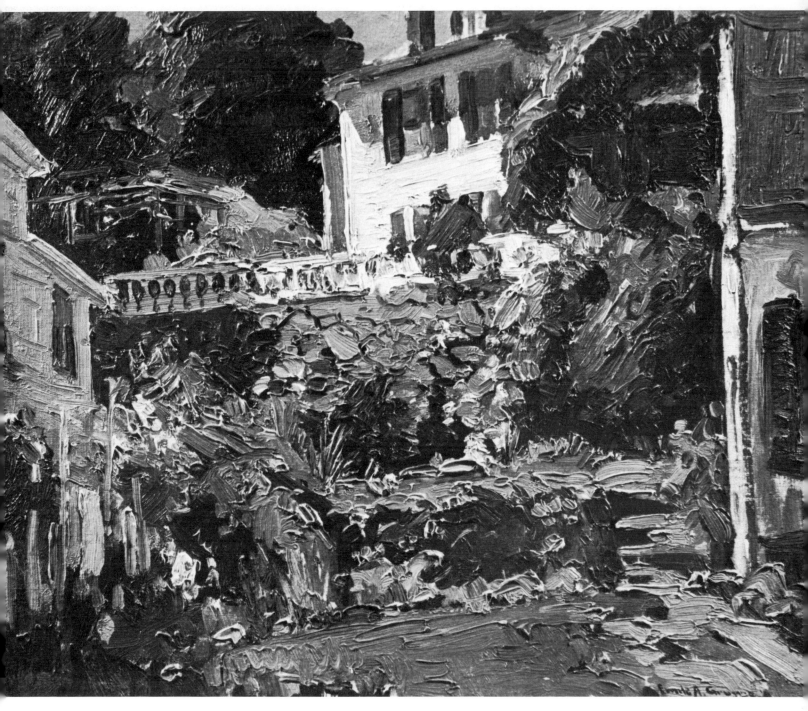

***Figure 33.*** Marblehead, *oil on panel, 16'' × 20'' (41 × 51 cm). In summer, the heavy foliage is very dark in value, even when hit by the sun. Here I use these dark masses to emphasize the whiteness of the principal house.*

that sharp edge, the rest of the room registers as a single big unit.

Students shift their attention as they work, painting first one object and then another—without deciding which object they want as their center of interest. As a result, you see everything in the picture with equal clarity. The painting looks as hard as nails. It might as well be made of cast iron. Glancing at such pictures, you feel the painter tells you more than you want to know. You look once—and don't bother to look again. Great work, on the other hand, is more elusive. Only certain areas are defined; and you discover something new in the picture every time you see it. George Inness, the great American landscape painter, dreamt of such pictures on his deathbed. "Oh the softness of it," he said. "If only I could paint like that!"

### The Viewer's Imagination
Your problem as a painter, then, is that you need to be able to draw. But you can't let your skill become so obvious that your paintings look like schoolroom exercises. You have to get the drawing right—and then forget it a little. The viewer should sense the accuracy of the draughtsmanship beneath the paint. He should feel the details, without your actually painting them.

One of my early experiences may make the point more clearly. I was in a New York artists' club when one of my teachers, the fine illustrator Charles Chapman, dropped a bunch of colored blotters on a nearby piano. He'd swirled color in a tub of water and dunked the blotters, capturing the random patterns on the paper. The abstract colors suggested themes to him; and he added a deer, or a tree with snow on it, or a figure—just a few details amid the maze of color. Once you saw those details, your eye immediately organized the surrounding color into a forest or the inside of a house. I can still remember how enthusiastically those blotters were received by the artists at the club. They showed how little you need to make a point—and how much the artist can trust to the imagination of the viewer.

### The Seasons
Now that we've given some thought to the landscape in general, we can look more closely at the seasons. In the following Color Portfolio, we'll study a number of interesting color relationships. But before we look at the color plates, let's make a few basic statements about the seasons.

### Fall
Fall is always bright and colorful—so colorful, in fact, that it's hard to paint it without being gaudy. It reminds me of a sunset—a subject I never do, simply because the paint can't carry the exaggerated color contrasts. In the fall, anybody can paint foliage using red or yellow out of the tube. But the artist has to get at the truth of the scene by showing the viewer the subtle varieties of red and yellow.

I try to control my fall color by avoiding the bright yellows and working instead with the mellower reds, oranges, and, when possible, greens. Birches, for example, have very yellow fall foliage. If the trees are yellow, that's how I paint them. I don't fake the color. But I also try to add some orange—which contains red and therefore modifies the color and makes it more "liveable." There's always some green left in the fall, too; and I make the most of such cool touches, using them to give the eye relief from the season's predominantly warm coloration. In order to keep the fall color brilliant, however, I avoid touching cool color into the sunlit foliage.

The brilliance of the foliage is enhanced by the thinness and transparency of the dying leaves. In Figure 27, for example, the light of the sky shines through the masses of background foliage. You can see how dark the tree branches look against this light mass. In the summer, these same leaves would appear much darker in value (compare the foliage in Figure 33).

I personally prefer to paint later in the fall, when the leaves are off the trees and you can see the structure of the trunks and limbs. A site like that shown in Figure 28, for example, gives me a chance to study the interesting silhouettes of the trees against the sky. When you paint such trees in the fall, pay particular attention to the way the limbs move across one another. Become accustomed to the way trees grow, and you won't paint branches that jut stiffly out of the trunk—like spokes out of a wheel.

### Winter
In the winter, you can develop interesting patterns by emphasizing the value contrasts between the snow and the land. In both Figures 29 and 30, you can see how a mass of light snow serves as a backdrop for the dark shapes of buildings and trees. I get a maximum impact in the picture by running the whole gamut of values from light to dark.

There's also a great opportunity in winter to study the effects of color. Influences are particularly noticeable because the snow—relatively colorless in itself—picks up all the colors of its surroundings. That's why artists say snow is every color—except white. Coming home late from a day of painting, I was always surprised at how the red evening sky made the long shadows on the snow look a vivid emerald green. "My God," I used to think, "how obvious it is!" It was an exaggerated effect, but it made you more alert to the subtle relationships present during the rest of the day.

### Spring and Summer
In the spring, the painter has a whole new set of problems: the delicate greens of the trees, the softness of new growth, and the color of flowering trees (Figures 31 and 32). As I've already noted, spring greens are very yellow—there's a minimum of modifying red in them, so they look light and fresh. Red creeps into the foliage as the seasons progress, and so there's much more of it in the bottle-green foliage of summer. Red, the complement of green, is what makes summer leaves so profoundly dark (Figure 33). By the time fall arrives, the reds have taken over completely.

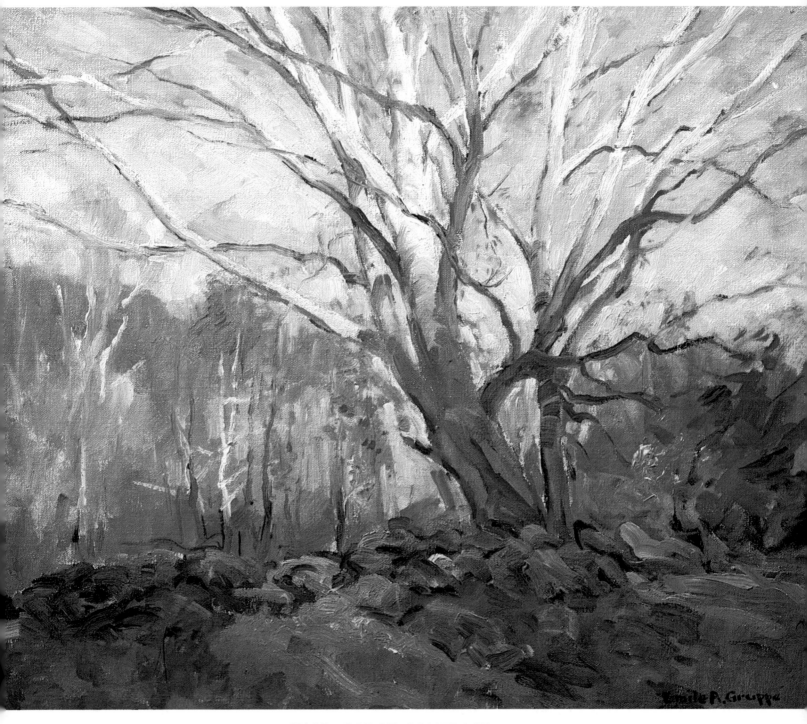

## FALL: COLOR CONTRAST

**Early Morning,** oil on canvas, 20'' × 24'' (51 × 61 cm). In the fall, the trees and the leaf-covered ground are very red. The sky thus looks green, by way of contrast. Notice that in this picture the sky is a hair *darker* than the sunlit beech tree. When you see such subtle value distinctions, you wish you were Houdini—just so you could gauge them properly. I started the tree with a very light cadmium red—to suggest the warmth of the light hitting it. I then made the tree appear gray by running light green over this wet underpainting. I used a lot of red in the shadow area—the red reflects into the tree from the surrounding leaves. I also added ultramarine blue from the sky. The local color of the rock wall is a fairly neutral gray. But because of all the nearby reds, it looks very green.

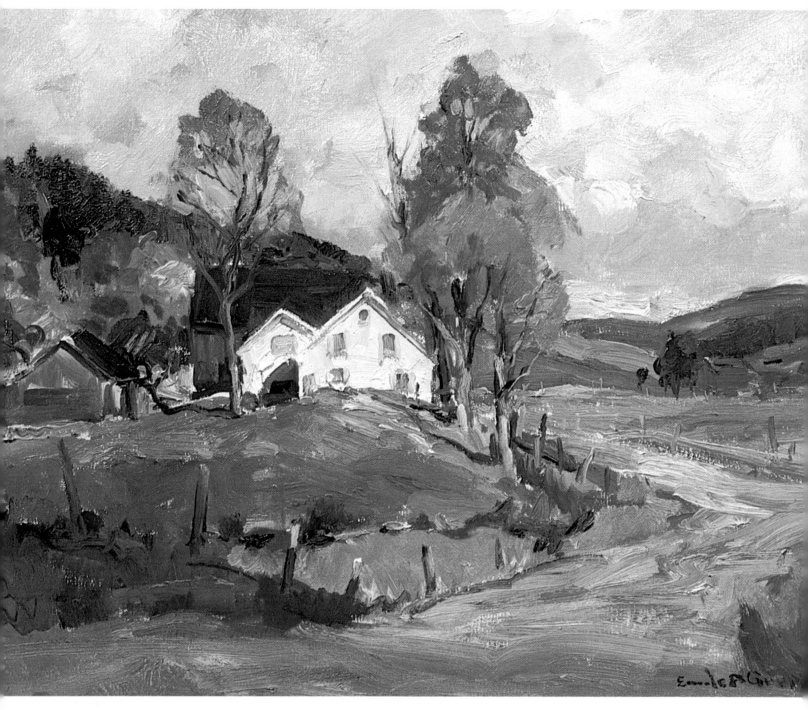

## FALL: CLEAR DAY

**The Farmhouse,** oil on canvas, 16'' × 20'' (41 × 51 cm). My reds and oranges are very strong in this picture. The colors looked that way outdoors; and the strong, warm colors also give, by way of contrast, a very satisfying softness to the green grass. Cover the reds and see how the grass loses much of its quality. The contrast between the two is essential. Remember: you can exaggerate color outdoors—but to be convincing, you have to have the correct value. The evergreens behind the white house are shadowed by a passing cloud. I paint them a cool blue-purple first and then run some dark green over it. I'd have used a *warm* red-purple if the evergreens had been lit by the sun. Notice the varying effect of the sky on the landscape. The puddle in the middle-distance, for example, reflects the green-blue of the sky above it. The foreground shadow, on the other hand, is influenced by the red-blue of the sky directly overhead—a part of the sky not visible in the picture.

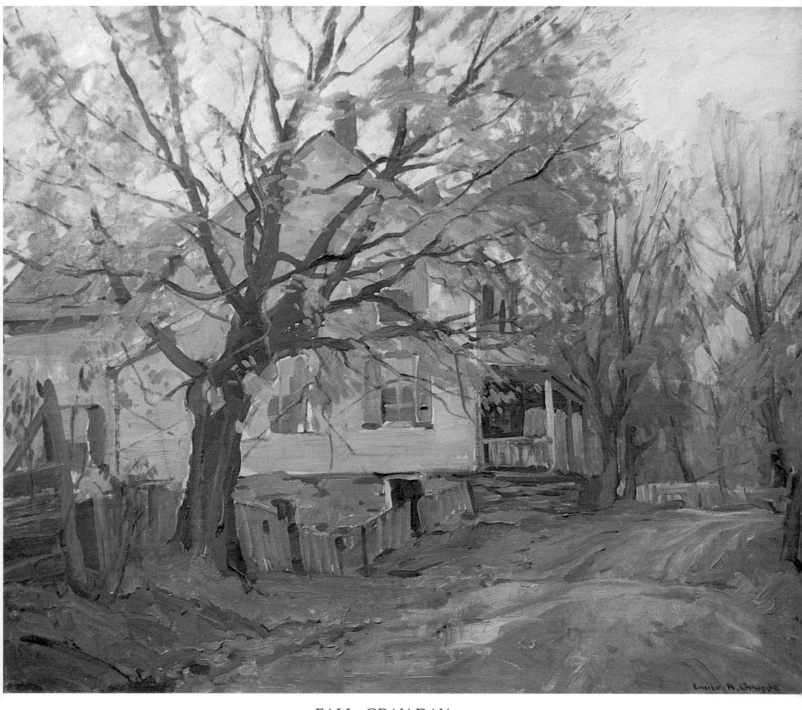

## FALL: GRAY DAY

**After the Rain,** oil on canvas, 25'' × 30'' (64 × 76 cm). Even on a gray day, fall leaves look brilliant. Notice, however, that the colorful leaves have little white in them and are therefore darker in value than the sky. It's important to get both the value and color right, in order to make your picture look like a gray day. Also notice that, in the previous picture, the sunlit white house was lighter than the sky. On a gray day, however, the white house appears darker than the sky. I used a lot of lemon yellow, white, and a hint of green in this sky to give it a luminous look. The house, in turn, catches a lot of warm color from the ground and from the nearby tree. The road in the picture is wet and therefore looks darker than the drier road in the preceding plate.

## FALL: DISTANT FOLIAGE

**Manchester, Vermont,** oil on canvas, 25'' × 30'' (64 × 76 cm). The way to avoid a gaudy fall picture is to work with oranges and reds rather than the more vivid yellows. That's what I've done in this painting of a hill covered with maples. The green field gives the eye relief from the red and lets you see how bright the red color is. The cool foreground shadow also emphasizes the warmth of the distant foliage. The white church—an isolated spot of white—attracts the eye into the picture; another small spot of white to the right of center then pulls you up into the mountains. Cover that spot with your finger, and you'll see how the area suddenly becomes less interesting. In the detail, the nearest trees are very orangy and red; but on the side of the distant mountain, they become just a light, purplish stain. Atmospheric perspective cools the color. Although there's a hint of a warm, orange-green in the near pines, the same trees on the distant mountain become simple masses of almost pure ultramarine blue.

## FALL: NEARBY FOLIAGE

**Art Students,** oil on canvas, 25'' × 30'' (64 × 76 cm). I painted this fall scene late in the afternoon. I was struck by the character of the day, the reflections in the water—and especially, by the falling leaves. The effect was almost unpaintable, but I tried to suggest it by spotting leaves all over the place. In the detail, you can see how I load the paint in order to suggest the texture and color of the trees. The preceding painting is a panorama; I didn't need to define my masses there—I painted them flatly. Here, however, the trees are near to me, and the added impasto creates volume and a sense of closeness. You can better feel the character of the trees and leaves. The green pines in the picture give the eye an essential relief from the dominant warm colors. Notice how the warm afternoon light affects everything it touches, even the rocks. They were first painted a warm red-orange; then they were grayed with cool touches of light green.

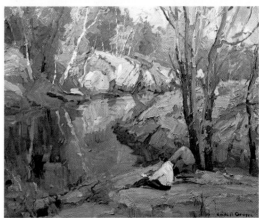

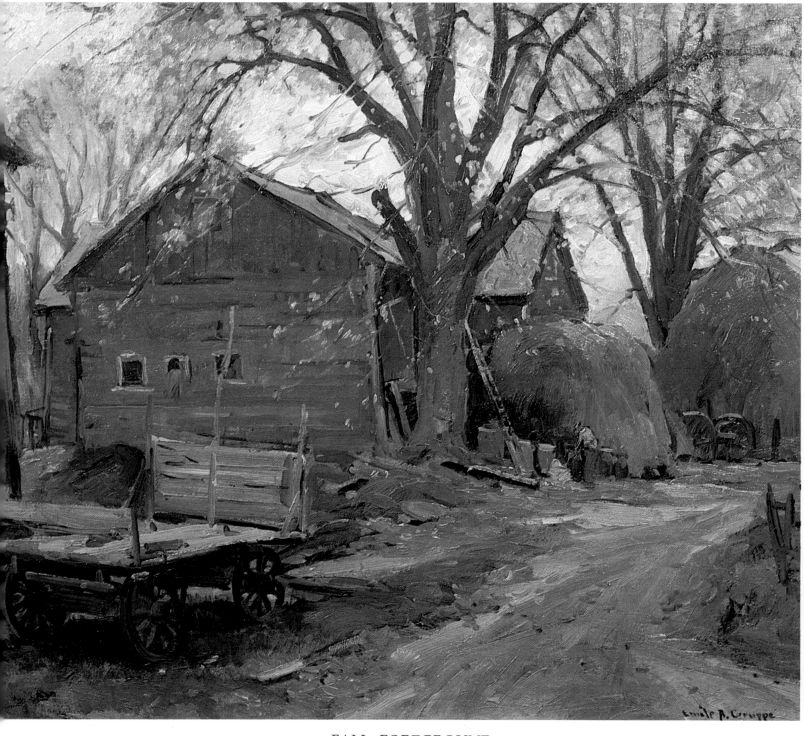

## FALL: FOREGROUND

**Vermont Farm,** oil on canvas, 25″ × 30″ (65 × 76 cm). This is a gray day, painted in a "tonal" manner. It's similar to a forest interior, with the buildings and farm equipment all dark beneath a few large trees. The same color runs through everything. I started the picture with purple, but quickly used other colors to neutralize it and make it take its place in the picture. The underlying purple unifies the design. If you look carefully, you'll see the purple in the barn (with red over it), in the tree trunks (with green over it), and in the nearby barrels (with orange over it). The picture is "intimate" in character; it's like a still life, with the big forms all concentrated in the foreground. The distance—the only spot of blue in the picture—attracts the eye and gives the viewer a needed escape route into the background. I placed the spot of blue toward the center of the design; it thus draws the viewer *into* the picture.

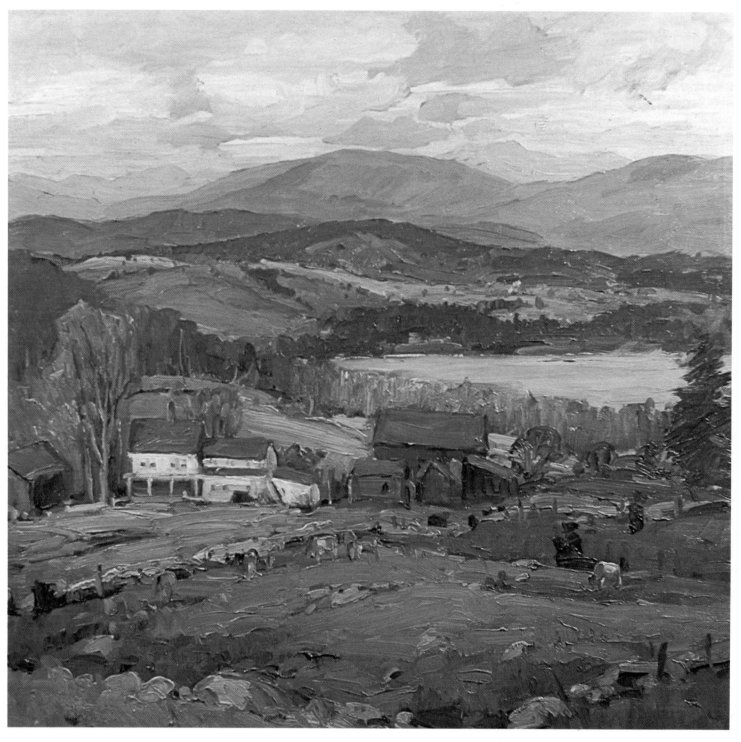

## FALL: PANORAMA

**Cloud Shadows,** oil on canvas, 30″ × 32″ (76 × 81 cm), Collection of Mrs. C. Richard Clark. Unlike the previous picture, this one deals with the whole Vermont landscape. I especially liked the way the clouds cast part of the scene into shadow. Notice how the oranges and reds drop out as the landscape recedes. The distant mountain, for example, is very cool—and the atmosphere so obscures it that it's actually lighter in value than the dark undersides of the clouds! In order to push the cool distance back, I've contrasted it to strokes of warm orange in the foreground. Such rich oranges and reds occur throughout the picture, but the brilliant red roof of the white farmhouse makes them hold their place. That red touch is so bright that, in contrast, the rest of the colors seem closely related. Cover the roof with your finger, and you'll suddenly begin to see the other colors. Uncover it, and the reds and oranges again fall into a subordinate position.

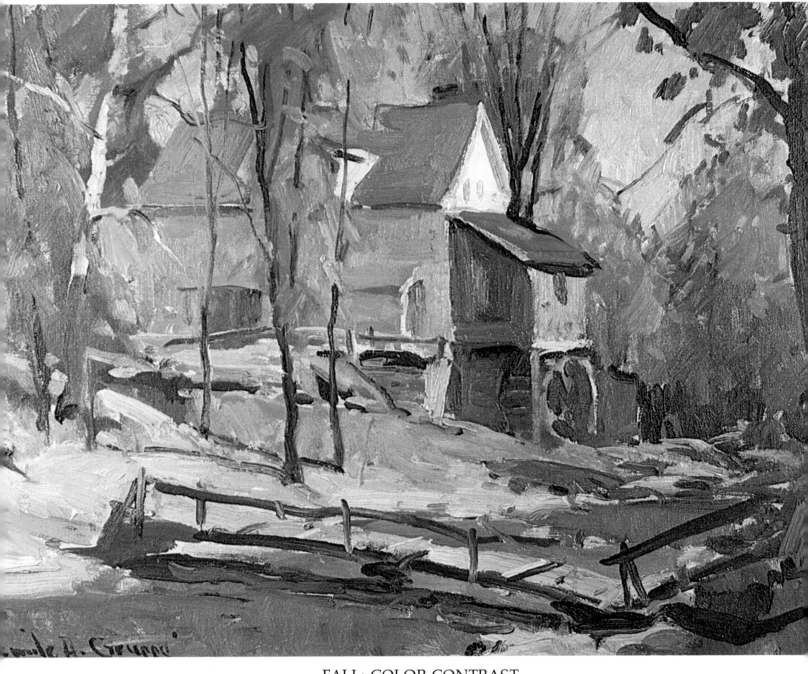

## FALL: COLOR CONTRAST

**The Mill, Woodstock,** oil on panel, 12″ × 16″ (30 × 41 cm), Collection of Mrs. Cathryn Nugent Gibbs. Compare this to the following picture, and you'll see what a difference a change in season can make. The strong fall sun adds warm color to the trees, the dead leaves, and the flat stones along the stream. The shadow side of the white house also catches a lot of warm reflected light from the surroundings. I started this shadow with ultramarine blue (the color of the sky reflecting into it from behind me) and then added the color of the nearby foliage. The warm foliage also reflects into the stream; I run greens over it to lower the value and intensity of the reflection. The stream is fairly light in value, however—especially when compared to the shadow cast on it by the ramshackle bridge. Notice that the sunlit side of the house—white with a touch of lemon yellow—is the lightest element in the picture. It stands out because the lemon yellow has little red in it and therefore contrasts with the dominant reddish coloring of the painting.

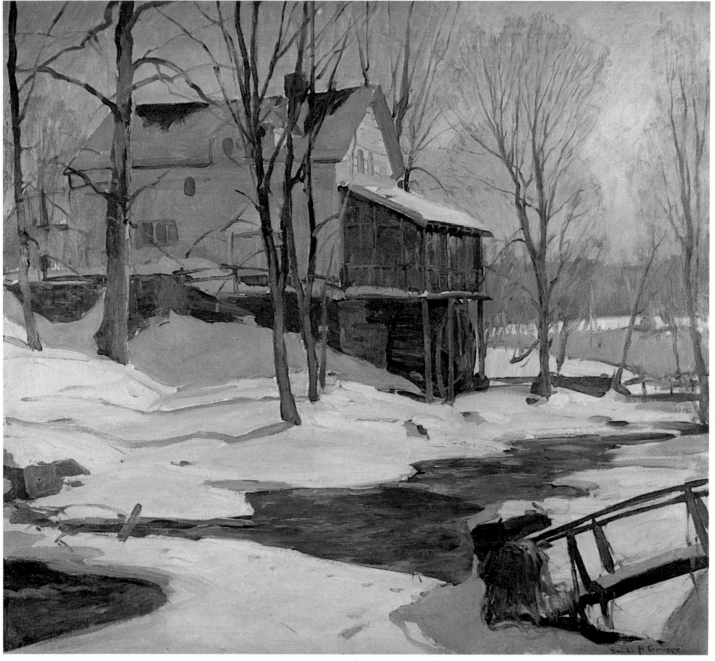

## WINTER: COLOR CONTRAST

**The Old Mill Stream,** oil on canvas, 30″ × 32″ (76 × 81 cm). With the coming of winter, the colors and values of the scene undergo a marked change. In the previous painting, the sky looked light compared to the foliaged trees and leaf-covered ground; it now appears dark, compared to the brilliant white snow. Since the sky contrasts with the cool snow shadows—instead of with the warm fall leaves—it now looks red instead of green. Against this red sky, the shadow side of the house now has a greenish cast. Notice that the shadowed snow on the roof of the mill is a hair darker than the side of the building. The house catches a considerable amount of reflected light from the ground, while the roof snow is angled and catches little light from the sky. Notice also that the snow is not a flat white. Where the snow slants from the sun, it takes on the reddish coloration of the sky. When it faces the sun, it becomes much warmer; you can see the hints of orange in it.

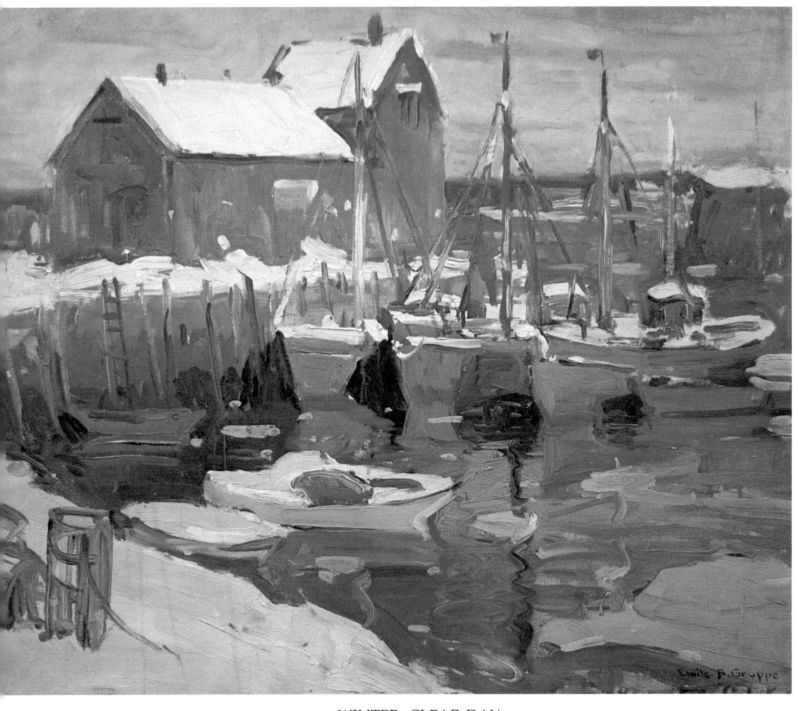

## WINTER: CLEAR DAY

**Motif No. 1,** oil on canvas, 25″ × 30″ (64 × 76 cm). I painted the sunlit areas of snow simply, using lemon yellow and lots of white. Because of the light snow, the ocean looks very dark. Its coolness is also accentuated by the picture's dominant oranges and reds. Notice also how the red building makes the sky look green. I first painted the Motif red—then, to set it back in space, ran some of its complement, green, over it. The boats were similarly started with a variety of reddish-orange tones—just to suggest the warmth of the sun. Various greens and blues were then worked into the warm color. Notice that much of the retaining wall is a simple orange stain. The stain is transparent and looks very brilliant—as would a mass hit by the late afternoon sun. So I left it alone, not bothering to work other colors over it. Notice, too, that the foreground ice is dark and green. On the spot, such pieces of ice always look light, compared to the dark water around them. But they're *dark* in value, when compared to areas of sunlit snow. If you paint them light, you lose the impact of your picture.

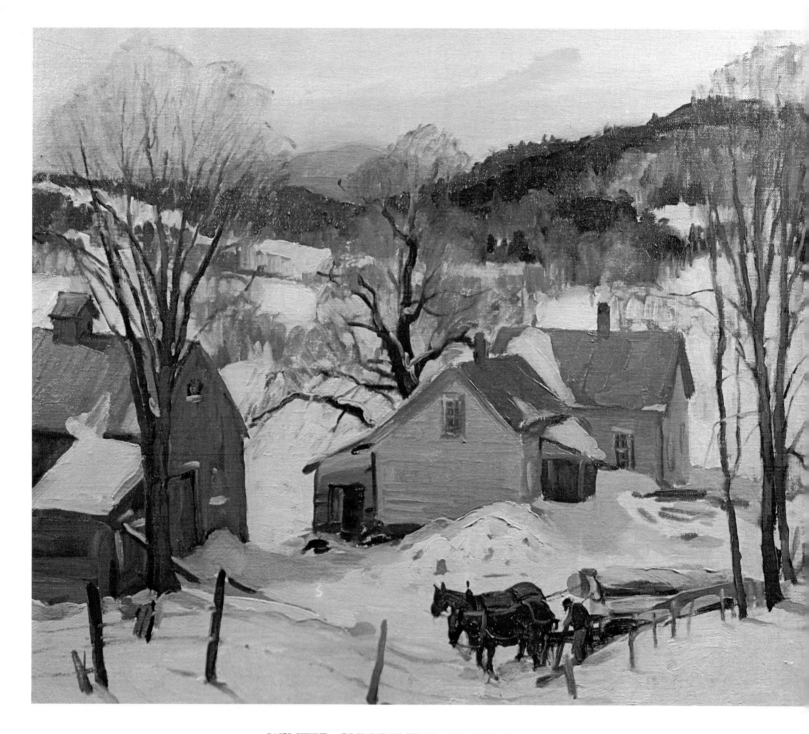

## WINTER: SUN BEHIND CLOUDS

**The Farm,** oil on canvas, 25″ × 30″ (64 × 76 cm), Collection of Mrs. C. Richard Clark. In the previous picture, the brilliant sunlight creates strong color and dark, rather opaque, shadows. Here the sun is behind the clouds. It penetrates the atmosphere, but the clouds diffuse its rays over the earth, much as a lampshade diffuses the light of a bulb throughout a room. As a result, the picture has less contrast than the preceding one. Everything is light, even the shadows on the snow. These shadows would be *much* darker, if the sky were clear and blue. Light also reflects into the shadow side of the house and barn. I painted the house an orange tone first, then worked the near-complement, purple, into the shadows, making each stroke represent a clapboard. I also used purple to mute the red barn.

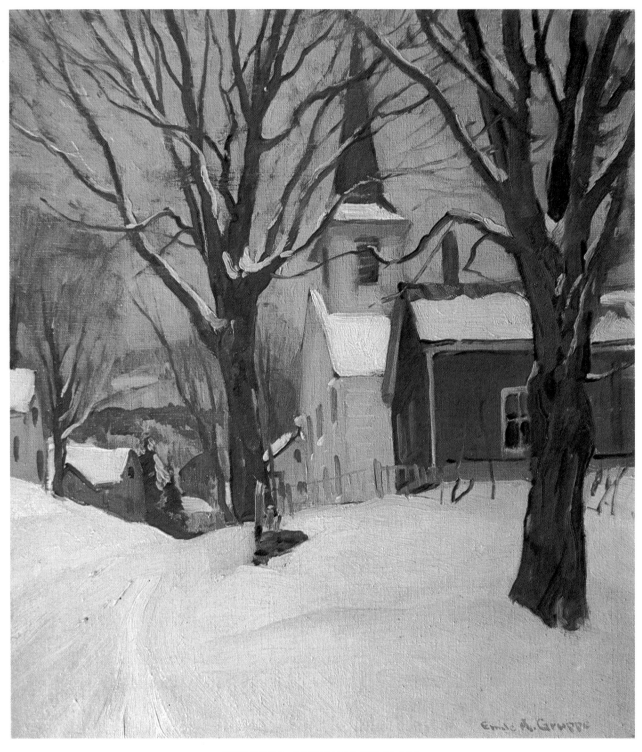

## WINTER: OVERCAST DAY

**After the Snow Storm,** oil on canvas, 20″ × 18″ (51 × 46 cm). The sky in the previous illustration was only slightly overcast; it still had lots of yellow in it. On a more overcast day, when the clouds are heavier, this yellow is blocked out. Some of the warm sun gets through, however, and so the sky has a lot of modifying red in it. Touches of green give the sky a gray look. The light from the sky has little effect on the snow; a few dark spots here and there suggest indentations on its surface. Against the reddish sky, the snow and the church both look green. I paint the snow with hints of phthalo blue, lemon yellow, and—so that it won't be too green—a bit of orange. On such a day, subtle value distinctions are more interesting to study than color. Notice, for example, that the roof of the big red house is sheltered by the nearby tree branches. Since they cut off light from the sky, the snow on the roof is relatively dark in value. The church, on the other hand, is in the open. It catches what little light there is in the sky, and the snow on its roof is therefore a bit lighter in value.

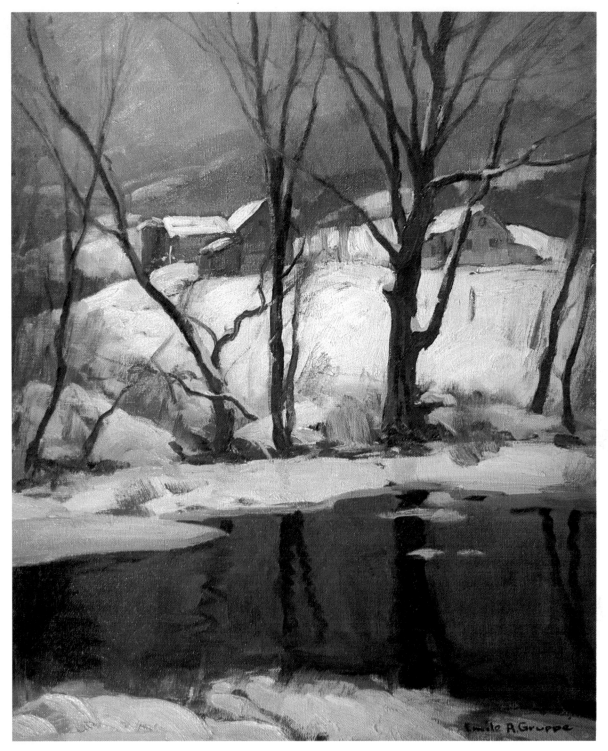

## WINTER: HEAVILY OVERCAST DAY

**Along the Stream,** oil on canvas, 24'' × 20'' (61 × 51 cm). Here you can see the character of a heavily overcast day. In the previous picture, some warmth from the sun had penetrated the heavy clouds. But as the atmosphere thickens, the sun has less chance to get through the cloud cover, and the sky loses much of its warmth. So here I use more green in the red-purple sky, thus more effectively dulling and neutralizing it. Against this greenish sky, the snow now looks a reddish orange. Since the dark sky reflects into it, the foreground stream is very dark in value—and this darkness is increased by its contrast to the light nearby snowbank. Notice, however, that the reflections of the trees are *darker* than the water—and a hair *lighter* in value than the trees themselves!

## WINTER: CLEARING

**Spring Thaw,** oil on canvas, 25'' × 30'' (64 × 76 cm). Although there's light in the sky, the clouds keep it from affecting the snow. I put a spot of lemon yellow and white in the sky where the sun breaks through—then run my reds and purples through it. The snow, in contrast to the red sky, again looks cool and slightly green. I use a touch of phthalo blue in it—but only a hint! You can see how atmospheric perspective takes the red out of the dead grass as it goes from the foreground to the distant mountain. Pay particular attention to the snow patches. When you're at such a site, ask yourself why the patches are where they are. Try to understand how nature works. Here, the snow accumulates in the valleys and behind sheltering groups of pine trees. The snow along the river is still thick, for example, because it's protected by clumps of nearby trees. I've caught these characteristic details, and you sense that the picture wasn't manufactured in the studio.

## WINTER: LATE AFTERNOON

**Snow Patches: 1938,** oil on canvas, 30'' × 36'' (76 × 91 cm). When painting this picture, I was struck by the way the afternoon light gave a rich glow to the field of cedars. Cedars are dense, closely packed trees; you have to paint them as masses, full of warm reds and oranges. There really isn't that much green in them. At the edges of the trees—where foliage and sky meet—you can still see some of my original orangy-red underpainting. Since the trees are so dense, very little light comes through the needles. The shadows are therefore very dark in value. I paint them with ultramarine blue and cadmium red. Notice how the afternoon light warms the snow, the ground, and even the distant mountains. The last were painted in red and then cooled by the addition of purple and blue. In relation to all this warm color, the sky, as you've come to expect, becomes a vivid green.

## SPRING: FIRST FOLIAGE

**The Fair,** oil on canvas, 25″ × 30″ (64 × 76 cm). Spring foliage is very yellow and light. It's a pure green, and I mix it with lemon yellow and phthalo blue. In the distance, a touch of orange mutes the green and sets it back in space. Since we're looking into the light, the sun warms the blue sky, making it green, too. The green grass, green foliage, and green sky make the eye hunger for touches of the complementary color red. The trunks and branches of the foreground trees thus look red against the sky. The chimney, the red tulips, the roofs of the houses, and the figures in red shirts and dresses are also essential to the overall color harmony of the picture. Notice how the brilliant sun eats away at the edges of the distant trees, making them light in value. I emphasize the effect by keeping the foreground trees dark. Notice also how the warm light from the sun bounces off the grass and up under the eaves of the white house, giving the shadows a warm, orangy glow.

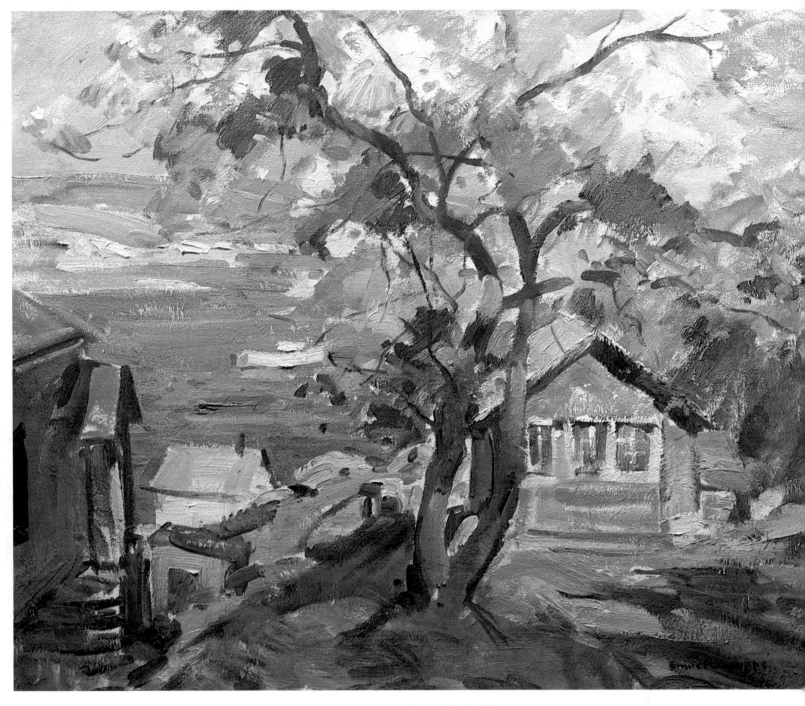

## SPRING: APPLE BLOSSOMS

**On the Way to Annisquam,** oil on canvas, 25'' × 30'' (64 × 76 cm). This picture isn't "complete." For some reason—now forgotten—I had to leave the site early. But I like the picture as it is. When you look at it, you know that I'm primarily interested in the blossoms. Such blossoms are hard to paint. On first glance, they appear white. But if you paint them that way, your picture will look insipid. You have to search for the color in the flowers. Study them, and you'll see how they're warm when hit by the sun and cool when thrown into shadow. Here, I've accentuated the warmth of the blossoms by putting a lot of pink in them. I've played this warm color against the complementary green of the foliage and the sky. Purple touches help harmonize the picture. Finally, the dark branches of the tree contrast with and accentuate the brightness of the foliage.

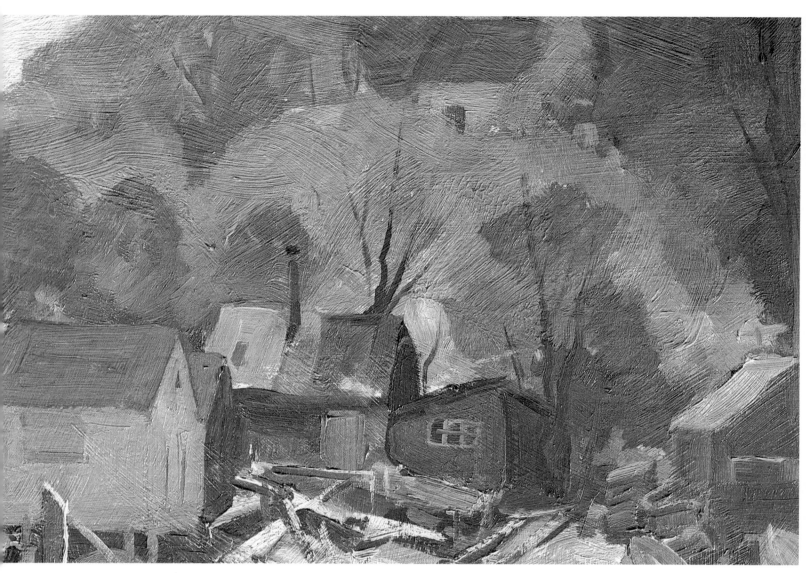

## FOLIAGE: SPRING

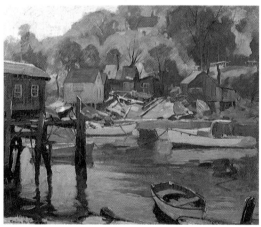

**Rockport Harbor,** oil on canvas, 25'' × 30'' (64 × 76 cm). In this spring scene, the green trees give the buildings a reddish cast. I blocked them in with a red-purple and then ran other colors over it. In the detail, you can see the spring greens are all warm and light against the sunlit sky. I first blocked in the background with a light, red-purple. The purple mutes the later green overpainting. Here and there, orange is used to suggest distant branches, still visible through the sparse foliage. I work light green into these purple and orange masses. Notice that none of the trees is very dark; the sun penetrates the transparent spring foliage and lights it up. Since I'm looking almost directly into the warm sun, the mass of green foliage isn't powerful enough to turn the sky a complementary red. This is one case where both the foliage and the sky are on the greenish side.

## FOLIAGE: SUMMER

**The Wall,** oil on canvas, 25″ × 30″ (64 × 76 cm). This is a picture of one of Florida's big Banyan trees. I liked the stucco wall and tried hard to emphasize the material's unique, warm glow. Notice how I've accentuated its character by contrasting it to the nearby white house. That building says "house paint"—you can see how its flat surface catches a lot of the blue color from the sky. In the detail you can see that I use a lot of orange and red to control (and neutralize) the rich summer greens. The branches of the tree look red against all this green. I'm really using the same colors as in the previous illustration—but I've added less white and have given the emerging reds a more important part. I place the mass of foliage first and then paint the sky into it. That way, I can put my skyholes wherever I feel the design needs them. If the wet underpainting dirties the sky color, that's okay. Skyholes are always darker than the surrounding sky anyway. As Carlson used to say, you can never make a skyhole too dark.

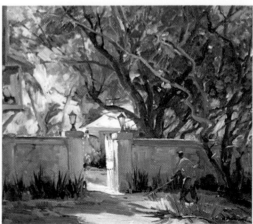

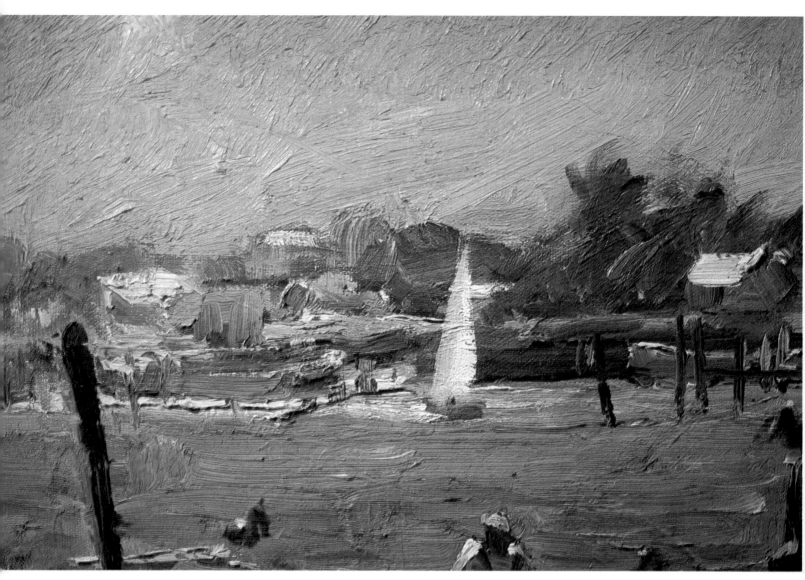

## SUMMER: DISTANCE

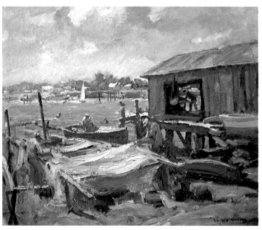

**Pompano Fishermen,** oil on canvas, 25″ × 30″ (64 × 76 cm). In this and the following picture, you'll see how the effects of atmospheric perspective vary in two different parts of the country. In Florida the air is clear; the sun, bright and strong. In order to get a feeling of this light on the foreground nets, I painted them a warm orange first—then added touches of white and lemon yellow to show where the wet nets catch a glare from the sun. Since you can see forever in Florida, the distance is sharp and dark. You can see this in the detail, for example, where the background greens are strong, although not as warm and rich as the greens around the feet of the foreground workers. Of particular interest in the detail is the presence of both yellow and bright white. Because of the clarity of the air, yellow holds up over much greater distances in Florida than in some other parts of the country. Similarly, distant whites remain light and crisp.

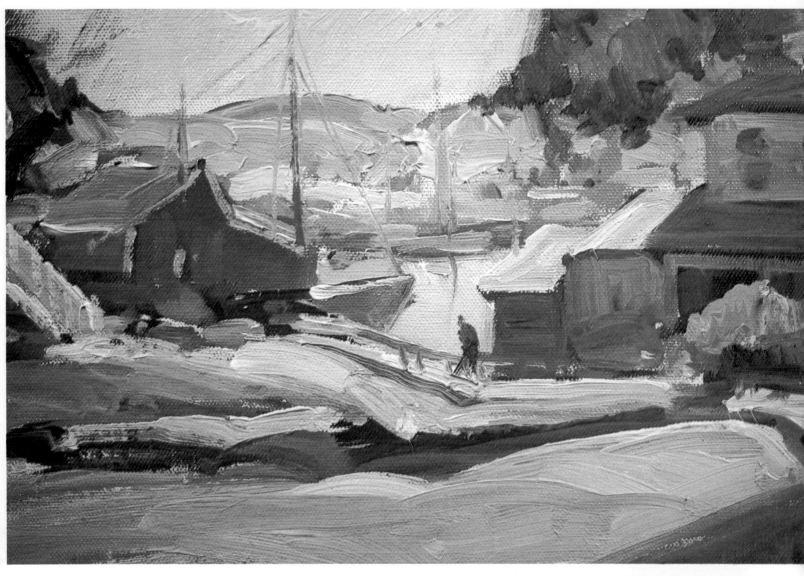

## SUMMER: DISTANCE

**Near My Studio,** oil on canvas, 20″ × 24″ (51 × 61 cm). Like Florida, Gloucester, Massachusetts—the site of this picture—is surrounded by water. But here, there's lots of moisture in the air, and the resulting haze mutes distant colors. In the foreground, you can see how strong the sun is; the warm road catches a glare, just as the wet nets did in the preceding painting of Florida. In the detail, however, you can see that the heavy, moist atmosphere obscures the distance, obliterating all sharp edges and strong color. Notice how pale the whites and greens look when compared to those in the previous illustration. Notice, also, how the blue of the atmosphere affects all the distant colors. I've accentuated the cooling and graying effect of the veils of air by placing a strong, warm reddish building in the foreground. This color contrast helps throw the distance back even farther.

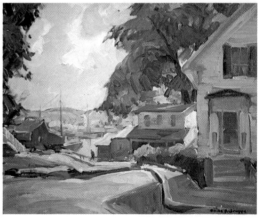

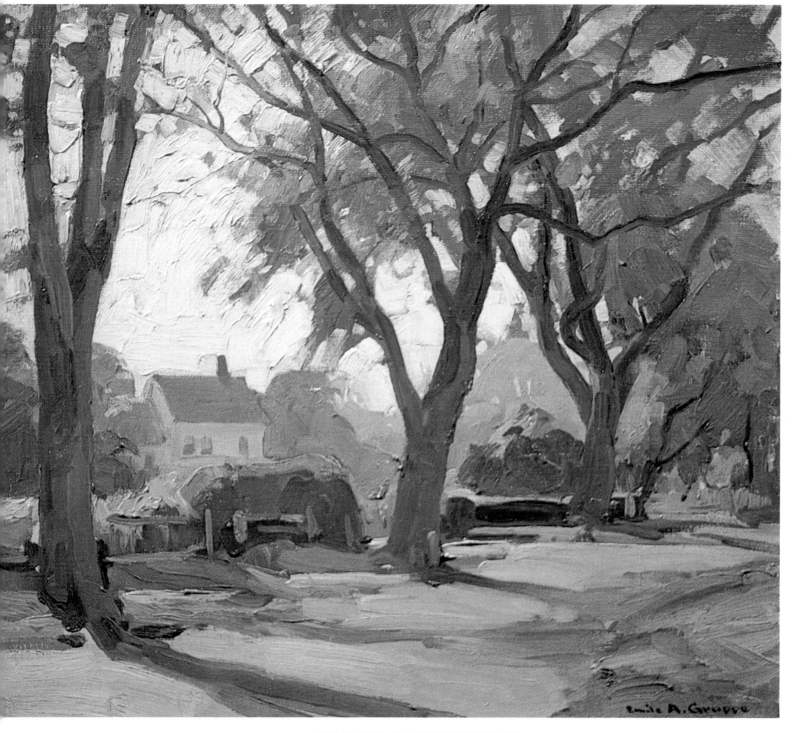

## SUMMER: BACK LIGHTING

**Road to Rockport,** oil on canvas, 18″ × 20″ (46 × 51 cm). Here the sun shines through the heavy green foliage, warming it up and adding lots of red, orange, and yellow to the foreground mass. The branches look dark against these sunlit leaves, but the trunks catch reflected light from the dirt road and are thus warmer and lighter in value. Where the sun hits the low bushes, they become very yellow. The shadow sides of these bushes, however, are painted with a cool purple—and then green is painted into it. Notice the changes in the greens as they recede. On the far right, the cool atmosphere begins to knock the oranges and yellows out of the foliage. Near the house on the left, the blues and purples become even more noticeable. And in the distance, the trees are lighter in value and bluer still. The yellow drops out of the green, leaving only the blue and the red modifier.

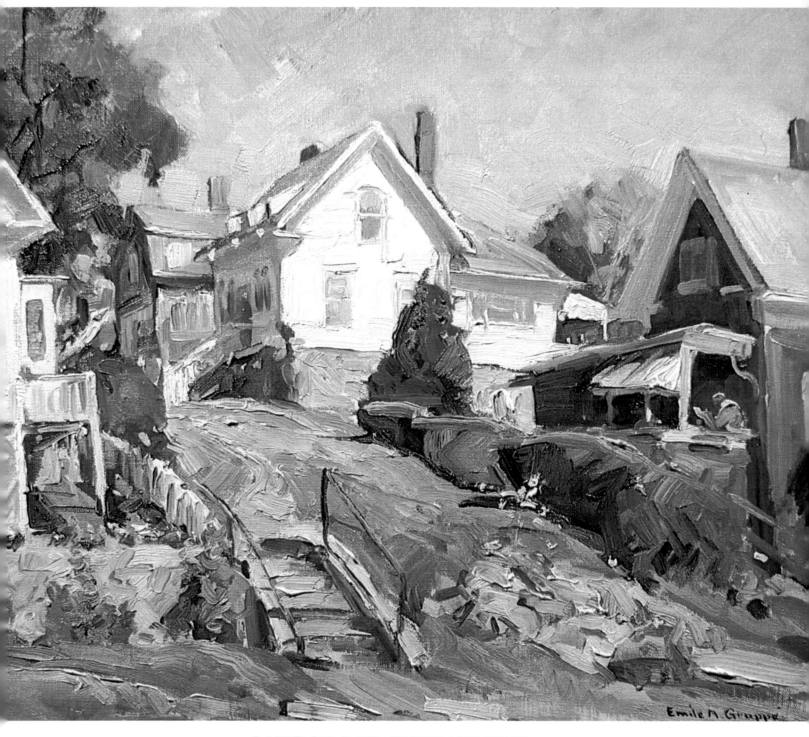

## LATER SUMMER: FRONT LIGHTING

**Buildings,** oil on canvas, 25'' × 30'' (64 × 76 cm). When I painted this picture, I wanted you to feel that you're looking up a hill. Notice how the white house towers over everything. The sharp perspective also lets you look up under the eaves. In contrast to the previous picture, everything here is in light; there are only a few dark shadows. It's late in the summer, and the fall warmth is beginning to creep into all the greens. This change is accentuated by the warm color of the sun itself. You can see how much red and orange there is in the grass and the trees—especially the evergreen near the house. Pay particular attention to this white house. The windows facing us catch the sun and are *light* in value. Students often paint such windows dark, thinking that the contrast will make the white seem brighter. Instead, the dark windows disrupt the sunlit surface and spoil the impression of a mass in sunlight. Here, the windows are dark only in the shadows. As Hawthorne said, "Things in shadow should pertain to the shadow, and things in light should pertain to the light."

111

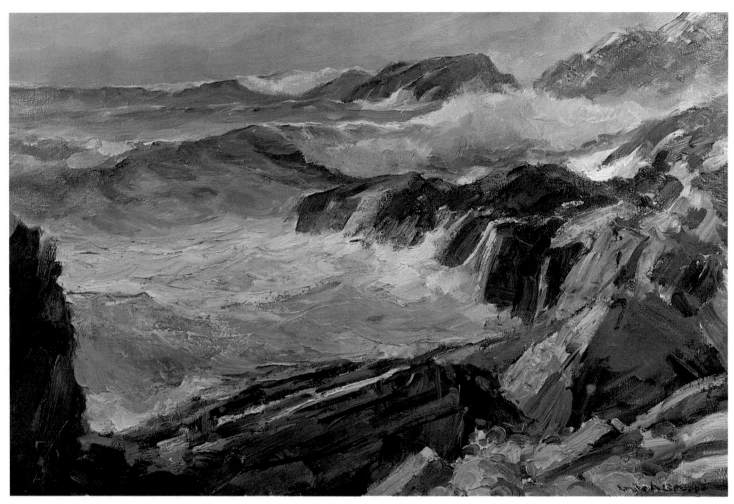

**Bass Rocks,** oil on canvas, 30'' × 36'' (76 × 91 cm), Collection of Lorraine Caldwell. I painted this picture on a stormy day, with only a little light breaking through the clouds. The dominant darks give the picture a very solid look. Against these darks, my lights really sing. Illustrators frequently use a similar technique to make their highlights pop; they accent the foam by making the sky very dark and gray. It's a good trick. But if you try it, don't overdo it—or your picture will look as if it were painted inside a cave!

# Marine Painting

A marine painting is all design. You have only a few elements to play with—rocks, sky, and water—and they have to be right if the picture's going to work. The more decorative the arrangement of these elements, the more striking the pattern then the better the painting. If the conditions are good—the tide's at the right level, the sun's in the right place, and the ocean's moving beautifully—you can get a masterpiece. But you can go back to the same spot tomorrow—and end up with a picture that's pure punk!

## Rocks or Water?

The student is often confused by the abundance of material at the seashore. To make some sense of the subject, first ask yourself: rocks or water? Which strikes you the most, and which do you want to feature? As with the landscape, you can't do things by halves. A picture half water and half rocks doesn't have a subject; the viewer can't understand it. In Figures 34 and 35, on the other hand, you can see how I've taken the same basic composition—but emphasized different aspects of the site. Figure 34 is a water picture; Figure 35 is painted for the sake of the rocks.

Learn to focus on what *attracts* you. If you're not sure what you like, take an 8'' × 12'' or 9'' x 12''(20 × 25 cm or 23 × 30 cm) canvas and divide it into quarters. Do a small sketch in each quarter, using a few strokes to make notes of the color relationships of sky, water, and rocks. Shift things around in each sketch. Emphasize the sky in one picture, the rocks in another, and the ocean in a third. Sometimes, don't have any sky at all—just run water out the top of the canvas. The small scale concentrates your subject and you can better see the design. It's also easy to make changes. Looking at the sketches, you'll find that your eye is naturally attracted to a particular composition. It may not be the one I'd like, or that your other instructors might pick—but it's the one *you* like. Use that simple color note as the basis for a larger picture.

## Water

When I paint surf, I'm not especially interested in every trough and whitecap. Some marine painters put in every drop of foam. But I'm more inclined to take liberties. I'm not afraid to move things around, because I know the ocean is constantly changing. If you took a thousand photos of it, each one would be slightly different. So you have a lot of leeway.

Besides, you don't see details when you look at the ocean. The moving water gives you the impression of a few big light and dark masses. You don't see individual waves; you feel the mist and see soft, elusive edges. Montague Dawson, the fine marine artist, would start to paint both the sea and the clipper ships in his pictures with great care; then he'd pull the ocean together with just big sweeps of a brush or palette knife. As a result, you *saw* the boat—and *felt* the water.

## Rhythm

Think of rhythm when you paint water. I try to get a sense of the broad swells of the ocean, frequently running my brush across the entire canvas in order to suggest the long, heaving line of a wave. This broad movement is typical of the sea, and it explains why so many marine painters prefer to use horizontal canvases. The shape matches the breadth of the subject. Frederick Waugh, the great American marine painter, worked in a square format, but he used a wide band of sky to cut the canvas into a horizontal shape.

Once you get the big movement, try to make the nearby water *do* something. I always think of Homer's *Fog Warning*: in the immediate foreground are a series of simple, angular lines, leading sharply and rhythmically into one another. The choppy strokes give you the feeling of the ocean.

In Figure 34, you can see how I handle different parts of the sea. Once I've established the large, convex masses of water, I use a series of concave strokes to suggest the broken, rhythmic surface of the ocean. The foreground wave is so close to us that its contour is obscured by the mist and spray in the air around it. Thus, the wave is soft and elusive—you don't see any details. Now, the background wave has mist around it, too; but it's so far away from us that the effect of the spray isn't visible. It therefore appears relatively sharp. By putting a hard edge here and there, I draw the eye toward this background wave, thus helping to make it the center of interest. If the foreground wave were equally sharp, you wouldn't know which one to look at.

## The Big Wave

Some people think that you should only paint the sea in the middle of a storm. But that's too gray for me—there's no color. I'd rather work after the storm, on a sunny day, full of colorful rocks and waves that are slowly rolling toward shore. That way, I can show a couple of breakers in the picture, and better give you a sense of the continuity of the ocean (Figure 36).

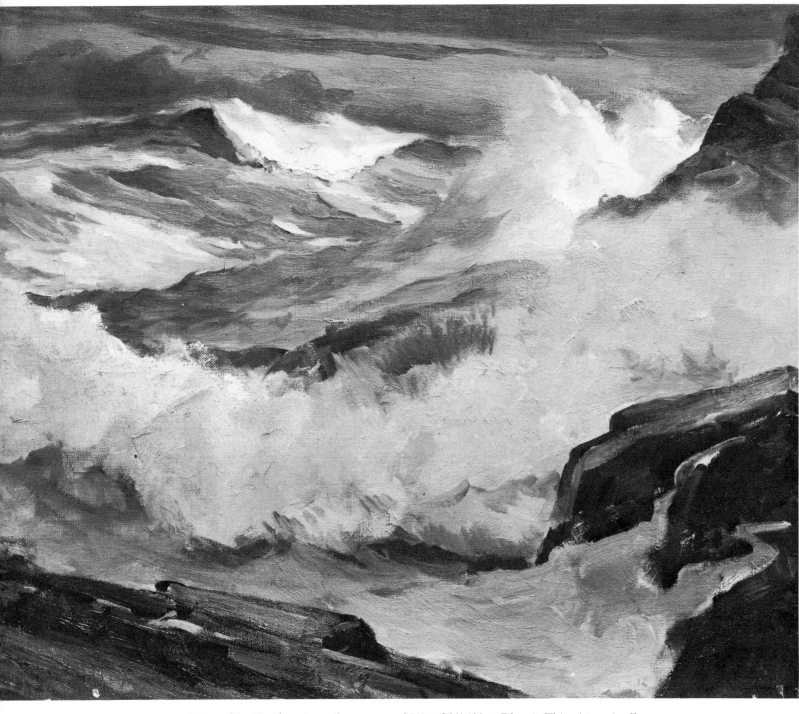

***Figure 34.*** Northeaster, *oil on canvas, 25'' × 30'' (64 × 76 cm). This picture is all water. The rocks are the secondary interest; the sky is third. The distance wave is far back and takes up little space—yet you know by the surroundings that it's a big breaker.*

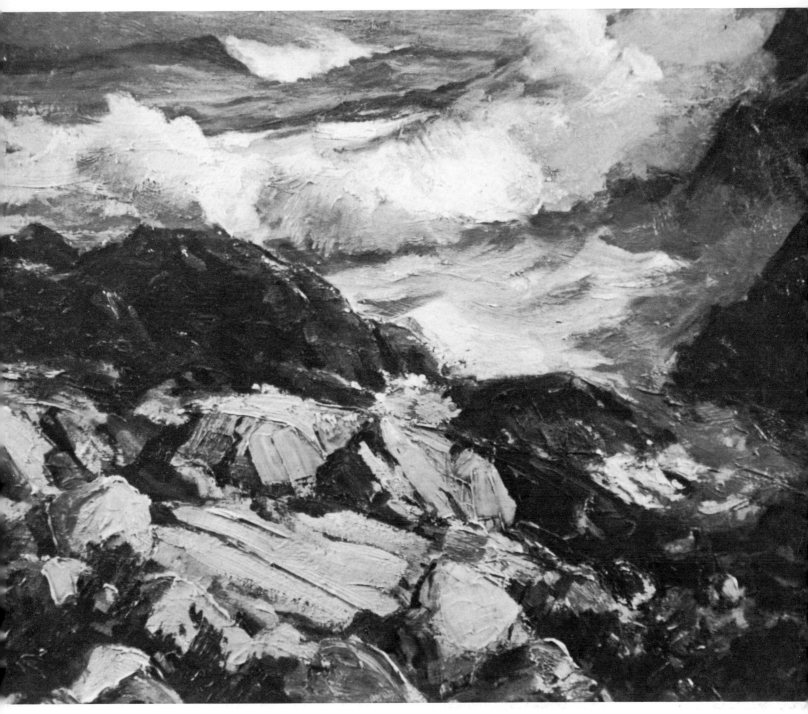

***Figure 35.*** *Bass Rocks, oil on canvas, 30″ × 36″ (76 × 91 cm). Although this picture is similar in composition to Figure 34, I've pushed the waves back and made the foreground the most interesting part. It's rocks with water, and you're most attracted to the green seaweed and the various-colored boulders.*

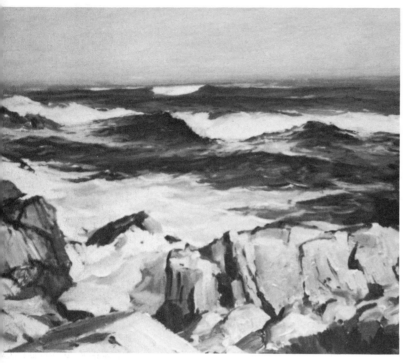

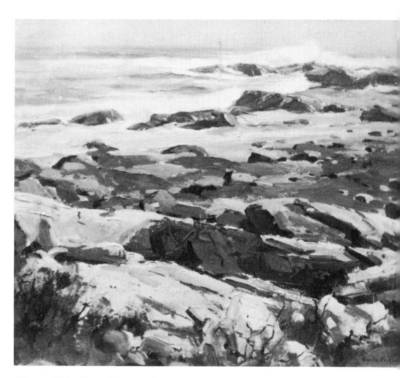

**Figure 36.** After the Storm, *oil on canvas, 25'' × 30'' (64 × 76 cm). By showing the foreground white water, the curling wave off shore, and the smaller wave making up in the distance, I give the viewer a sense of the breadth and continuity of the ocean.*

**Figure 37.** Gray Day, *oil on canvas, 25'' × 30'' (64 × 76 cm). The large nearby rocks give the viewer a strong sense of foreground. Comparing the background waves to the rocks, you're better able to judge the scale of the various elements in the picture.*

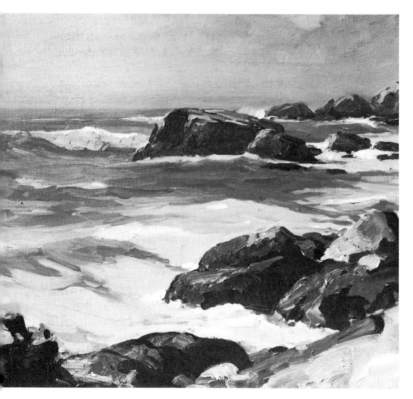

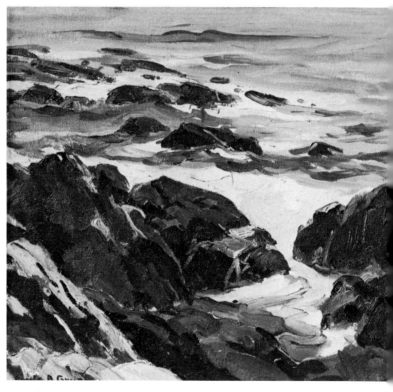

**Figure 38.** Table Rock, *oil on canvas, 20'' × 24'' (51 × cm). This is a picture of a clear, moderately active day. The waves are approaching shore but haven't hit. The low sun catches the sides of the rocks and creates a strong shadow pattern—notice, however, that there are only a few highlights on the water; the rest is in semi-shadow.*

**Figure 39.** Seaweed at Low Tide, *oil on canvas, 18'' × 20'' (46 × 51 cm). On a fairly quiet day, waves leave white water eddying among the rocks. I decided to emphasize these rocks and, especially, the moss and seaweed that grow on them. I therefore eliminated the sky completely.*

Besides, painting a wave close up is like painting a waterfall—an almost impossible assignment, because there's no way you can convincingly show all the air bubbles and rivulets of water. And even if you could, the wave would hover in midair, making the viewer wonder when it was going to fall.

In addition, the viewer wouldn't know how big the wave is. You need something to compare it to. If, for example, you have a few big boulders in the foreground, some smaller ones in the background, and a wave next to the most distant rocks, the eye immediately senses how big that wave is (Figure 37). Similarly, it's easier to see a wave when it's in the distance. In Figures 36 and 37, the background waves are just a few strokes. Since they're so far away, you know they can move a couple of hundred feet without changing shape. As a result, they don't seem as static as a carefully painted foreground wave, caught in a position that lasts only a second or two.

## Anticipation

When I was at the Art Students League, the illustration teacher told us never to show a murder occurring at the minute the gun is fired. Have your figure either pull the gun from his holster—or hold the smoking pistol. It's the same with a marine painting. I like to show how things look before the wave hits (Figure 38) or after it has run through (Figure 39). That way, I can avoid painting the usual puffball of foam splashing into the air.

## Rocks

Personally, I like a marine that features more rocks than water. Like most painters, I've done so many crashing waves that I'm tired of them. Besides, I live in an area—Cape Ann—where the red and orange rocks give me a chance to play up color contrasts between the cool ocean and the warm land. In Maine, for example, the rocks are all black and volcanic. There isn't much you can do with them.

Since I like rocks, I prefer to paint at low tide when the most rocks are visible. I also like to work early in the morning or late in the afternoon. The low-lying sun emphasizes the rocks' structure and creates strong angles and shadows that you can exaggerate to make a strong design. The sun also gives extra color to the exposed moss and seaweed.

Of course, it's easy to get too involved in crevices, cracks, and seaweed. You have to learn to squint at the scene, so that the rocks become simple shapes: a light mass, a dark mass, a darker mass. Once you've got the big areas, you can add a few details. But first you have to see the simple pattern. In Figure 40, for example, the rocks are mainly in shadow. Squint at the picture and you'll see how they form a simple, interconnected, light-and-dark pattern. The crevices then form "leading lines," directing you up and into the picture.

## Edges

Years ago, I did marines with a palette knife; the knife gave the nice, edgy feeling to the rocks and kept them from looking too rounded—like a bunch of potatoes.

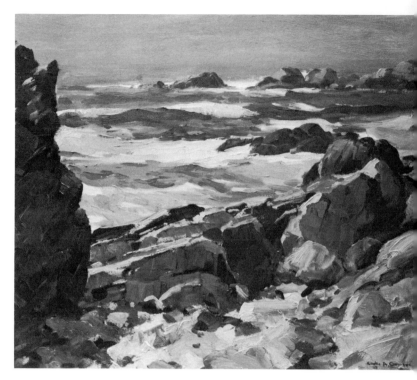

**Figure 40.** Morning Light, *oil on canvas, 30'' × 36'' (76 × 91 cm). Rocks dominate this design. The ocean is of secondary interest; and the sky is a simple, dark note—graded, of course, toward the source of light on the left. A few carefully placed crevices make you feel the structure of the rocks.*

Looking at your rocks, the viewer should sense their crispness and hardness. He should feel that if he fell on them, he'd skin his leg.

To get the character of rocks, I paint them with zig-zag lines, making their edges broken and uneven (Figure 40). The sharp edges contrast with the softer and more elusively painted waves. Nowadays, I get this crispness with brusque strokes of the brush. But whenever I have a bad morning and the rocks don't look right, I may use the knife to pull areas together and to create a few harsh edges.

## Scale

When you paint rocks, remember to compare the sizes of those in the foreground and the distance. We've already seen how important such comparisons are in the landscape. In Figure 40, for example, the foreground rocks are immense. The ones in the background are much smaller. In fact, some of the small rocks in the immediate foreground are actually bigger than the large boulders near the horizon. Comparing the two, you immediately feel the distance between them. Winslow Homer often pulls one huge rock completely across the front of his canvas, thus forcefully establishing his foreground. And I had a friend, Morton Roberts, who went one better than Homer, painting a huge barnacled rock—with just a bit of water visible in the background. It was terrific—and I'd give my eye teeth to have it today!

## The Environment

I like rocks because I enjoy seeing what happens *before* you get to the ocean. I'm reminded of Winslow

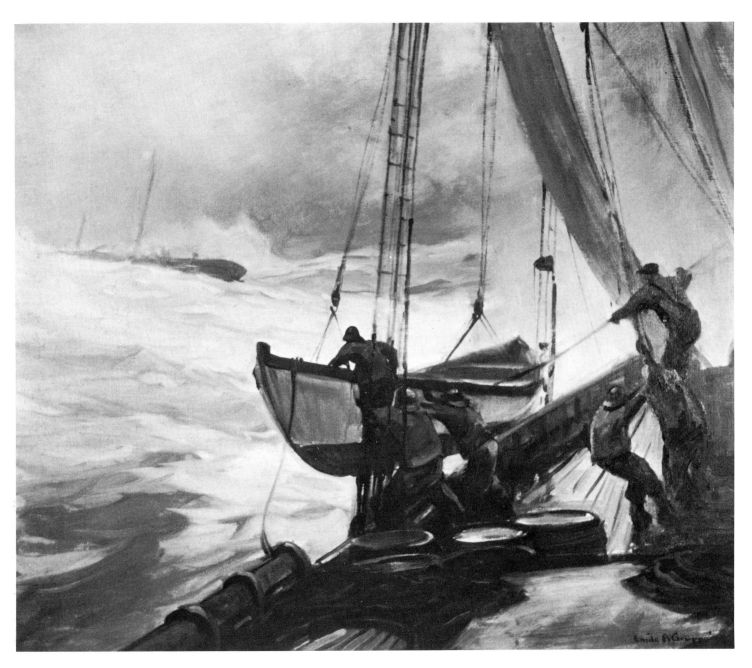

**Figure 41.** The Rescue, *oil on canvas, 30" × 36" (76 × 91 cm), Collection of Mr. and Mrs. George Ankeles. In a picture of this sort, the ocean is simply a setting for the story. It and the sky form a light mass, against which I silhouette the distant ship and the dark, interconnected shapes of the foreground men and boats.*

Homer's painting, *The Wreck.* In it, you hardly see the ocean; but the foreground is full of men, carts, and horses—all kinds of interesting and exciting material. I like that kind of picture and sometimes try my hand at it myself (Figure 41).

It took an old friend of mine, Lester Stevens, to show me what could be done with the local scene. He hardly had any water in his marines, preferring. instead to emphasize the masses of rocks with their reflected light and interesting crevices. Seeing something done that well, I naturally felt like trying it myself. In Figure 42, for example, I've included not only the foreground rocks, but grass and a small rose bush, too. I play up the differences in the color and value of the land, the light foreground rocks, the dark sap rocks near the ocean, and the interesting seaweed-covered rocks in the distance.

## The Power of Suggestion
Remember, you don't have to show every detail in order to make a convincing picture of the sea. I knew a

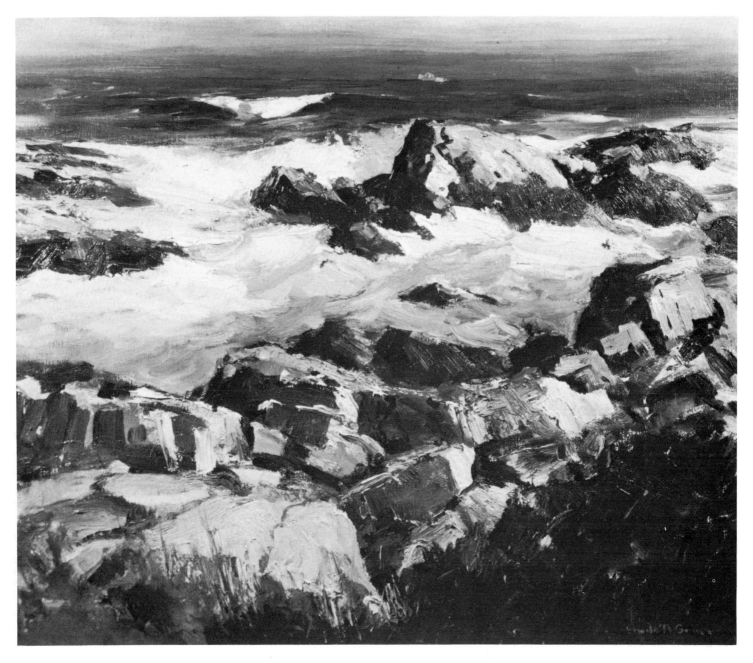

*Figure 42.* Light and Shadow, *oil on canvas, 30'' × 36'' (76 × 91 cm). When you show a lot of foreground in a marine, you give the viewer interesting things to look at and also add to the space of the picture. The viewer feels he has to travel a ways before getting to the ocean. Squint at the picture, and you'll see how it becomes a simple, decorative pattern of light and dark shapes.*

great sea painter in the old days. He was a master technician, but he always gave you too much of *the thing itself.* He put in every line, every ripple, every highlight—you might as well have taken a photo of the subject. But look at the work of Childe Hassam. I can remember a picture he did of a woman standing on a beach. The ocean was just a small part of the scene, but Hassam painted it as a simple mass, so true in color and value that you felt the sea—without all the unnecessary details. Hassam's simple color note said, "This is the ocean." And that, to me, is the greater art.

## Color Portfolio

The color portfolio that follows begins with a step-by-step demonstration showing how I paint a marine subject. However, the subject matter is incidental; I use the same approach when painting all outdoor subjects. (You'll find more tips for painting outdoors in the next chapter.) Then a series of marine paintings follows, each illustrating another problem in painting the sea.

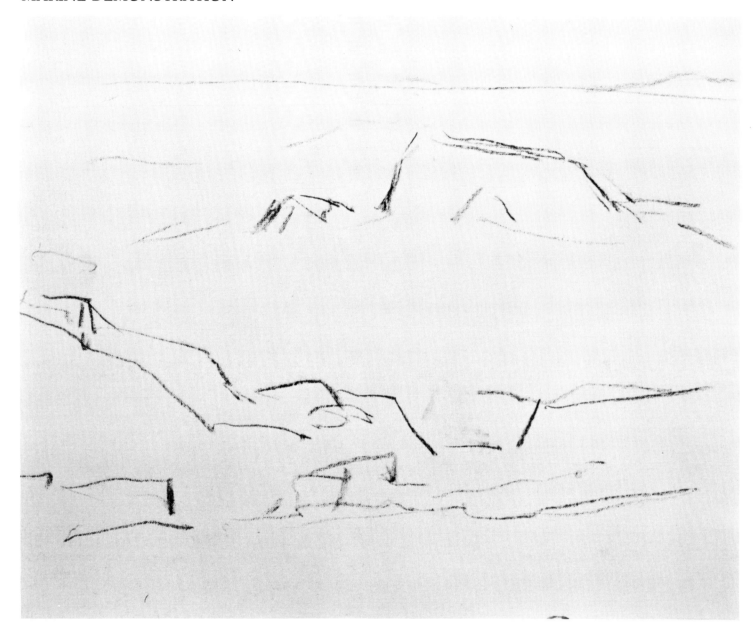

**Step 1.** My first charcoal lines on the gessoed panel help me determine the basic shapes and areas of the composition. I use plenty of foreground in the picture, so that the viewer knows where he stands and can feel that he's outdoors looking at the scene. The interplay and counterpoint of angles makes the design of the rocks interesting to look at. Notice, for example, that the foreground rocks slant downward from right to left—and then move sharply upward. The distant rock echoes this movement, but in reverse. Where the foreground rocks slant downward, the background ones slant upward, and *vice versa*. Since I'm not interested in the sky, I keep its area to a minimum.

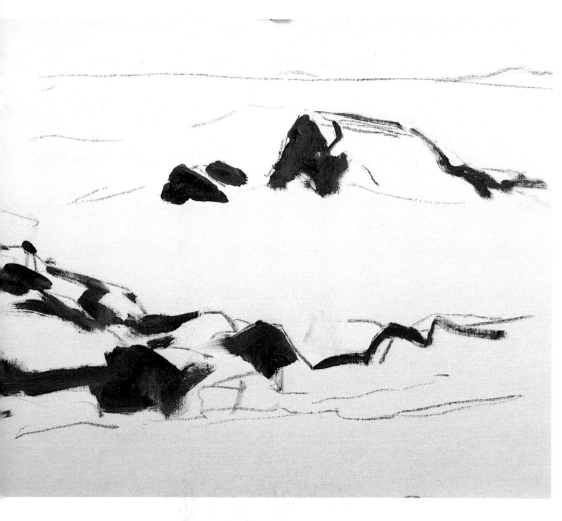

**Step 2.** The light is coming from the right. I first establish my dark shadow pattern, using a purple made with cadmium red, ultramarine blue, and a hint of white (which lightens its value so I can see the color). Since the planes and crevices in the rock receive varying amounts of reflected light, I suggest these variations by "accidental" changes in the darkness of my purple wash. Such changes occur naturally as I move the brush. I'll develop these planes and crevices later. Now, I think only of the big masses. I start to vary the color only after I'm sure where I'm going.

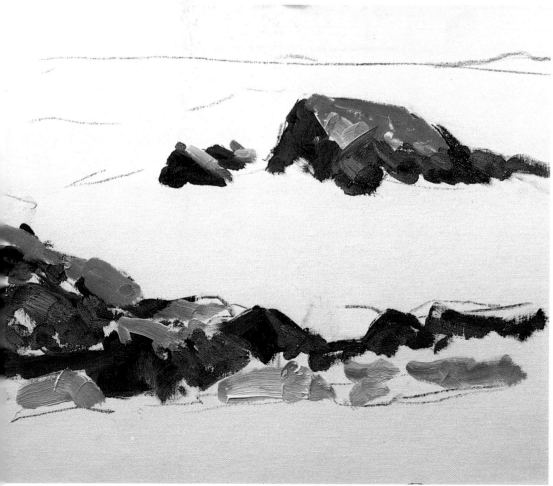

**Step 3.** Having established my darks in Step 2, I now quickly block in the sunlit areas of rock. The low-lying sun warms all the vertical planes. I use cadmium red in the background rocks and add more yellow and white to the color as it comes forward. The nearest rocks are high on the shore and less stained by the tide. Cadmium yellow and phthalo blue make up the green seaweed color. Since wet seaweed is dark in value, the natural darkness of the phthalo blue helps to create a rich, deep green.

**Step 4.** I now add more greens and blues to balance the color in the painting and to keep me from making my colors too purple. I use the same green in the water that I used on the dark foreground seaweed. Where the zenith of the sky reflects down on the water, I add touches of dark ultramarine blue in angular strokes that suggest the movement of the water. The orange of the distant rock reflects into the troughs of the ocean. Near these rocks, a very light phthalo blue shows where the water is churned and full of air bubbles. The white water is heavily painted, with touches of phthalo blue in the shadows. The breaking waves don't receive a direct blast of light, so I paint them with a white from the tube—without any yellow.

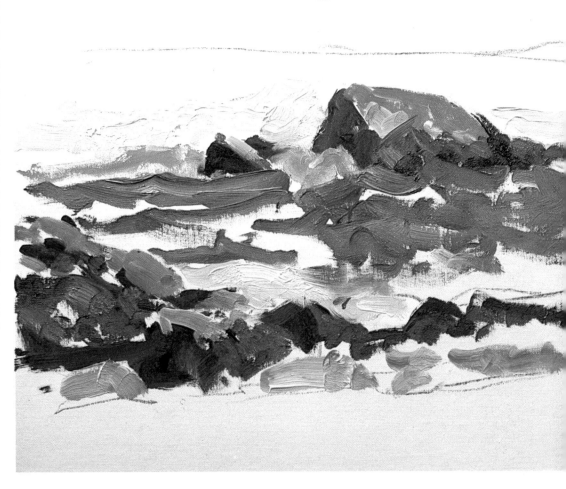

**Step 5.** Once the foreground is established, I begin work on the distance. I quickly cover the canvas—before starting to finish any one part. I get the warmth of the sky down first, blocking it in with a mixture of cadmium red and white. The sky is slightly darker toward the horizon, where the atmosphere accumulates and thickens. In order to relate the distant water to the sky, I paint it a very warm blue—a purple made with the cadmium red plus ultramarine blue and white. This purple also complements the warm orange rocks, accentuating their color. In the foreground, where the sky overhead (not seen in the picture) reflects down on the water, I add more ultramarine blue. The breaking wave in the distance is cut to shape with a rich green (phthalo blue and orange). Since I can always adjust and change my shapes in this way, I never feel I have to draw an object precisely when I'm blocking it in.

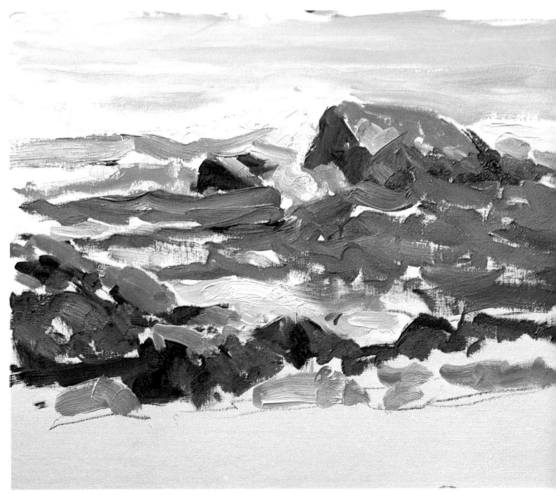

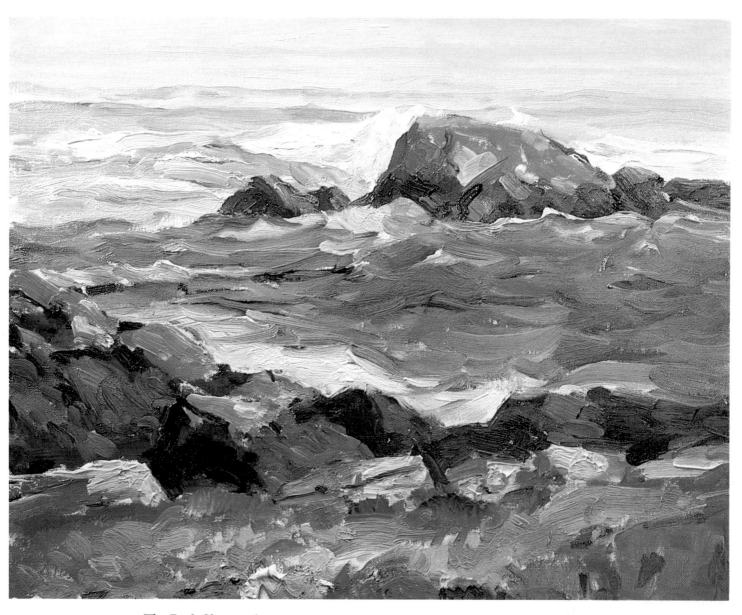

**The Back Shore,** oil on panel, 16″ × 20″ (41 × 51 cm). I warm the sky further by adding cadmium yellow—not the cooler lemon yellow. I then push the area back in space by cutting a cool, light green-blue into it (phthalo blue and lemon yellow). The same blue-green reflects down on the ocean near the horizon. I use dark purple to suggest the waves on the open sea. A little red is added to the distant breaking wave; the red works well with the nearby greens and relates the area to the sky and to the warm rocks. Using the same colors as in Step 3, I add heavier paint to the rocks, each stroke suggesting where a different plane catches the light. A few dark crevices add extra snap to the area. I also develop the movement of the water. I load on the paint in the foreground, and its texture makes you feel that the area is near to you. The warm yellow in the grass also pulls the area forward, as do the few very dark shadows among the jumble of foreground rocks. Since some of the cool foreground greens are too strong, I modify their color by running warm orange over them.

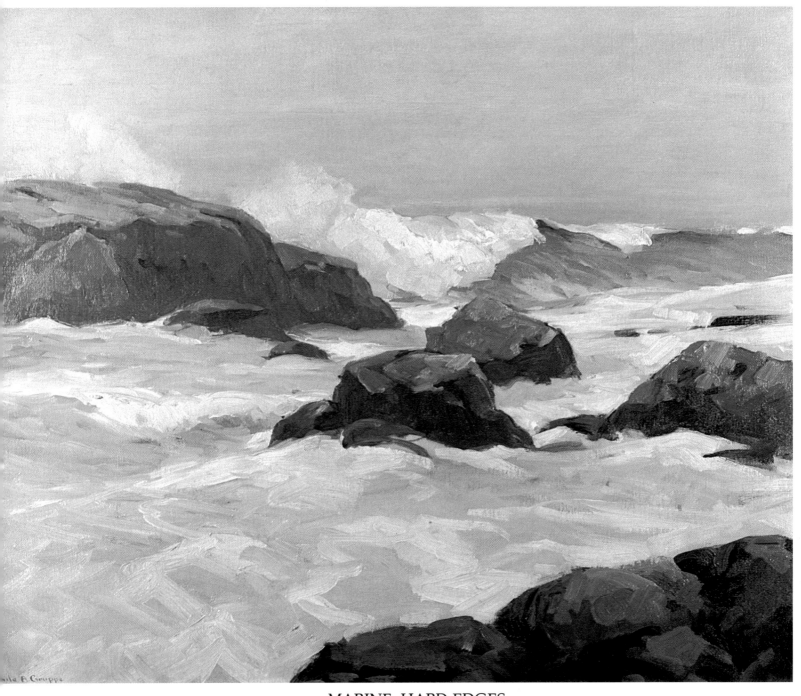

## MARINE: HARD EDGES

**Table Rock,** oil on canvas, 30″ × 36″ (76 × 91 cm). This is an example of the kind of marine I did forty years ago, when I'd just begun to tackle the subject. There's a nice balance to the picture; but can you feel how *careful* I was? Unfamiliar with the subject, I wanted to get the rocks just right. I drew them conscientiously, making sure they neatly led out to the distant breaker. The wave was similarly drawn with great care. As a result, the picture looks static; it has little sense of movement.

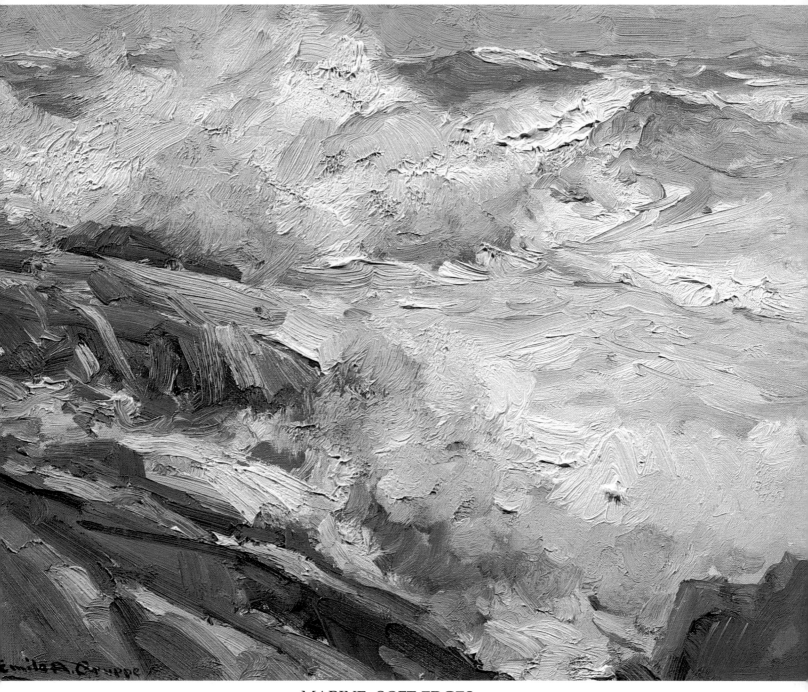

## MARINE: SOFT EDGES

**Rough Sea and Windy Weather,** oil on panel, 16'' × 20'' (41 × 51 cm). Here's a sketch I did just a few years ago. You can see that I no longer worry about getting the drawing right. Instead, I want to capture the feeling of the sea. It was a wild day, and the wind blew foam everywhere. The wind was so strong that I could hardly hold onto my easel. You couldn't nail down the rapidly moving surf; you just saw foam and mist. I softened and lost my edges in order to suggest that constant movement. The picture is therefore much softer and more elusive than the previous illustration. The red of the gray-day sky reflects down onto the mass of white foam. Without the sun, the lightest parts of the foam have very little yellow in them. The white is fairly pure, right out of the tube.

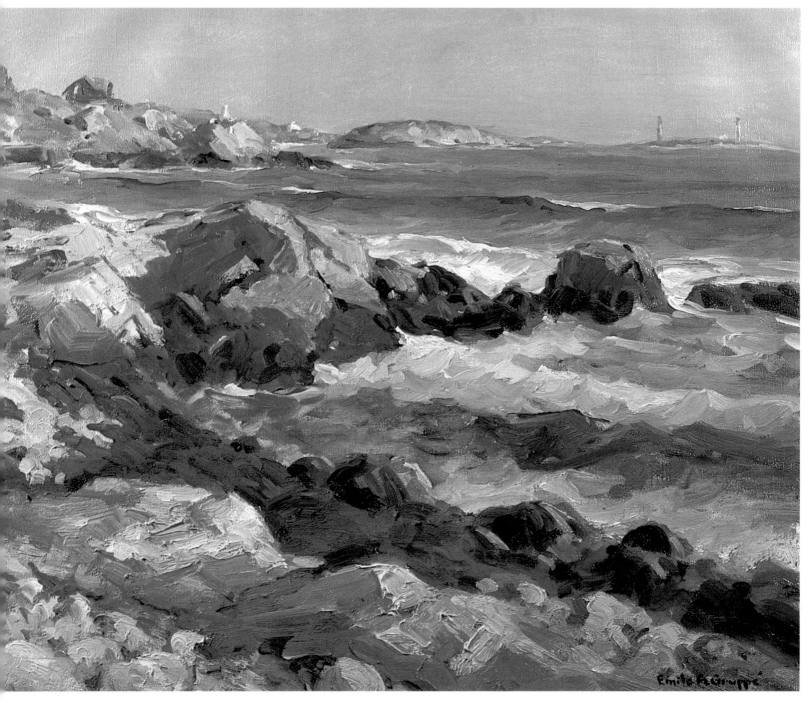

## A QUIET DAY

**Twinlights,** oil on canvas, 25'' × 30'' (64 × 76 cm). On a clear day, the sun hits the granite rocks of Cape Ann so strongly that the scene becomes hard to paint. The violent color can easily get out of hand. I used lots of reds and oranges in the foreground rocks. The distant headlands look bright, too, and I used the same colors in them—but I dulled them by adding a touch of the complement, ultramarine blue. Because the day is relatively clear, a lot of blue color from the sky reflects into the water, making it dark in value. The rich purples and reds in the foreground water show where uprooted kelp and seaweed have been blown to shore by a passing storm. As they roll back and forth with the tide, you can see their dark forms through the water.

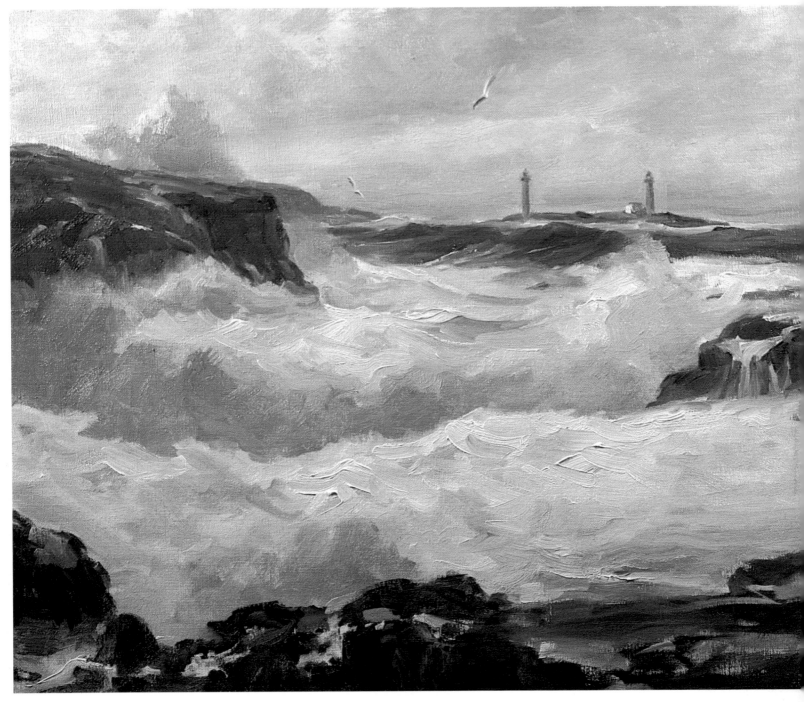

## AN ACTIVE DAY

**White Water,** oil on canvas, 25'' × 30'' (64 × 76 cm). In the previous illustration, the ocean was relatively calm. The waves were small and there was just a little white water among the rocks. In this picture, on the other hand, the pounding surf has churned the foreground water into a mass of white foam. In order to make the foam visible, I emphasized the dark nearby rocks and the bit of distant water (dark because its slanting side catches a reflection from the blue sky overhead). Although the foam looks bright, I placed very few highlights in it. You don't need to add a lot of highlights to get a feeling of brilliance. I used purple, touches of orange, and green in the foam. Every color in the rainbow is there, a result of accidental mixes that formed as I painted. You feel the color as you work; you know your palette so well that the color just seems to appear on the end of the brush.

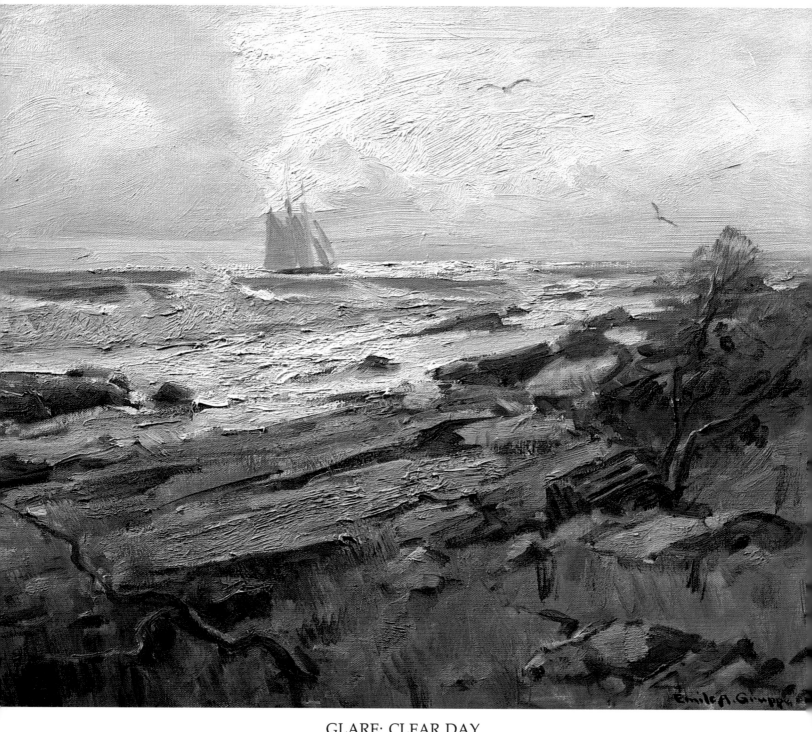

## GLARE: CLEAR DAY

**Coming Home,** oil on canvas, 16'' × 20'' (41 × 51 cm). In this picture, I was mainly interested in the foreground rocks and shrubs. It was painted in the fall, and you can see all the reds and oranges in the grass. The foreground dominates the canvas; the sky is the second largest and most important area; the water comes third. I used a lot of lemon yellow in the highlights on the water and in the sky. Amid the glare, a few dark rocks contrast with and accentuate the brightness of the water. Since we're looking directly into the sun, the sky is very warm. I used a lot of orange with red near the horizon where the atmosphere thickens and becomes less warm. I worked touches of purple into the sky for clouds and then added a hint of phthalo blue. Against this reddish sky, the water looks green.

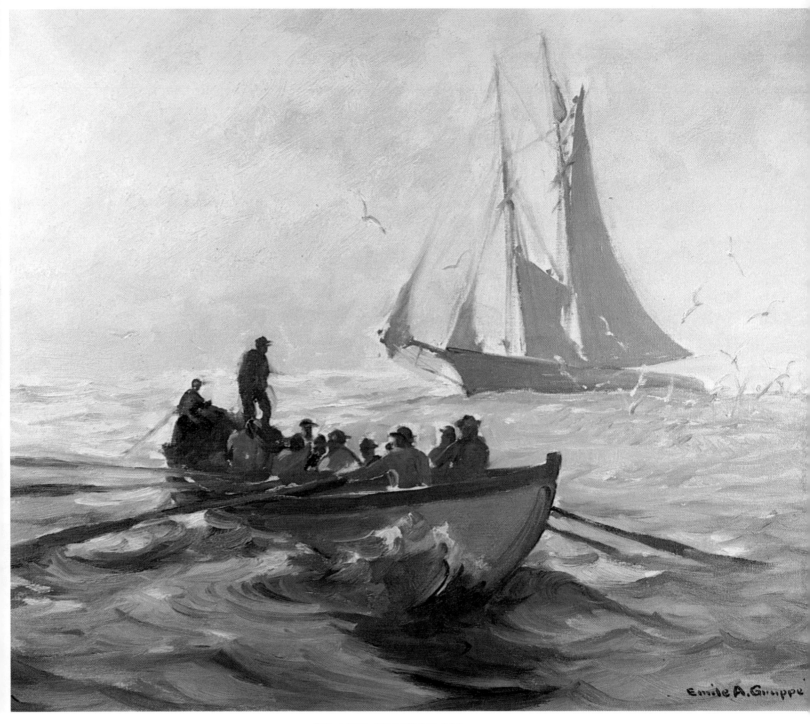

## GLARE: HAZY DAY

**Lowering the Seine Net,** oil on canvas, 25″ × 30″ (64 × 76 cm), Collection of Mr. and Mrs. George Ankeles. This painting is also lit from behind. The sun reflects brightly in the troughs of the water. In the previous painting, the rollers near the shore were large and opaque—the sun couldn't get through them and they appear as dark masses. Here the waves are much smaller and the light passes easily through them, warming them up. I painted the water red (the sky color) first and then ran warm orange-greens over it. The workmen are warm in color; they wear yellow oilskins and catch a lot of reflected light from the inside of the boat. The most brilliant area in the painting is, of course, the glare on the water (lemon yellow and white). But since it's a hazy day, the glare isn't as strong as in the previous picture. I accent the area by positioning it against the dark silhouette of the fisherman and the stern of the seine boat. Against the sunlit sky, the sails of the distant schooner look dark. I paint the sails purple to suggest the cooling effect of the sky, then run orange over it to show the warming effect of the sun.

## A ROCK PICTURE

**Bass Rocks,** oil on canvas, 20″ × 24″ (51 × 61 cm). This is a picture of rocks; there's only a bit of ocean in the distance. I was interested in the different kinds of rocks visible at low tide. The existence of the foreground foliage tells you that the nearest rocks are rarely underwater. Instead, they're bleached by the sun and therefore tend to be lighter and cooler than the rocks directly in back of them. I mix their tannish color with orange, red, and touches of ultramarine blue. The distant rocks are underwater half the time and so have been stained and darkened by the sea. They're rich and deep in color; you can actually see the red in them. Farther out, the rocks become practically black. They're almost always underwater and, in addition, are covered by dark masses of seaweed.

## A WATER PICTURE

**Morning Surf,** oil on canvas, 30'' × 36'' (76 × 91 cm), Collection of Mr. and Mrs. George Ankeles. This is a study of a single breaker. The subject is the small translucent area under the curving wave. I get the delicate green with lemon yellow, phthalo blue, and lots of white. Since the foam is constantly moving, you can't see the strong highlights on it. If I put one in, the wave would immediately stiffen up. The brilliant highlight on the foreground rock on the right adds a staccato note, a bright touch which, because it attracts the eye, makes you see the entire background as a single large unit. It functions much like the red roof in the painting on page 95. Cover the spot, and see how the variations in the foam suddenly become more noticeable. The highlight also establishes the foreground and, by way of contrast, pushes the wave back in space.

## A MUD PICTURE

**Low Tide: Ten Pound Island,** oil on canvas, 25'' × 30'' (64 × 76 cm), Collection of Lorraine Caldwell. This picture emphasizes the mud. Since it's warmed by the sun, wet mud is always on the reddish side. I started it with reds and oranges and then worked into it with purple and blue-green reflections from the sky. Since the mud and water run together, you can't paint the area with thick, obvious strokes. It has to be handled in a more subtle manner. The softness of the mass is accentuated by the strength of the distant rocks and by the sharp line of the broken foreground board. This board is an essential element in the picture, for it tells you where you're standing. Cover it with your finger, and you'll see how the picture loses much of its depth.

## A SKY PICTURE

**Jensen Beach,** oil on panel, 16'' × 20'' (41 × 51 cm). Here I emphasize the sky. The sun is low and throws the foreground into shadow. Even the upright planes of the surf don't catch the light. The sun hits only the tops of the clouds. The clouds, therefore, are very warm; the water, foam, and sand, on the other hand, are all cool. Notice the foam in particular. It looks "white" but is very gray and blue when compared to the brilliant clouds. This is a good example of how the three secondary colors work to create a striking effect: the clouds are orange; the cloud shadows are purple; and the sky itself is green. This interaction of color gives the picture its punch, just as it did in the painting on page 55.

133

## A BEACH PICTURE

**Wingaersheek Beach,** oil on canvas, 25″ × 30″ (64 × 76 cm), Collection of Lorraine Caldwell. I did this picture for the sake of the sky and the foreground. I was especially struck by the early morning sky and by the great, flat expanse of the beach. It was very simple—and I tried to capture the peacefulness of the day. I could have faked "interest" by adding a breaking wave on the beach—but that would have contradicted the prevailing mood. I put a lot of red in the sand in order to keep it from looking like snow. I then made it look gray by running light green over it. The sand became wet (and dark) near the water. I used the same colors, but with less white. I added touches of phthalo blue where the wet sand picked up color from the sky. There's also a lot of red in the distant ocean. The water is very shallow, and you can see the sand through it.

## SAND DUNES

**The Dunes,** oil on canvas, 20'' × 24'' (51 × 61 cm). I was attracted to this subject by my feeling for the big, convex mass rearing up into the dramatic, late afternoon sun. Because of the large shape, the subject looked very dignified. In order to keep that dignified feeling, I painted the dunes as big masses, without getting too involved in the individual clumps of grass. Since it was late in the summer, the sand-grass had a lot of orange in it. Its rich olive-green contrasts with the red of the low-lying bushes—probably some kind of sumac. I used a lot of lemon yellow in the hills, with the shadows catching ultramarine blue from the sky. The shadowed foreground helps throw the sunlit distance into greater relief. In contrast to these bulging dunes, the background water and beach are handled very flatly.

**The Old Homestead,** oil on panel, 16″ × 20″ (41 × 51 cm). In the middle of the fall, the earth and the foliage reflect warm light into everything. Notice how warm the shadow side of the house is, for example. Light even reflects up from the ground and under the eaves. The warmth of the reflected light becomes obvious when you look at the window on the shadow side of the house. Since it's glass, it clearly shows the reddish orange light bouncing into it. The tremendous amount of red in the landscape affects not only the house and sky but the distant hills as well. In summer, these hills would be a reddish blue. Seen against the red foreground, they appear very green—you can see the strong touches of phthalo blue.

# Painting Tips

Now that we've discussed my color theories and have given some thought to landscapes and marines, it's time to go out and paint. Here are a few practical points to keep in mind that might help you when painting outdoors. You might also want to review my painting procedures in the demonstration on pages 120–123.

## Paint Like a Millionaire

John Carlson used to say that if you didn't have the money to buy paints, then paint only once a week—but paint like a millionaire! He meant, of course, that it takes plenty of paint to make a picture. So put out lots of color. I go by the following rule of thumb: squeeze out what you think you'll need, then double it—and use it all! I remember an elderly student who kept his paints in a little wooden box and carefully placed them on his palette in a series of little spots—like polka dots. "What's that," I asked him one day, "peas?" Then I took a tube of cadmium red and squeezed the whole thing onto his palette. "Okay," I said, "that's your lesson for today."

## Preparing Your White

I find it hard to paint with white exactly as it comes from the tube. It's too stiff. So I always add medium to the mound of white and beat it for a few minutes with a palette knife, exactly as you'd beat an egg. I try to get it the consistency of cold cream or mayonnaise. Then it takes the color quickly, and you don't fight the puttylike quality of white straight from the tube. I learned the trick years ago at a demonstration by Dean Cornwell, the great American illustrator. As we watched, it seemed as if he'd spent half an hour beating his white; then he turned to the audience and said, "Well, now the picture's half done."

Beating your white is essential when you paint on a cold day. In winter, the white can get like cement. I remember working outdoors in 30° cold—without whipping my color—and having all kinds of trouble. I had thick gobs of white all over the picture and used almost an entire pound tube—on one 16''×20'' (41×51cm) canvas! So try beating your white next time you paint outdoors. You'll be surprised at how much more quickly and easily you can work. As with the other colors, make sure you put out as much as you need for the picture—and then some. That way, you can beat it all at the beginning and not worry about doing it again later.

## Medium

I use a 5-to-1 mixture of stand oil and turpentine as a medium. The stand oil is like molasses and has to be cut so you can use it, but I prefer it to linseed oil because it yellows less.

I use a lot of medium in my initial lay-in, painting transparent darks that merely stain the canvas. Once I'm into the picture, however, I don't need to use much medium—there's enough of it in my soupy white. I may use some extra when I need to do fine lines—like the dark crevices in a rock. In that case, the extra medium acts like a lubricant, allowing the color to slide over the canvas.

## Brushes

I use all the brush sizes from 1 to 12; and I carry two of each size with me. In the course of painting, I might use from 8 to 20 of these brushes—rather than trying to get clean color by carefully wiping each brush in turpentine. That wastes time outdoors, time I could better spend painting. Besides, you can never get the brush clean enough.

When I want a nice, clean color, I use a clean brush. I stop using a brush as soon as all three primaries are on it; that is, when I mix a green and then use the same brush to work some red into it. The three primaries may work on the canvas, but on the brush they blend and make a mud that would creep into all the other color picked up by that brush.

## Dangers of Reflected Light

Light, as we know, can be very exciting. But it can also create practical problems for the painter. That's why, for example, you should never wear a red shirt when you're painting. The sun will bounce off your shirt and send the color onto the canvas. Then the reflected light mixes with the pigment, and what looked like a nice, warm painting outdoors becomes much cooler once you bring it inside. So, for outdoor painting, I generally try to wear a neutral outfit.

The same problem can develop if you're painting near a red barn—or near any brightly colored object, for that matter. Sorolla, the great Spanish artist, was well aware of the danger of reflected light. He did huge canvases, painted right on the beaches of Spain. But he always put a dark cloth under his easel so warm light wouldn't bounce off the sand into his eyes and onto the canvas.

## Light on the Canvas

When you're painting outdoors, also try to keep the canvas in shadow. If you should have to face the sun, you may need to put newspaper on the back of the canvas to keep the light from shining through. It is possible to paint with sunlight on the canvas, but such a picture always looks darker when you get it inside. Whatever happens, don't start painting with your canvas in shadow—and continue working on it when the sun comes round and falls directly onto the picture. Many students work so intently that they don't notice that the sun has crept over their shoulder. If you keep working, all your values will be off. So remember: if you *start* with light on the canvas, *finish* the picture that way. And the same holds true if you begin with your canvas in shadow.

## Handling the Paint

Over the years, I've picked up techniques from all the instructors I've admired, and you can see my training in the way I apply paint to canvas. If, for example, I feel that the "indirect" method of working color over color will give me a good effect—then I work color over color. On the other hand, if there's a spot where I can work "directly"—where I can get the color with one stroke and it looks lively and vibrant—then I put that one stroke down and leave it alone. Sometimes I use small, broken strokes; sometimes I use big, broad strokes. I don't bend the subject to my technique. Instead, I try to adjust the technique to the characteristics of the subject.

## Conclusion

When I paint outdoors, I've always liked to let the paint do some of the work. I go for the big effect; and when I get it, I let the rest go. Of course, I can still remember my father telling me "try taking it a bit further." But I always felt that if I did, I'd ruin the spontaneity and excitement of what I had in the first place. After all, it's possible for a thing to be well drawn and so systematically developed that the essence of the subject is lost.

Here's the important difference between tight and loose painting: tight, meticulous work can be copied—even a reasonably clever student could do it. But loose, spontaneous work is full of accident and inspiration. And great paintings done in this manner can never be duplicated—the painter himself doesn't know how he got some of his effects. All he knows is that he was outdoors. Something happened to him. He saw differences; he felt the shadows and the textures—and put them down. Such painters see their pictures even before they begin them—as if in a dream. The subject hits them hard. When they finish, the picture is better than nature, but never as good as what was in their mind's eye. They worry about it, of course—but they also know that you can never achieve perfection. There's never an end to things. It's like the universe: where do the stars end and heaven begin?

Subject matter can also be a problem. Many artists get stuck painting one particular subject: snow, boats, mountains, or the like. They feel that subject strongly and eventually get hooked on one way of painting it. But art is a lot more than subject matter. It's design and color, too. It's what you feel about the subject. Paint your feelings and you'll never be trapped into formulas. Using your knowledge of design, you can make almost anything interesting.

Art is personality, too. You paint the way you're made. And the viewer, looking at your pictures, is interested because he senses your mind and emotions at work. One painter sees things one way; another sees things in a different way. I studied with everybody that I thought was any good—and each artist had his own approach. But when they differed, it didn't matter, because the real art comes after the study, when you're on your own and have to think for yourself. At that point, you have to consider everything your instructors told you, pick from it what you need, and begin to express your own attitude. Then, when a subject attracts you, it's because you see something of yourself and of your approach to things in it. That's why you can't really copy anyone's style. When a man paints, he expresses his whole life: what he's done and what he's experienced. If you're bold and outgoing, your work will show it. If you're small-minded and grasping, your work will show that, too.

So be adventurous: use lots of paint and skid it around. Get interested. See the big relationships and leap in. Don't be too choosy, and don't be afraid of a subject. Look at Steve Brodie: he jumped off the Brooklyn Bridge and lived. So take some chances, too!

# EMILE A. GRUPPÉ
## November 23, 1896–September 28, 1978

Although Emile Gruppé was born in Rochester, New York, he spent the first decade of his life in Katwyk an Zee, Holland, where his artist-father had acquired a villa through the bartering of his own pictures: one painting for the architect's fee, one for the materials, and one for the contractor. Gruppé often referred to the studios he visited as a child. He also recalled his family's strong interest in music—and remembered spending one summer walking the Dutch shore with a promising young house guest: Pablo Casals.

As Gruppé entered his 'teens, the early rumblings of World War I brought his family back to the United States. Knowing Dutch but little English, he struggled through the New York City schools and was relieved when his family decided to try to make him into a painter. His father was his first teacher, followed by a decisive four years with John F. Carlson. Meeting John Carlson, he often said, was the luckiest thing that ever happened to him.

Gruppé visited Cape Ann, Massachusetts, in 1925 and found it the perfect place for a confirmed outdoor painter. He was soon painting the ocean, the streets, and, especially, Gloucester harbor, filled in those days with a fleet of over 500 sailing vessels. This material provided him with subjects for the rest of his career. For variety, he made regular trips to Vermont and Florida.

Throughout his working life, Gruppé taught. Teaching was habitual with him; he even ran a painting class at Woodstock—while himself studying under John F. Carlson. He felt that teaching was part of the painter's life, and he was angered whenever he heard that a good artist had ceased to have classes. He once said that he was the right man to ask about painting problems because "in my sixty years of painting, I've made every mistake there is."

Gruppé was also a prodigious worker, and had disciplined himself to paint every day. If he didn't paint outdoors, then he'd study and work on some of his older pictures in the studio. He continued this habit till his death; the day before he left for the hospital, he stretched a 30" × 36" (76 × 91 cm) canvas in preparation for his regular Thursday morning painting demonstration. A friend once told him to take a vacation; the friend even suggested a likely spot. "But there's nothing to paint there," Gruppé replied. "Well," the friend said, "Don't bring your paints." Gruppé looked perplexed for a second. "Don't bring my paints," he exclaimed. "Then what's the point of going?"

*Emile Gruppé as a young boy in Holland.*

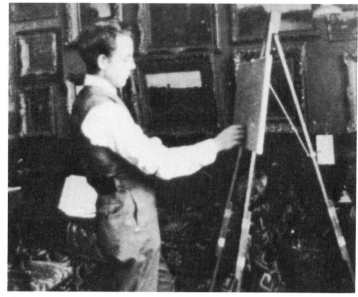

*Gruppé at work in his father's picture-lined studio in Carnegie Hall.*

*Painting on Gloucester's Bass Rocks in the early 1930's.*

*Gruppé at work on the streets of East Gloucester—surrounded, as usual, by a group of students.*

*Gruppé and a class at work on the Gloucester docks; after a rain storm, the schooners raised their sails to dry.*

*Gruppé in the early 1950's points out a problem to one of his students.*

*In the early 1970's, Gruppé studies a student's composition and suggests ways to improve it.*

*Gruppé late in life—posing for the camera.*

# Bibliography

Bates, Kenneth. *Robert Brackman, His Art and Teaching.* Noank, Connecticut: Noank Publishing Studio, 1951.

Bridgman, George. *Life Drawing.* New York: Dover Publications, 1961.

Carlson, John F. *Landscape Painting.* New York: Dover Publications, 1974.

Gruppé, Emile A. *Gruppe on Painting.* New York: Watson-Guptill Publications, 1976.

Gruppé, Emile A. *Brushwork.* New York: Watson-Guptill Publications, 1977.

Hawthorne, Charles W. *Hawthorne on Painting.* New York: Dover Publications, 1960. (paperback)

Henri, Robert, *The Art Spirit.* Philadelphia: J. B. Lippincott Company, 1930. (paperback)

Karolevitz, Robert. *The Prairie is My Garden, The Story of Harvey Dunn.* Aberdeen, South Dakota: North Plains Press, 1969.

Schlemm, Betty L. *Painting with Light.* New York: Watson-Guptill Publications, 1978.

Edited by Bonnie Silverstein
Designed by Jay Anning
Set in 11-point Palatino